Sarane Alexandrian
was born in 1927. After graduating
in the Faculty of Letters at the Sorbonne in Paris,
he studied art history at the Ecole du Louvre. In 1947
he became associated with the leader of the surrealist
movement, André Breton; he subsequently edited the
surrealist journal *Néon* and acted as Secretary of Cause,
the International Surrealist Bureau. He has written a
number of books of criticism and art history, and is the
author of two major studies of the surrealist painter
Victor Brauner. He also also written two novels, and
contributes regularly to a number of
international periodicals.

Thames & Hudson world of art

This famous series
provides the widest available
range of illustrated books on art in all its aspects.
If you would like to receive a complete list
of titles in print please write to:
THAMES & HUDSON
181A High Holborn, London WC1V 7QX
In the United States please write to:
THAMES & HUDSON INC.
500 Fifth Avenue, New York, New York 10110

Printed in Singapore

Sarane Alexandrian

Surrealist Art

231 illustrations,
50 in color

 Thames & Hudson world of art

Translated from the French by Gordon Clough

English translation © 1970
Thames & Hudson Ltd, London
L'Art surréaliste © 1969 Fernand Hazan Paris
Artistic rights © 1969 S.P.A.D.E.M. and
A.D.A.G.P. Paris

Published in paperback in the United States
of America in 1985 by Thames & Hudson Inc.,
500 Fifth Avenue, New York, New York 10110

thamesandhudsonusa.com

Reprinted 2004

Library of Congress Catalog Card Number
85-50750
ISBN 0-500-20097-1

Printed and bound in Singapore by C.S. Graphics

Contents

Preface

From its very beginning, surrealism resisted all attempts to turn it into a doctrine. Instead of teaching a system, the surrealists set out, by means of appropriate actions and productions, to create new demands on reality. They set out to liberate the workings of the subconscious, disrupting conscious thought processes by the use of irrationality and enigma, and exploiting the artistic possibilities of terror and eroticism. In this way they created a new form of sensibility which had a profound influence on modern art, and which was able to meet an enormous range of personal requirements and to find expression in the greatest possible variety of creative processes. Surrealist artists and writers became international masters whose influence was so fertile that any study of them seems to lead right to the heart of the most important avant-garde work of our era.

Unlike romanticism, with which it has often been compared, surrealism was able to establish, between the language of the plastic arts and the language of poetry, a relationship which was not limited to the illustration of the one by the other. It set poetry at the centre of everything, and used art to make poetry into something which could be seen and touched. The surrealist painters and sculptors, moreover, were themselves poets.

René Magritte, two months before his death, wrote me a splendid letter in which he said: 'I conceive of the art of painting as the science of juxtaposing colours in such a way that their actual appearance disappears and lets a poetic image emerge.... There are no "subjects", no "themes" in my painting. It is a matter of imagining images whose poetry restores to what is known that which is absolutely unknown and unknowable.' If surrealist art avoided being literary, it was by invoking poetry as the opposite of literature, and because it was supported by poets, like Breton, Eluard and Aragon, who were well-informed collectors of art, and who encouraged its technical innovations.

The evolution of surrealism is merged almost completely with that of André Breton, its founder; although he did not invent the word, he made the fortune of the idea, whose purity he strove constantly to protect. To be a surrealist, one had first to be granted the title by Breton; no one ever raised a murmur of protest against this obligation, so self-evident did it seem. His manifestos, however personal in style, were emanations of the will which moved his companions of the moment. He was able to impose on those who approached him not only a discipline of action, but also, which is far more surprising, a discipline of dreaming.

However, an artist did not necessarily stop being a surrealist when, after having been a part of this common enterprise, he was driven by his individual development to withdraw from it. Any artist who worked with the surrealists acquired, and kept forever, principles and stimuli which he would never have found on his own; for everything, from the passionate diatribes about books down to the games the surrealists played, had the unconditional aim of maintaining the poetic climate.

From 1947 onwards, I myself was a member of the surrealist group; my conversations with Breton and my contacts with other artists are my most valuable source of information.

To understand the surrealist artists one must be aware that they all believed that art was not an end in itself, but a method of creating an awareness of all that is most precious, most secret and most surprising in life. They wanted to be neither craftsmen nor aesthetes; they wanted only to be 'inspired ones' and gamblers. When I visited Francis Picabia in his Paris home in 1949, he showed me photograph albums which contained the memories of his past pleasures; he was prouder of these than of his paintings. As he once wrote: 'How little I care about my painting, if only the vital spirit, which is the art of celebrations, remains with me!' This sublime nonchalance cannot diminish the scope of a creative adventure which became a tragedy for so many: the surrealist revolt, despite its frequent use of humour, often reached the depths of despair. It is not difficult to conclude, if one opens one's mind to its works, that surrealism, the product of its century, transcends the limitations of dates and events; it is not so much a category of art as one of those living forces which imagination has always in reserve.

Precursors

There are certain precursors whom the surrealists claimed as their own, and to whom they constantly paid homage in their periodicals and their exhibitions. André Breton said, in an interview towards the end of his life, 'Surrealism existed before me, and I firmly believe that it will survive me.' However, although the movement was based on the cult of the strange and the exaltation of the imaginary, we should avoid the common error of believing that all the masters of fantastic art, of mannerism and baroque, were its ancestors. Surrealism has no room for the fantastic when it is elaborated without inner need: it is not so much the description of the impossible as the evocation of the possible, supplemented by desire and dream. Thus, there are painters of strange universes who have no connection with it at all. For instance, Odilon Redon, in his charcoal drawings and etchings, created fantastic animalcules and nightmare landscapes with the avowed intention of putting 'the logic of the visible at the service of the invisible'; but the surrealists firmly refused to acknowledge any kinship with this artist, whom they considered insipid. Conversely, there are some works by classical painters which are undeniably surrealist in the ambiguity of their content or their execution. Ingres, for instance, in *Jupiter and Thetis* (1811, Aix-en-Provence, Musée Granet), produced the image of a regal couple which has all the enigmatic effulgence of the figures in the work of Paul Delvaux.

The surrealists assembled for their own use an 'ideal museum' made up of a small number of works which they admired. They did not wish to destroy existing libraries or art galleries, but merely to give them a thorough shaking-up, to sweep away hallowed glories, and to bring unappreciated geniuses into the full light. Surrealism is based on the belief that there are treasures hidden in the human mind. It was this that brought the surrealists to claim that in the cultural legacy of the past there remained undiscovered personalities and works which were to be preferred to the names and titles revered by official teaching.

If we consider only those forerunners of surrealism whom the surrealists themselves recognized as such, and whom they regarded as authorities, we find that they all fall into one or another of three groups: visionary art, primitive art and psycho-pathological art. It was this triple influence which gave birth to surrealism, which is in a sense a fusion of the principles behind each of these three forms of art.

Paolo Uccello was one of the great visionary artists, those who show objects not merely as they actually appear, but through the mind's eye. He was honoured by the surrealists for paintings like the *Desecration of the Host* (1465-7, Urbino, Galleria Nazionale). It was the lyricism of his conception that they consciously admired, and they were indifferent to the legend of 'Paolo the bird-lover', and to his mania for perspective. Uccello freed painting from the slavish imitation of nature by giving arbitrary colours to animals, houses and fields, and by arranging his figures as a function of a combination of converging lines. These means also allowed him to endow reality with a sense of irrationality.

According to Vasari's account, another painter of the Italian Renaissance, Piero di Cosimo, would spend long periods in the contemplation of stains on a wall or clouds in the sky. In the stains or in the clouds he saw great processions, cities and magnificent landscapes, which he used as models. For a festival in Florence he organized a macabre masquerade which both terrified and delighted those who saw it. His powers of transfiguration enable him, in paintings like *The Battle of the Centaurs and the Lapiths* (London, National Gallery) and the *Misfortunes of Silenus* (Cambridge, Mass., Fogg Art Museum), to evoke the Dionysiac ecstasies of the Golden Age.

The most important pre-surrealist visionary was Hieronymus Bosch, and it was on his example that the surrealists relied most. In *The Garden of Earthly Delights* and *The Haywain* (Madrid, Prado) and the *Temptation of St Antony* (Lisbon, Museu Nacional), he parades an exhaustive repertoire of prodigies. There are wheeled dragons, fish with legs, hybrid demons, contortionists, living rocks, weird vegetables, birds larger than men, delirious processions and dizzy battles, people walking on their hands or vomiting frogs, rebel angels transformed into dragonflies. All these are part of the heritage of Gothic art, but Bosch's meditative genius reinvents them and

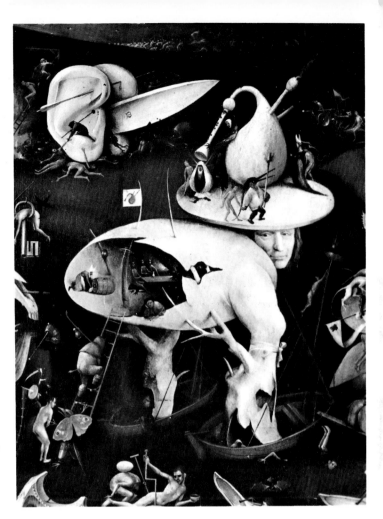

1
HIERONYMUS BOSCH
*The Garden of
Earthly Delights
c.* 1500
(detail of right
panel of triptych)

offers an obsessive spectacle of the prodigality of nature, of humanity's
feverish squandering of life, and of the universal triumph of unreason.
There have been many attempts to explain the philosophical preoccu-
pations which make Bosch's painting, to an even greater degree than
that of the elder Bruegel, something which remains a secret - in other
words, by definition a surrealist form of painting.

There were more forerunners of surrealism among sixteenth-
century German painters. Albrecht Dürer's woodcuts and copper *2*
engravings gave episodes from the Apocalypse and various allegories
the force of hypnagogic images. Albrecht Altdorfer, an architect at

Regensburg in Bavaria, applied miniaturist techniques to his large painting *The Victory of Alexander* (1529, Munich, Alte Pinakothek), and by this method was able to make hundreds of warriors, lit by dawn in the heart of a mountain landscape, swarm over the canvas in a hallucinatory way. Mathias Grünewald, the greatest colourist of the German school, reached the heights of the fantastic in his *Isenheim altarpiece,* and did so through a very excess of realism. Hans Baldung Grien's frenzied imagination, shown in his linking of Pleasure and Death, and in his witches' sabbaths, compelled the intense attention of the surrealists.

Antoine Caron, the court painter of the Valois, whose job it was to commemorate the festivities of the court of Charles IX, has a place of honour in the surrealists' ideal museum. He painted two pictures of massacres, in particular the *Massacre of the Triumvirs* (1566, Paris, Musée du Louvre), in which the convulsions of the beheaded victims and the bloody rage of the soldiers contrast with the smiling

2
ALBRECHT DÜRER
The Rape of Amymone
c. 1498

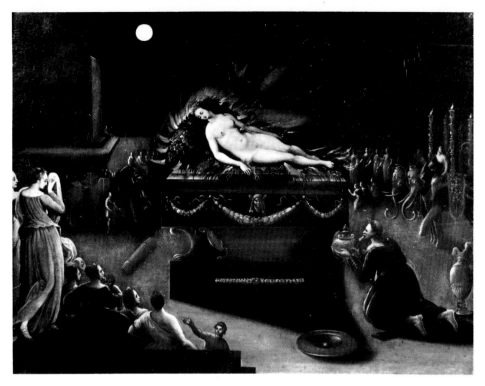

3 After ANTOINE CARON Copy of *The Apotheosis of Semele* 16th or 17th century

calm of the statues and the harmony of the architecture to create a
nightmare of cruelty. There is a strange quality, too, in other paintings
by Caron, such as the *Apotheosis of Semele* and *The Elephant Carousel*, 3
and also in his engravings for *Le Livre de Philostrate*, which had a great
success during his lifetime.

The 'double image' technique which some of the surrealists used
to great effect was anticipated by Giuseppe Arcimboldo, official 4, 5
portrait painter to the Holy Roman Emperors, who lived at the
Hapsburg court from 1560 to 1587. He was noted for his 'composite
heads', in which he used assembled objects to make up allegories and
portraits. He also painted *Summer* (1563, Vienna, Kunsthistorisches
Museum), a figure composed of a pile of vegetables, fruit and flowers,
and *The Librarian*, made up of a heap of books. Some of the minor
Flemish masters, among them Joos de Momper, imitated Arcimboldo
and painted anthropomorphic landscapes. The figures who play

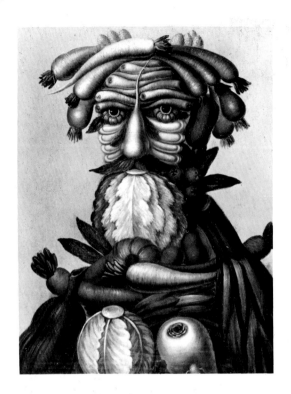

4
GIUSEPPE ARCIMBOLDO
The Market Gardener
16th century

5
GIUSEPPE ARCIMBOLDO
The Cook 16th century

instruments and dance in the fifty engravings in the series *Bizarrie di varie Figure* (1624), by the Florentine painter Giovanni Battista Braccelli, are made up of chains, drawers, springs and set-squares, rather like some of the drawings produced in the surrealist game of Exquisite Corpse.

Henry Fuseli (Johann Heinrich Füssli), a Swiss-born painter who lived in England, liked to paint dreams in which a sleeping creature was surrounded by unreal figures; his most successful picture in this genre was *The Nightmare* (1782, Frankfurt, Goethe-Museum). His taste for tragic lighting effects and his fondness for fairy landscapes, where wyverns mingle with winged toads, redeem his over-literary inspiration : most of its subjects were drawn from Shakespeare. The poet-engraver William Blake was more openly a visionary. He had genuine hallucinations during which he saw into the future and

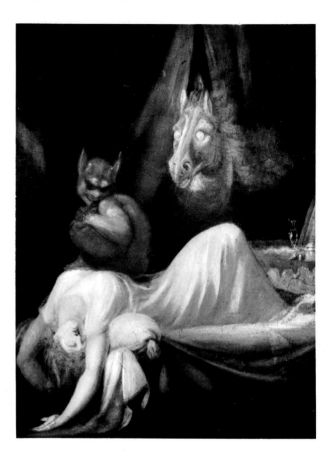

6
HENRY FUSELI
The Nightmare
1782

conversed with angels and with the dead. In his visionary epics, illustrated with engravings, and in his illustrations to Dante, he expresses Chaos and the Forces of Good and Evil with frenetic brilliance. *13*

Goya's *Proverbs* are deeply surrealist, both in the spontaneity of line *7* and in the originality of the subjects. He is surrealist, too, in other works where his merciless grip inflicts violent twists on reality, forcing it to bring forth monstrous truths. Charles Meryon, the romantic engraver, descends from Goya's line. From the time when he was first afflicted by the persecution mania which led to his detention in the Charenton asylum, his etchings of Paris were enlivened by disturbing apparitions in the sky. Typical of these is the aerial flotilla in his *Ministry of the Marine* (1865). Rodolphe Bresdin, who lived an eccentric and miserable existence, made etchings containing extraordinary

7
FRANCISCO GOYA
Is there no one to untie us?
1796-9

landscapes, with trees scaled like fish, confused jumbles of rocks, animals and skeletons, and glimpses of dreamlike buildings.

The great romantic poet Victor Hugo also made a contribution, through his drawings, to the development of free and imaginative art. Between 1848 and 1851, in the large studio he had set up in Paris, he did large drawings in which he used every kind of audacious technique to evoke castles on the Rhine and more or less sinister ruins. He used strange mixtures of ink and coffee, and made use of soot, carbon and sepia. Often he used a scraperboard technique. When he was in exile in Guernsey, he turned to chance methods, and created forms by folding a piece of paper on to which he had dropped an ink blot, or by placing a scrap of lace on a blot. On other occasions he chose to use crossed nibs which left blots and stains. A series of etchings

10

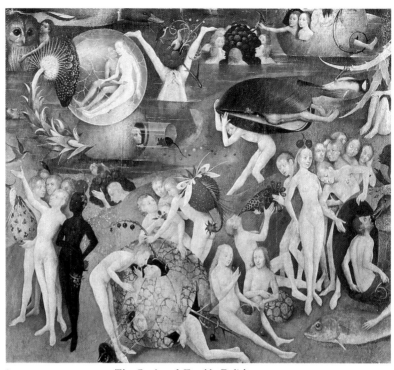

8 HIERONYMUS BOSCH *The Garden of Earthly Delights c.* 1500
(detail of central panel of triptych)

9 PAOLO UCCELLO *The Desecration of the Host* 1465-7
(detail of predella : *Execution of the repentant woman*)

made from his drawings, known as the *Album Castel* (1863), reveals his capacity for visual poetry.

Arnold Boecklin, who was to be admired by both Chirico and Dalí, was born in Basle, but lived for a long time in Italy, where he tried to discover the secret of the technique used in the mural paintings of Pompeii. While he was living in Florence, from 1872 to 1885, he painted the *Island of the Dead* (1880, Basle, Kunstmuseum), one of the masterworks of his style, which creates an atmosphere of muted unreality. Boecklin made a conscious effort to associate painting with poetry, both by attaching a great deal of importance to the content of the picture and by using shimmering colour.

Towards the end of the nineteenth century, some painters began to formulate demands which the surrealists later applauded. They admired Gauguin for his rebellion, and for his rejection of civilization for a wilder form of life; they admired Van Gogh, with whom Antonin Artaud identified himself in some impassioned pages; they admired Seurat, whose neo-impressionism they regarded as a 'pre-surrealism' which bathed everyday reality in a magic light; and they admired Charles Filiger, who was a painter of Gauguin's Pont-Aven group, living a hermit's life at Plougastel, whose plans for stained glass for an imaginary church have a spare, hieratic quality.

10 VICTOR HUGO *Wash drawing* 1862

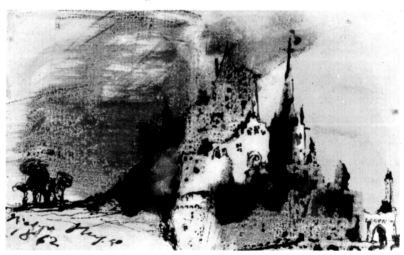

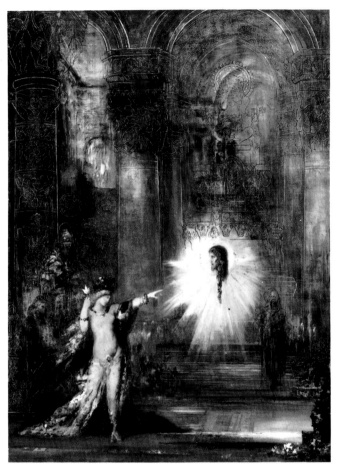

This period was dominated by Gustave Moreau, a master whom
the surrealists rated second only to Hieronymus Bosch. A refined and
learned teacher at the Ecole Nationale des Beaux-Arts, where his
pupils included Rouault and Matisse, Moreau was a solitary whose
contempt for modern life led him to shut himself up in his house in
Montmartre (now his museum), and to spend his life evoking visions
of Greece and the Orient. Moreau had a sense of visual splendour. Art, *11*
he said, should obey the principle of 'necessary richness' ; in other
words, it should represent everything that is most sumptuous in the
world. His watercolours, more so than his enormous paintings, blaze

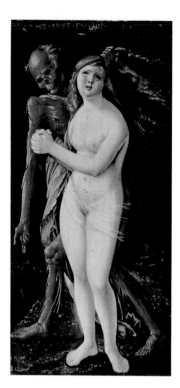

12
HANS BALDUNG GRIEN
Death and the Maiden
1517

13
WILLIAM BLAKE
The Simoniacal Pope
c. 1824-7

with enamels, jewels and embroideries, giving to Sirens, Chimaeras and other fabulous characters the luxurious brilliance of nostalgic visions.

15 Henri *(le Douanier)* Rousseau, too, was a notable forerunner of the surrealists, particularly in his exotic paintings, which always prompt the question as to whether he did them from imagination or from memory. In the *Dialogue créole* between André Breton and André Masson, the former remarks : 'A good question for an advanced examination for art critics (don't you think that they ought to be made to take examinations?) would be : "Does the painting of Rousseau prove that he knew the tropics or that he did not?".'

Finally, very close to their own beginnings, surrealists in search

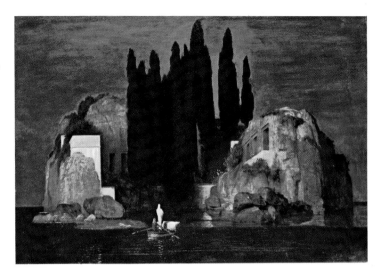

14
ARNOLD BOECKLIN
The Island of the Dead
1880

15 HENRI ROUSSEAU *Virgin forest at sunset. Negro attacked by a leopard* 1907

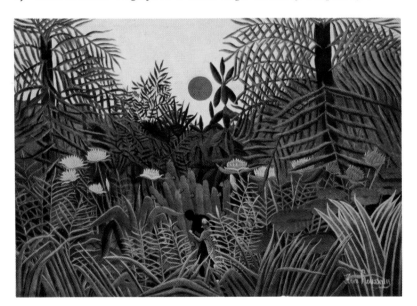

of precedents came across the Norwegian Edvard Munch, who, although claiming to be an expressionist, goes far beyond expressionism in his paintings, where he gives mystical expression to love, to solitude and to primitive fears : such paintings as *The*

Dance of Life (1899-1900, Oslo, Nasjonalgalleriet). They found also Alfred Kubin, who, at the time he published his novel *Jenseits* (1909), was painting virgin forests inhabited by extinct animals, and who set down his night dreams in pen drawings the moment he woke.

One thing which the majority of these visionary artists had in common was that they could develop their faculties only by starting from subjects from Graeco-Roman mythology, from the Bible or from daily life. What distinguishes them from the surrealists is that the latter wanted to invent their own mythology, or to draw it from sources which had hitherto remained untapped.

16-19 They sought this new stimulation from primitive art. They developed to the highest degree the interest that it is possible to feel in the creations of distant peoples. They were able to do this because they immediately made it a matter of love and not of mere curiosity. The cubists had wanted to make use of the plastic solution which was offered by African masks; the surrealists, on the other hand, tried to establish communication with the mind that had imposed the form of the mask. The first twentieth-century amateurs of what were called 'barbaric fetishes' were as willing to collect rubbishy tourist souvenirs as authentic pieces. In 1905 Vlaminck and Derain were wholly undiscriminating in the purchase of objects which sailors had brought back from Africa. The surrealists made *their* choices as genuine connoisseurs; some of them, indeed, were specialists in ethnography. In 1939, the surrealist Wolfgang Paalen visited British Columbia and Alaska, where he discovered some ancient witch-doctors' tombs. After an expedition to a little-known area of the state of Veracruz in Mexico, he published a treatise on Olmec art. The finest pieces shown at the exhibition of North American Indian art in the Museo Nacional in Mexico City in 1945 came from his collection. Although the surrealist painters were not all as expert as Paalen, they were on the whole well-informed amateurs of primitive art.

They did, however, have a distinct preference for the art of Oceania as opposed to the art of Africa. This is not to suggest that they undervalued or systematically rejected the resources of Africa; this can be seen from Michel Leiris' fine work on the secret language of the Dogon of West Africa and on the possession rites of the Gondar of Ethiopia. The fact is that surrealism merely accepted the principle

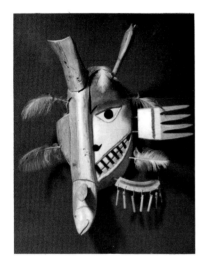

16
Eskimo art *Salmon Inua*

17 Eskimo art *Witch-doctor's drum*

that African art, because it was based on criteria of realism, was less
capable of regenerating the plastic arts in the West than was Oceanic
art, which was based on a poetic interpretation of the world.
'Oceania ... what power that word will enjoy in the surrealist
movement. It will be one of the lock-keepers who will open the
floodgates of our hearts', André Breton acknowledged. The fascination
with Oceanic art derived from a nostalgia for a 'lost world' : its signs
suggested the possibility of a life of paradise. But it was a result, too,
of the profusion and variety of its styles, with new revelations coming
from every island. Tortoiseshell masks from the Torres Strait,
basketwork masks from Sulka in New Britain, tree-fern sculptures
from the New Hebrides, mother-of-pearl inlays from the Solomon
Islands, monumental drums from Ambrym, Easter Island megaliths;
in all these, an exuberance of imagination gives vitality to the deco-
ration. What the surrealists loved in this art was the fact that
conceptual representation was more important than perceptual. In the
bark paintings from Arnhem Land in Australia, totemic animals and

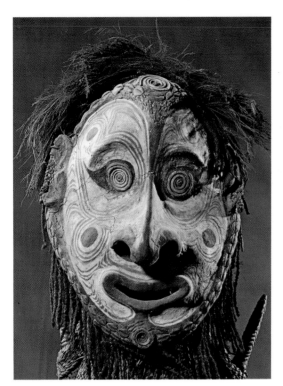

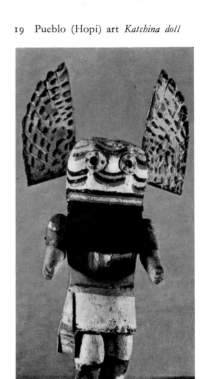

19 Pueblo (Hopi) art *Katchina doll*

18 Melanesian art *Mask of a Kararau clan*

mythical figures, depicted with their entrails visible, show the need to paint what is known, what is believed, while making use of what is seen.

The time which many of the surrealists spent in America gave them the opportunity of discovering American Indian art, which moved them to the same enthusiasm as the art of Oceania. The traces of pre-Columbian civilizations, too, evoked a 'lost world', and they too were probed to give forth their meaning. Max Ernst and André Breton, particularly, were captivated by the myths and drawings of the North American tribes; for example by the Hopi of north-east Arizona, with the wall paintings in their *kivas,* underground temples,

their initiation rituals which culminated in the 'night of mystery and terror', their cult of cloud-ancestors, and their supernatural guardians the *Katchina,* who were represented by dolls or by masked dancers.

Finally, 'psycho-pathological' art is a field of study which the surrealists were the first to turn to profit. Here there was an inexhaustible reservoir of authentic works, motivated neither by a desire to please, nor by material interest, nor by artistic ambition, but by the irrepressible need to pour out a message from the depths of the being. This category includes the paintings of mediums and the paintings of the mentally sick. The medium who was most admired was Hélène Smith, the subject of Théodore Flournoy's book *Des Indes à la planète Mars* (1900). When she was in trance, Hélène Smith described her adventures on Mars, spoke Martian, and drew and painted the plants, landscapes and houses which she had seen there. In 1912 a miner from the Pas-de-Calais, Augustin Lesage, in obedience to an inner voice, began to produce enormous decorative panels, which,

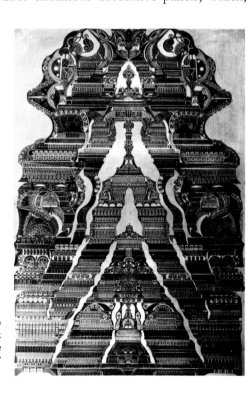

20
AUGUSTIN LESAGE
*Symbolic composition
signed 'Médium Lesage'*
1925

despite the fact that he was an uneducated man, included examples of various Oriental styles; he believed himself to be in contact with spirits (including that of Leonardo da Vinci), who guided him in his choice of patterns and colours.

But the surrealists attached more importance to the evidence of the mentally deranged, who proved that the least cultured being possessed genius, once it abandoned itself to the promptings of the unconscious mind. Of all the mental patients they adopted, the one they appreciated the most was Adolph Wölfli. Wölfli's mother was a washerwoman and his father a mason. He himself worked as a labourer, and after a conviction for indecency took to drink and fell prey to schizophrenia. From the time of his hospitalization in 1895, when he was thirty-one, until his death in 1930 he painted tirelessly. At first he painted scenes of self-punishment, where he showed himself undergoing tortures, then he moved to scenes of grandeur in which he saw himself as a masked superman surrounded by winged goddesses and emblematic animals. His horror of blank space led him to overload his surfaces, filling his images with decorations and musical compositions. The rending violence of such masterpieces of psycho-pathological art strip naked the instinct which drives man to deform reality.

But, left to themselves, these precursors, illustrious or obscure, would not have been enough to impose a new scale of values. The realization that the lessons which they offered could be of value to modern art had to wait for the appearance of the surrealists, a group of creators who sought allies from the past to support their bid for the recognition of the absolute rights of the dream.

Anti-art

Before surrealism became a concept of beauty which spread to all the plastic arts, it was a revolt against aesthetics in the name of total freedom of inspiration. This revolt started in Paris in 1919, with the foundation of the anti-literary review *Littérature*. The founders of *Littérature* were three young poets, André Breton, Louis Aragon and Philippe Soupault, who were brought together largely by their devotion to Guillaume Apollinaire, the poet who had died the year before. They came under the influence of the spontaneity of his 'poem-conversations', of his stories, which he called 'philtres of fantasy', and of his quest for 'the new spirit' which he was nevertheless able to reconcile with his love for curiosities of the past.

Apollinaire showed them that the poet must always be the accomplice of the painter, a firm ally in the conquest of the unknown. He himself had led a vigorous battle against the aftermath of impressionism, particularly in his column 'La Vie artistique' in *L'Intransigeant* from 1910 to 1914. In an article on the Salon des Indépendants in 1910, subtitled 'Prenez garde à la peinture', he wrote : 'If we were to interpret the overall meaning of this exhibition, we would say readily - and with great delight - that it means the rout of impressionism.' He took an active interest in all the new movements which arose : he became a patron of Robert Delaunay's post-cubist 'orphism', and published a book on the 'futurist antitradition' *(L'Antitradition futuriste,* 1913). He saw in every new movement a chance of superseding the lessons of the impressionists. In the programme for the ballet *Parade,* which was performed on 18 May 1917, he used the word *'sur-réalisme'* in print for the first time. He used it again on 24 June of the same year when he put on *Les Mamelles de Tirésias* ('The Breasts of Tiresias'). It seemed that he foresaw the use to which it would be put, for he spoke to Paul Dermée of 'the need, in the near future, for a period of organization of lyricism'. He drew the attention of artists to contemporary life : 'Today drawing, oil painting, watercolour and so on no longer exist.

There is painting, and there is no doubt that illuminated signs are more a part of painting than most of the pictures exhibited at the National.'

The first contemporary painters whom the future surrealists admired were those whom Apollinaire pointed out to them. Chirico and Picasso were among them, of course, but so were Chagall, Braque, Derain and Matisse. Aragon made an allegorical eulogy of Matisse in his *Le Libertinage,* in which he personified his painting in the form of a pretty woman called Matisse.

43 André Breton and his friends - who were soon joined by Paul Eluard, Jacques Rigaut, Benjamin Péret, and other poets - were anxious to take further and further steps towards originality; they lay in wait for the signs which would reveal the age. From the appearance of fauvism in 1905 until the debut of purism in 1918, school after school came into being. Expressionism, cubism, orphism, rayonnism, the earlier constructivism, synchronism, vorticism, futurism, all claimed to renew the techniques of creation and its aims. Faced with all these sects, some individuals developed a streak of militant cynicism. Of these the most gifted was Arthur Cravan, who was proud of his athletic physique and wanted to be a 'boxer-poet'. He once said that 'every great artist has a feeling for provocation'.

Cravan ran a review, *Maintenant,* which he edited single-handed and which he sold from a costermonger's barrow. In 1914 *Maintenant* carried a virulent review by Cravan of the Salon des Indépendants, lashing every exhibitor with ferocious sarcasm in an unparalleled example of critical brutality. He said of one picture : 'I would rather spend two minutes under water than in front of this painting. It would be less suffocating. The values of this work are arranged with the aim of *doing good,* whereas in a painting which is the product of a vision the values are nothing but the colours of a luminous sphere.' Arthur Cravan organized a show in Paris, on 5 July 1914, during which he fired a pistol, boxed, danced and delivered a lecture, punctuated by insults to the audience, in which he maintained that sportsmen were superior to artists. Cravan's statement that 'genius is an extravagant manifestation of the body' heralded the dadaist insurrection.

Another refractory individual was Jacques Vaché, a young cynic who expressed his scorn for art in his *Lettres de guerre.* Vaché did some

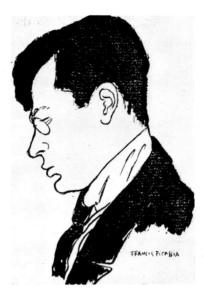

FRANCIS PICABIA
Portrait of Tristan Tzara 1920

sketching, but turned down Breton's invitation to illustrate some of his poems. He did not particularly want to be an artist, but longed to be 'a member of a Chinese secret society, with no purpose, in Australia'. Cravan and Vaché both died in 1919, but the memory of Vaché, in particular, was to hover over the *Littérature* group, and it was Vaché's nihilist humour that Breton was to seek to recapture in his temporary involvement with dadaism.

Dada was not a movement added to all the other movements. Rather it was an anti-movement which opposed not only all the academicisms, but also all the avant-garde schools which claimed to be releasing art from the limits which confined it. Dada was a detonation of anger which showed itself in insults and buffoonery. 'Dada began not as an art form, but as a disgust' was Tristan Tzara's defi- *21* nition : disgust with a world racked by war, with boring dogmas, with conventional sentiments, with pedantry, and the art which did nothing but reflect this limited universe. Dada was born in a neutral country at the height of the war, and it appeared as a declaration of the rights of fantasy.

Its starting point was the opening in Zurich of the Cabaret Voltaire. This was run by the German writer Hugo Ball, who issued a press release on 2 February 1916, stating his aim as 'to create a

centre for artistic entertainments'. The presence of Tzara, a born dis-organizer, brought subversive energy to the musical and poetry meetings held in the cabaret. Readings of phonetic or simultaneous poetry, performed in horrific costumes and masks, hurled defiance at the public. There was a review, *Dada,* in which Tzara propagated the principles of derision. Dada had no programme, wanted nothing, thought nothing, and created only with the intention of proving that creation was nothing. In a mocking attack on systems, Tzara proclaimed 'Pure Idiocy', and announced : 'Intelligent man has become an absolutely normal type. The thing that we are short of, the thing that is interesting now, the thing that is rare because it possesses the anomalies of a precious being, the freshness and the freedom of the great anti-man, that thing is the *Idiotic*. Dada is using all

22
TRISTAN TZARA
Page of *Dada* 1919

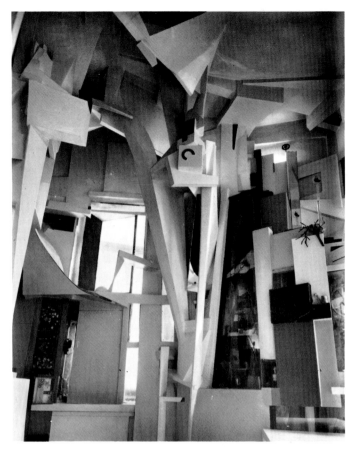

its strength to establish the idiotic everywhere. Doing it deliberately. And is constantly tending towards idiocy itself'.

Dada filled its statements with incoherence, on the grounds that life itself is incoherent, and played havoc with art because art lovers had lost the idea of art as a game. 'All pictorial or plastic art is useless; art should be a monster which casts servile minds into terror' was Tzara's cry in his 1918 Manifesto, which 'attracted the attention of André Breton.

To achieve the destruction of art by artistic means, Tzara advocated that oil painting and all aesthetic demands should be abandoned. 'The new artist protests; he no longer paints (this is only a symbolic and illusory reproduction). He creates directly in stone, in wood, in iron or in tin. He creates rocks, locomotive organisms which

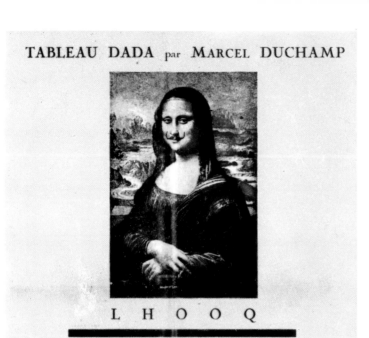

TABLEAU DADA par MARCEL DUCHAMP

L H O O Q

Manifeste DADA

eulent couvrir Dada de neige ; ça vous étonne mais c'est ainsi, ils veulent vider la neige
Dada.

24
MARCEL DUCHAMP
and FRANCIS PICABIA
L.H.O.O.Q.
1920

25
MARCEL DUCHAMP
*The Bride
stripped bare by
her bachelors, even*
1915-23

can be turned in any direction by the limpid wind of momentary sensation.' Thus, Marcel Janco, who made dadaist posters and masks, also made plaster reliefs which he sometimes encrusted with mirror fragments. Jean Arp, and Sophie Taeuber who lived with him, produced automatic drawings, collages made 'according to the laws of chance', and even tapestries. They combined very simple forms without making any deliberate choice of arrangement. Hans Richter did not abandon the picture form, but painted his *Visionary portraits* (1917) in the half-light of evening, when he could no longer distinguish the colours on his palette or on the canvas. The Berlin dadaists, led by Raoul Hausmann, invented photomontage, making up works from scraps of photographs. Soon after this, Kurt Schwitters, in Hanover, was to initiate 'Merz', his own personal version of Dada, which involved collecting rubbish to make pictures or sculptures.

Had not two exceptional men, Marcel Duchamp and Francis Picabia, pushed anti-art to its furthest limits, nothing would have

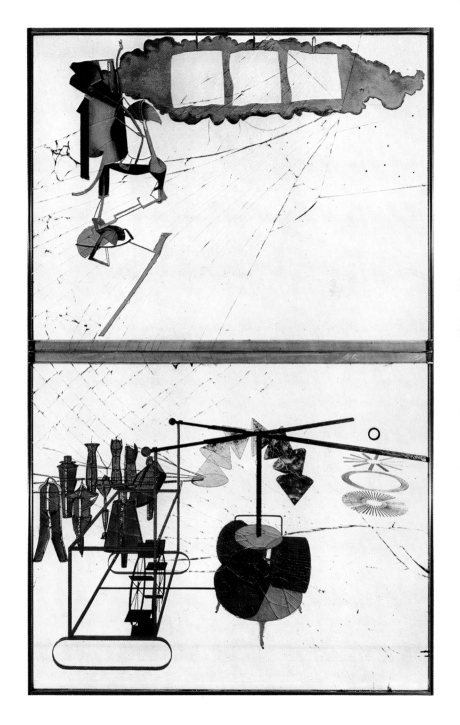

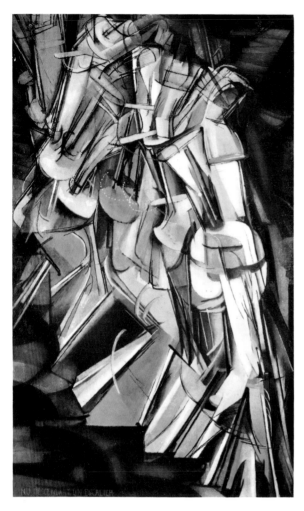

remained of the Dada revolt but the memory of an ephemeral agitation. Duchamp, the ascetic of non-sense, turned all his finds into the result of an exercise in meditation. In fact, what he did was not exactly anti-art, but what he described as 'dry art', by which he meant an art from which every aesthetic sentiment, even emotion or judgment, was excluded. 'The worst danger is that one might arrive at a form of *taste*', he said; to avoid both good and bad taste, he set about the 'dehumanization' of art. To this end he used 'the irony of affirmation', in which he put forward, with a glacial wit, absurd propositions intended to disturb rather than to provoke laughter.

Duchamp's imperturbable severity in rejecting the easy course, and his power of intellectual concentration gave his actions their real value. If anyone but he had drawn a moustache on a reproduction of the *Mona Lisa* and entitled it *L.H.O.O.Q.* (1919), it would have been mere facetiousness. *(L.H.O.O.Q. - Elle a chaud au cul -* She has hot pants.) It would have had no more effect than the grimacing Beethoven who appeared on the cover of the *Dada Almanach*. With Duchamp, every pun was a charge of mental dynamite placed under a convention to be exploded.

The small number of pictures which he condescended to paint have no aim other than that of dismantling the pictorial process like a clock mechanism. In the *Chess players* (1911, Philadelphia, Museum of Art), he analysed cubism; in *Sad Young Man in a Train* (1911, Venice, Peggy Guggenheim collection), a painting with a black border like a death announcement, he gave subtle expression to an inner state; in the *Coffee mill* (1911), the way he showed the rotation of the handle brought a still life to real life. He examined the effects of movement of a body in *Nude descending a staircase* (1912, Philadelphia, Museum of Art), which made his reputation in New York, and in *King and Queen surrounded by swift nudes* (1912, ibid.) For *Passage from Virgin to Bride* (1912, New York, Museum of Modern Art) and *The Bride* (1912, Philadelphia, Museum of Art), he abandoned the brush and applied his colours with his fingers. Finally, in the work which was

24

26

27
MARCEL DUCHAMP
Apolinère enameled 1916-17

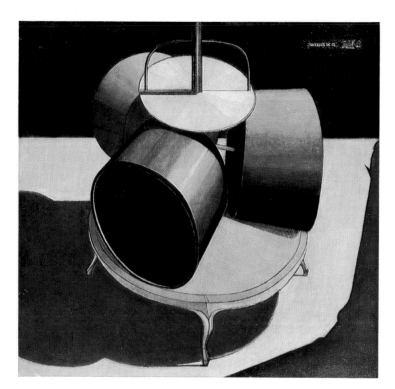

his last painting on canvas, *Tu m'* (1918, New Haven, Yale University), he showed a *trompe-l'œil* tear in the canvas, held together with real pins, among the shadows cast by objects in the painting.

Duchamp tried to destroy traditional ideas of painting and sculpture by employing plays on words and plays on objects. Sometimes he put forward entirely unprecedented creations : 'Take a cubic centimetre of tobacco smoke and paint its interior and exterior surfaces with waterproof paint.' Sometimes he defined new art forms : 'Painting or sculpture. Receptacle, glass dish - all manner of coloured fluids, pieces of wood, iron, chemical reactions. Shake the receptacle and look through it as through a transparency.' He sought the collaboration of chance, and submitted his work to the ' régime of coincidence'. Beyond this, he examined the way in which a common object could become something rare by the addition of some personal detail. This he called the readymade. His first readymade, *Bicycle wheel* (1913), was followed by others whose quality was a result of their title or of the way in which they were presented. *Apolinère*

27

enameled was based on a paint advertisement; *Fresh widow* (1920, New York, Museum of Modern Art) was a window with black leather panes. The inverted urinal, with the title *Fountain*, which he sent to the committee of the 'Independents' exhibition, of which he was a member, in New York in 1917, was a supreme act of defiance, which brought with it his resignation not merely from the committee but also from that kind of art which is criticized and which is bought and

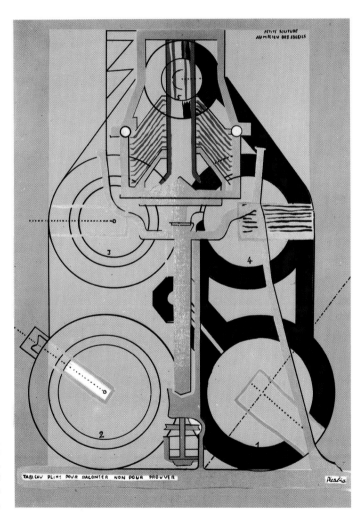

29
FRANCIS PICABIA
A little solitude
amidst the suns
(A picture painted
to tell and not
to prove) 1919

sold. Although he could have turned out any number of readymades, Duchamp established a strict rule - 'Limit the number of readymades per year' - and used a kind of moral algebra in their selection : 'to dissociate the readymade, mass produced, from the invented - this dissociation is an operation.'

Marcel Duchamp accumulated notes, drawings and experiences - documents subsequently collected in his *Valise* and *Green box* - for the construction, over a period of eight years, of his 'Large Glass', *The Bride stripped bare by her bachelors, even* (1915-23, Philadelphia, Museum of Art). This is not, as some people think, an unfinished work, but an unfinishable work. This distinction is vitally important. He was in search of an ideal which he defined as 'painting of precision and beauty of indifference'. Like Picabia's *Girl born with no mother*, Duchamp's *Bride* is the Machine, seen as the key element of the modern world. Duchamp starts from the principle that a new machine in operation for the first time is like a virgin at the moment she is deflowered, and makes a constant play on this ambiguity. He does

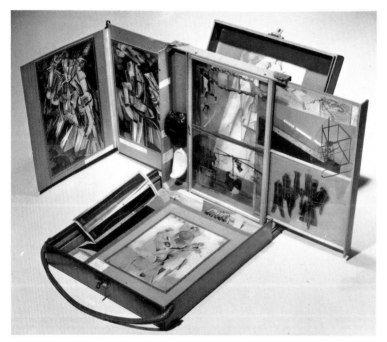

30
MARCEL DUCHAMP
Valise 1942

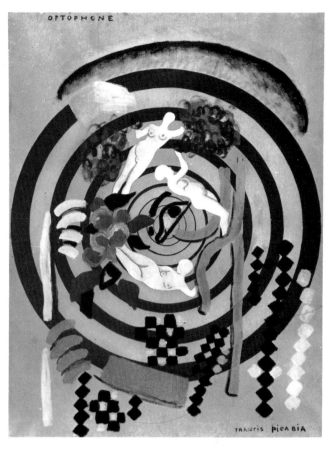

31
FRANCIS PICABIA
Optophone 1918 (?)

FRANCIS PICABIA

this to such effect that it is not possible to tell whether his satire is
aimed at the cult of the machine or at physical desire. He developed
the plan of a weird machine, constructed with a maximum use of
error and chance. The outline of the panel includes an invisible motor,
comprising, above, the Hanging Female Object (or the Bride) and
below, nine 'Malic Moulds' in which a 'gas' is cast into the form of
nine Bachelors. Then there is a Chariot, enclosing a Watermill whose
to-and-fro movements recite a Litany, a Chocolate Grinder and so on. *28*
When Duchamp abandoned painting, in 1923, he retained his influence
over the avant-garde, who treated him as a referee to decide who
should join them; this was not because of what he had done but
because of what he had chosen not to do.

Francis Picabia, the complete opposite of his friend Duchamp,

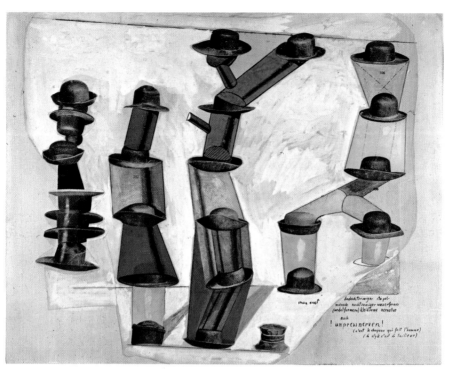

32 MAX ERNST *The hat makes the man* 1920

33 MAN RAY *The rope dancer accompanies herself with her shadows* 1916

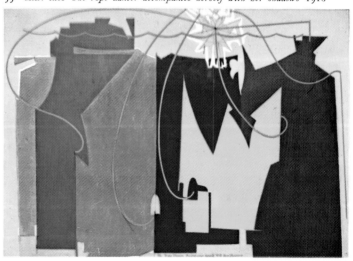

used painting as a springboard from which to make giddy and perilous leaps. Picabia, the 'aristocrat of disorder', started off by painting landscapes in the style of Sisley and Pissarro. His first exhibition in Paris in 1905 was a huge success, and he was hailed by the critics as a post-impressionist of the future. But in 1908 he turned his back on this career and broke his contract with his dealer. From then on, Picabia, who was rich, generous, witty and volatile, set off on an impassioned search for pleasure both in art and in life. 'My thoughts love everything which is against reason', he said. 'There is nothing I would rather be than a man of inexperience.' When he painted *Rubber* (1909, Paris, Musée National d'Art Moderne), he was taking up abstractionism a year ahead of Kandinsky. On his honeymoon in Spain with Gabrielle Buffet he painted two 'orphic' pictures, *Procession in Seville* (1912, New York, private collection) and *Dances at the Spring* (Philadelphia, Museum of Art), which were a great success at the Armory Show in New York in 1913. After his exhibition in New York, he won over Paris with more 'orphic' pictures, *Udnie or the dance* (Paris, Musée National d'Art Moderne), and *Edtaonisl* (Art Institute of Chicago). But he wanted to avoid being confined to any genre, and in 1915 he moved into his 'mechanist' period. His paintings in this period are of real or imaginary machines, and are *29, 34, 35* sometimes engineering drawings with humorous additions. In January 1917 he founded the review *391*, in which he kept up a *24* constant mockery of artistic circles. 'O laggardly painters, the regions you explore are ancient histories. You would do better to paint the cliffs of Dieppe in red and blue.' He played with words and images like a juggler with coloured balls, and just as swiftly and skilfully. In *31* 1918 in Switzerland he published 'Poems and Drawings of the girl born with no mother' *(Poèmes et dessins de la fille née sans mère)* and the 'Funeral Athlete' *(L'Athlète des pompes funèbres)*. During this visit Picabia met Tristan Tzara, and hurled himself, his wealth and his *21* enthusiasm into dadaism. Picabia was almost forty, no boisterous adolescent, but he was a whirlwind of irresistible vitality.

Dada was taken up by the *Littérature* group, which gave it such an individual turn that a historian, Michel Sanouillet, has produced the theory that 'Surrealism was the French form of Dada'. Tzara's arrival in Paris was made the occasion, in January 1920, for the 'First Friday of *Littérature*' (and the last : there were no others). This

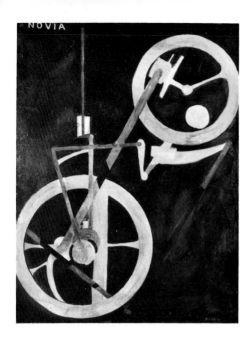

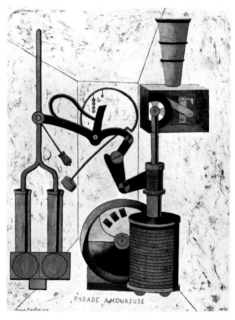

34
FRANCIS PICABIA
Novia 1917

35
FRANCIS PICABIA
Amorous Procession 1917

'Friday' was a poetry soirée at which Tzara read a newspaper article, under the title *Poème*, to the accompaniment of bells, and Breton, who gave a commentary on the pictures on show to the public, unleashed a row by showing a picture, *Riz au nez*, which Picabia drew in chalk on a blackboard and which Breton wiped off to symbolize the inanity of art. There were other meetings, in particular that at the Théâtre de l'Œuvre on 27 March, when Tzara's *La Première Aventure céleste de M. Antipyrine* was staged in a set designed by Picabia. The set - transparent, and placed in front of the actors instead of behind - was made up of a bicycle wheel, cables and picture frames. Picabia also designed paper costumes, and wanted to include in the show a *tableau vivant* of a live monkey fastened to a canvas. At the last moment he had to be satisfied with a toy plush monkey. His *Manifeste cannibale*, read by Breton dressed as a sandwich man, produced great commotion among the audience. For the Festival

Dada on May 26 in the Salle Gaveau, which began with the appearance of the 'Sex of Dada' and which ended with a performance of *Symphonic Vaseline* with a twenty-voice choir, this dedicated iconoclast also designed, in his own inimitable way, the set for the playlet by Breton and Soupault *Vous m'oublierez,* in which Paul Eluard played the part of 'Sewing Machine'. Picabia was the moving spirit of these 'happenings', which were planned in his apartment. In this year, 1920, his fantasy knew no limits : he painted pictures in Ripolin enamel, made collages of matchsticks, toothpicks and dressmakers' tape measures *(Flirt, Match woman, The Handsome Pork Butcher,* etc.), wrote impertinent books like *Unique Eunuque* ('Unique Eunuch') and *Jésus-Christ Rastaquouère* ('Jesus Christ the Adventurer'), and bombarded with sarcasms anyone who took him too seriously.

Many surrealist principles were certainly developed during the Dada period. For instance the printed *papillons,* wall stickers,

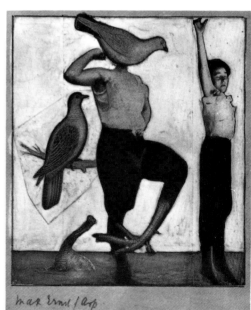

36 MAN RAY *Legend* 1916

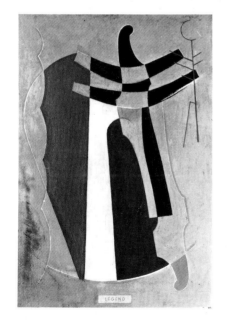

37
MAX ERNST and JEAN ARP
Fatagaga 1920

43

appeared first in 1920. Breton himself was the author of the *papillon* which read 'Dada is not dead. Watch out for your overcoat'. The publications of this period, *391, Bulletin Dada* and *Dadaphone,* with their revolutionary typography, were forerunners of the layout of the surrealist journals. In 1920, too, we see the establishment of the principle of 'intervention' in the meetings of opponents. The dadaists burst in on a lecture by the former futurist Marinetti, who was trying to launch 'tactilism', a movement based on touch, with works intended to be fondled and caressed. They disturbed the first production of *Les Mariés de la Tour Eiffel* (1921) by Jean Cocteau, whom they loathed, by getting up in turn and yelling '*Vive dada*'. Finally, the way in which the dadaist exhibitions in Paris were organized established the climate which was to reign later in the surrealist exhibitions, particularly those of Max Ernst and Man Ray.

32
37 The group admired Max Ernst for his *Fiat Modes* lithographs, his *Fatagagas,* painted together with Arp, and his collages. His exhibition entitled 'La Mise sous whisky-marin', in May 1921, which he was not able to attend himself, brought in *le Tout Paris,* the high society of Paris, attracted by the programme of festive excitements which was announced for the private view. The dadaists, tieless and wearing white gloves, produced a never-ending stream of absurd gestures; a man hidden in a cupboard insulted the guests as they arrived; then the lights were put out, and from the cellar, whose open trapdoor emitted a crimson glow, Aragon let out yells and pronounced meaningless sentences. This kind of *mise-en-scène* was not intended as mere propaganda : its aim was to ridicule the very idea of a private view.

33, 36 Man Ray had arrived from the United States preceded by a considerable reputation. He had painted abstracts recalling those of Duchamp and Picabia - sometimes using a spray gun. He had made poetic objects such as *Catherine Barometer* which parodied everyday objects, and above all he had published *New York Dada,* in association with Duchamp. In December 1921 the poets of the *Littérature* group assembled his works at Librairie Six, Soupault's bookshop in the Avenue de Lowendal, and sent out this invitation; 'No one knows any longer where M. Ray was born. After having been a coal merchant, several times a millionaire, and chairman of the Chewing Gum Trust, he has now decided to accept the invitation of the dadaists to exhibit

FRANCIS PICABIA
Cover for *Littérature* 1922

39
Cover for *Le Cœur à barbe* 1922

his latest work in Paris.' When the public arrived for the private view, the room was full of toy balloons, which completely hid the paintings. At a given signal, the organizers, with yells of 'Hurrah', burst the balloons with their cigarettes.

Dada was soon to burn itself out, for lack of fuel. Picabia spun on his heel away from the movement because he no longer found Tzara amusing. He declared 'The thing I find of least interest in other people is myself'. Breton and Duchamp refused to take part in the 'Salon Dada' presented by Tzara at the Galerie Montaigne on 6 June 1921. In order to proclaim the confusion of genres, he asked poets to send paintings and painters to send poems. He set an example himself by showing three paintings. *My*, *Dear* and *Friend*. Soupault, Aragon, Péret and Rigaut also showed work in this exhibition. The room was full of strange objects, and there were inscriptions all over the walls and stairs : 'This summer elephants will be wearing moustaches ; what

about you?' - 'Dada is the biggest confidence trick of the century'.

Breton was no longer satisfied with this kind of manifestation. His natural seriousness needed some enterprise of greater breadth. In 1922 he decided to organize a 'Congress of Paris', at which people with varying points of view would try to define the various trends of the Modern Spirit. He wanted debates on questions such as 'Has the so-called Modern Spirit always existed?' and 'Among objects which we call modern, is a top hat more or less modern than a locomotive?'. This was followed by a breach with Tzara, who disapproved of the idea of a Congress which would not be dominated by anti-art, and subsequently by the dissolution of Paris dadaism. Tzara's counterblast to the Congress, *Le Cœur à barbe*, was Dada's swan-song.

On March 1922, *Littérature* appeared under a new banner. Francis Picabia set out its programme in an editorial note. 'Do not admire yourself. Do not let yourself be shut up in a revolutionary school which has become conventional. Do not allow commercial speculation. Do not seek official glory. Draw your inspiration only from life, and have no ideal save that of the continued movement of intelligence.'

Without the Dada experience, surrealism would not have existed in the form in which we know it. It ran the risk of being a continuation of symbolism topped up with polemic. During the two years of Dada, the surrealists underwent a physical and spiritual training which allowed them thereafter to confront problems equipped with a knowledge of avant-garde struggle which they had not previously possessed. It is not true to say that surrealism was born *after* Dada, like a phoenix arising from its ashes. It was born *during* Dada, and became aware of its resources while it was in public action. Surrealism acquired a need to relate verbal or graphic delirium to an underlying cause, one less gratuitous than the total negation of everything. Nevertheless, some artists who took an active part in surrealism - Picabia, Max Ernst, Man Ray, Duchamp, Arp - retained the imprint of dadaism. Arp, for instance, wrote in 1927 : 'I exhibited with the surrealists because their attitude of revolt towards "art" and their direct attitude to life were as good as Dada'. These artists were to nurture a constant feeling for nonsense, for the absurd chance discovery, which was a counterweight to the solemn speculations of the other surrealists.

Conquest of the marvellous

As soon as André Breton moved in 1922 into the studio, in the Rue Fontaine in Paris, which he made into a holy place of surrealism, he set about turning the studies of the group towards 'automatic writing', a method which he and Soupault had used in 1920 to compose *Les Champs magnétiques*. Automatic writing consisted of writing down as rapidly as possible, without revision or control by reason, everything that passed through the mind when the writer had been able to detach himself sufficiently from the world outside. This exercise was intended to lay bare the 'mental matter' which is common to all men, and to separate it from thought, which is only one of its manifestations.

When Breton was a medical student at the Centre Neurologique in Nantes, he had become interested in possible methods of regenerating psychology on the basis of data provided by psychiatry. It was his ambition to make poetic language into an exploration of the unconscious. In this he based himself on the ideas of Sigmund Freud, who was at that time not appreciated in France, but whom Breton admired enough to visit him in Vienna in 1921. He also sought the views of scientists such as Th. Flournoy and Charles Richet, who had made studies of hypnosis and mediumship. In the 'sleep period' which was started at Breton's apartment at the suggestion of René Crevel, transcripts were made of what trance subjects said. The drawings of Robert Desnos, the hero of this period, show that the possibility of applying the techniques of automatic writing to painting was also envisaged at this time. Experiments of this kind produced a kind of almost intoxicated exhilaration and nervous exhaustion, as is borne out by Aragon's little book *Une Vague de rêves* (1924).

Breton sets out the contents of these sessions in his *Entrée des médiums,* in which he defines what he means by surrealism : 'a kind of psychic automatism which corresponds very closely to a dream state, which today is very difficult to delimit'. So the term which

Apollinaire had used in the sense of 'lyrical fantasy', when he described his *Les Mamelles de Tirésias* as a 'surrealist drama', now took on a new and strictly experimental meaning.

Breton's surrealist manifesto, *Manifeste du surréalisme* (1924), in noble and impassioned language, opened the indictment of the realist attitude in life and in literature. He struck up an enthusiastic hymn to imagination, the fountain where men could find eternal youth, and denounced adults for having let the passage of time rob them of a child's faculty of playfulness : 'Perhaps childhood is the nearest state to *true life*; childhood, beyond which, apart from his laissez-passer, man has only a few complimentary tickets'. Breton indicated that the aim of the movement was 'the marvellous', and preferably the marvellous in modern life, inspired by the symbolism of dreams, whose latent content was revealed by psychoanalysis. Surrealism was against the world of appearances, but it was not enough merely to reject it, with whatever brilliance. This world must be replaced by the world of apparition. He prayed for fairy enchantment. 'However delightful they may be, man would think it beneath him to draw all his nourishment from fairy tales, and I agree that not all of them are suitable for his age. But man's faculties do not undergo a radical change. Appeals to fear, the attraction of the unknown, chance, fondness for luxury, are appeals which will never be made in vain.'

Breton wanted surrealist paintings to give form to humanity's most secret longings : 'The fauna and the flora of surrealism are shameful and cannot be confessed to.' And he wanted the surrealist artists to eschew all pretensions to talent or style, and to behave as 'modest recording devices' who will not be hypnotized by the drawing they are making. He defined surrealism as the spontaneous exploitation of 'pure psychic automatism', allowing the production of an abundance of unexpected images. He stressed the intoxication which was produced by automatic writing, and said : 'Surrealism is a *new vice,* which, it seems to me, should not be the prerogative of only a few men.' (Later Aragon was to be more precise : 'The vice of surrealism is the uncontrolled and impassioned use of the drug *image.*') There was no question of replacing reality by a fantastic universe. The aim was to reconcile reality with the illogical processes which arise in ecstatic states or in dreams, with the aim of creating a

super-reality. Surrealism cannot accurately be described as fantasy, but as a superior reality, in which all the contradictions which afflict humanity are resolved as in a dream.

The generosity and lyricism which bubbled over in Breton's message, and his impetuous, brilliant insolence, were sure to win over many minds. Yet the *Manifeste* led to a temporary break with Picabia, who, ever faithful to his maverick course, still believed that Dada would be resurrected, and scoffed at the new movement in *391*: 'There is only one movement, and that is perpetual motion'. He invented 'instantaneism' as a game, and when he wrote the libretto of *Relâche* in that same year, he baptized it an 'instantaneist ballet'. Shortly afterwards, Picabia retired to the Château de Mai, built to his own design in Mougins, near Cannes. There he led a bustling life between his yacht, his racing cars, the galas and competitions which he presided over, and the festivities he organized for the town of Cannes. He no longer took any decisive part in surrealism, but he remained in association with the movement because of his impulsive friendships, and of the development of his painting, which was moving into the so-called 'Monster' period.

The poets and painters who gathered under the black banner of surrealism claimed to be 'specialists in revolution'. They banded together to protest against intellectual privilege and intellectual malpractice. They affirmed the rights of the dream, of love, of awareness, and they joined in encouraging the mind to be open to wild encounters and to the surprises afforded by chance. From this time on they justified their wilful embracing of the scandalous by their anxiety to denounce the obstacles which prevent life from being a poetic adventure. Instead of jeering at the public, they sought its collaboration. A 'Bureau of Surrealist Enquiries' was opened in the Rue de Grenelle on 11 October 1924. Here, where a dress-shop dummy dangled from the ceiling, the public at large was invited to bring along accounts of dreams or of coincidences, ideas on fashion or politics, or inventions, so as to contribute to the 'formation of genuine surrealist archives'. Antonin Artaud took on the direction of the bureau and inspired it with his own nervous fire. 'We need disturbed followers more than we need active followers.'

La Révolution surréaliste, 'the most scandalous periodical in the world', was founded in December 1924. The tone of its famous

40 ANDRÉ BRETON, TRISTAN TZARA, VALENTINE HUGO and GRETA KNUTSON
Exquisite Corpse c. 1933

surveys ('Is suicide a solution?'; 'What kind of hope do you put in
love?' etc.) forced its readers to express a sensibility which went far
beyond the normal clichés. Writing, painting and sculpture became
aspects of one single activity - that of calling existence into question.
The 'Declaration of 27 January 1925' laid down the statute. 'Surrealism
is not a new or easier means of expression, nor is it a metaphysic of
poetry; it is a means toward the total liberation of the mind *and of
everything that resembles it*.... We have no intention of changing
men's habits, but we have hopes of proving to them how fragile their
thoughts are, and on what unstable foundations, over what cellars
they have erected their unsteady houses.' The twenty-six signatories
included three painters, the first, chronologically, to join the
movement : Max Ernst, Georges Malkine and André Masson.

The group's ideal was to share genius in common, without any
loss of individuality. This was the reason underlying the surrealist
games, which were not mere entertainments. When the friends met

42
JACQUES HÉROLD, ANDRÉ BRETON,
YVES TANGUY and VICTOR BRAUNER
Exquisite Corpse 1934

41
JACQUES HÉROLD, ANDRÉ BRETON,
YVES TANGUY and VICTOR BRAUNER
Exquisite Corpse 1934

in each other's apartments they felt the brotherhood of their imaginations. The Game of the Analogical Portrait, the Truth Game, the When and If Game, and the Game of Exquisite Corpse, were methods devised to extract marvels from everyday reality. The most popular game was Exquisite Corpse *(le Cadavre exquis)*, in which a sentence *40-42* or a drawing was made up by several people working in turn, none of them being allowed to see any of the previous contributions. *La Révolution surréaliste* published many results of this poetry of chance : 'The winged vapour seduces the locked bird'; 'The strike of the stars corrects the house without sugar'. Paul Eluard, in *Donner à Voir,* stressed the ritual nature of these sessions. 'Several of us would

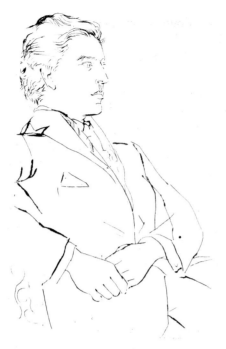

43
PABLO PICASSO
Portrait of André Breton

often meet to string words together or to draw a figure fragment by fragment. How many evenings we spent in the loving creation of a whole race of Exquisite Corpses. It was up to every player to find more charm, more unity, more daring in this collectively determined poetry. No more anxiety, no more memory of misery, no more tedium, no more stale habit. We gambled with images, and there were no losers. Each of us wanted his neighbour to win more and more, so that he could pass it on to *his* neighbour'. When he recalled the Definition Game in his *L'Amour fou* (1937), André Breton spoke of it as 'the most fabulous source of unfindable images', that is, images which resulted from unforeseen associations of forms or themes, and which the surrealist artists kept in mind in their works.

However, right from the first issues of *La Révolution surréaliste*, two authors bluntly put the question as to whether there was such a thing as surrealist painting. In an article entitled 'Les Yeux enchantés' ('Enchanted Eyes'), Max Morise stressed the difficulties which painters had to face when they tried to accomplish the equivalent of automatic

writing in their pictures. He doubted whether they could ever keep up with the speed of ideas and the succession of images with the same intensity as poets could keep up with the flood of words. Pierre Naville, the co-director of the magazine, came out soon afterwards with a categorical statement : 'No one remains unaware of the fact that there is no surrealist painting. It is clear that pencil marks resulting from chance gestures, a picture which sets down dream images, and imaginative fantasies can none of them be described as surrealist painting.' He went on to say that from now on the plastic arts would be replaced by shows, spectacles such as were provided by the cinema, by photography, or by the direct observation of street scenes. This negative attitude, a relic of the dadaist anathema of art, was justified by the passion that the surrealist group had for the cinema. Films like *Nosferatu the Vampire* and *The Student of Prague* were to be the models for a 'fascinating' style, which the surrealists considered that painting was not yet able to attain. Man Ray, who had made *Return of Reason (Retour de la raison,* 1923) on the same principle as his 'rayograms', said at this time : 'The cinema is a superior art which is worth all the others put together'.

The first group exhibition of surrealism in 1925 at the Galerie Pierre was not very representative. The exhibitors were Chirico, Klee, Arp, Ernst, Man Ray, Miró, Picasso, and Pierre Roy. This was a random collection and showed that although the movement knew what its aims in poetry were, its ideals in painting were still unstable. Klee's inclusion was a tribute to an artist who was not appreciated in France, but he was a surrealist neither in his creative method nor in his beliefs. Picasso's presence was evidence of an interest which was *43* to become active rather later. In the *Manifeste,* Breton confined himself to saying : 'Picasso is hunting in the environs'. Arp, Ernst and Man Ray had not entirely freed themselves from the dadaist spirit. Only Miró was genuinely representative of surrealism. Pierre Roy, a *44* friend of Apollinaire, had first been interested in fauvism, and had then flung himself into the evocation of 'everyday marvels'; he did minutely detailed pictures of collections of strange objects which raised calls to adventure or to dream like those evoked by a collection of random objects in an attic. His part in the movement was episodic, and he cannot be regarded as an artist who counted in surrealism. Giorgio de Chirico, the great painter of dreams, persisted in dashing

44
PIERRE ROY
Danger on the stairs 1927-8

the hopes of the group, who kept in constant contact with him, and who tried to turn him into a root-and-branch surrealist.

Surrealist painting owes a great deal to Chirico, whose example even led to people joining the movement. Max Ernst was influenced by him initially; Pierre Roy imitated him, or rather translated him into his own language; both René Magritte and Yves Tanguy received powerful creative impulses from his paintings. For his part, Chirico owed a great deal to the surrealists, although he always claimed with pride that neither his admirers nor his critics had ever understood his work. Had it not been for the revelatory illumination which surrealism cast on his fertile period from 1911 to 1918, this period would still be regarded as a part of 'metaphysical painting' (*Pittura metafisica*), a loose concept made even more so by the fact that Carlo Carrà and Giorgio Morandi gave it different meanings, and

45
GIORGIO DE CHIRICO
The Brain of the Child 1914

the importance of this period would have been diminished by his subsequent development. There are two men in Chirico : one whom the surrealists loved, and one whom they hated and fought against. They even thrust themselves between these two men so that the latter should not persist in distorting the message of the former.

The Chirico whom the surrealists adored had all the poetic *45, 48* genius, the sarcastic humour, the intolerance and the sense of mystery *57* which they expected of a master. His temperament was inherited. His father, a Sicilian engineer who lived in Greece, had an aristocratic temperament and had fought several pistol duels. His mother was romantically enough inclined to have had one of the bullets which had wounded her husband mounted in gold. After studying in Athens, Chirico left Greece with his mother and brother after his father's death in 1906, when he was eighteen. He went to Munich,

where he became a student of art. He painted in the spirit of Boecklin, and read the German philosophers, particularly Nietzsche, who influenced him greatly. From 1909 to 1911 he divided his time between Milan and Florence, receiving impressions which were later to be the inspiration for his *Places d'Italie*.

In 1911 he moved to Turin, and then to Paris, where he made himself known by showing three pictures in the Salon d'Automne, and painted desolate cities and arcades. He soon became a regular attender at Apollinaire's Saturday soirées. Apollinaire was at that time the only one to hail the innovation of his painting. In 1914, Paul Guillaume became the first dealer to buy his work and to give him any encouragement. Chirico turned out *Enigmas* in his Montparnasse studio. A clock, a statue seen from the rear, a furtive shadow, the empty spaces and the occupied spaces of a piece of architecture, were

46

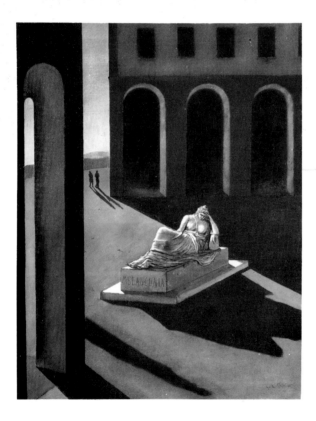

46
GIORGIO DE CHIRICO
Melancholy 1912

47 GIORGIO DE CHIRICO
The Philosopher's Walk 1914

48
GIORGIO DE CHIRICO
The Disquieting Muses 1917

the simple elements from which he was able to compose eerie pictures. He began to produce combinations of objects, such as fragments of sculpture, gloves, artichokes and bananas, which took on a votive aspect. The *Mannequins* added their enigma to that of the cities. Uncannily, one painting showed Apollinaire with a target shape marking the fatal bullet wound of 1918. *47* *49*

He was recalled to Italy during the war, and lived in Ferrara from 1915 to 1918. There he met Carlo Carrà, with whom he invented 'metaphysical painting', and created his *Metaphysical interiors* and his strange still-lifes with biscuits, matchboxes and set-squares. His colours became more intense, and his *Mannequins* more complex, as in *The Disquieting Muses* and *Hector and Andromache* (1917, Milan, *48, 57*

Fondazione Gianni Mattioli). Sometimes he included a map or a *trompe-l'œil* picture of a factory in his interiors, thus creating a supplementary illusion. Chirico hated music, and jeered at music-lovers who would sit and listen for hours in a concert hall. He suggested that they should be made to spend a similar period of time examining a master painting through opera glasses. Any one of his works would have stood up to this kind of scrutiny; Chirico is the painter of silences. He describes the moment of waiting, where everything holds its breath and is transfixed before the arrival of some portent or some apparition. His universe stands on the threshold of the event. Its calm and harmonious lines conceal the alarm and curiosity aroused by what is to come.

At the time when the surrealists were hailing Chirico as a master, he was living in Rome and changing his style. 'I have been tormented by one problem for almost three years now - the problem of craftsmanship', he wrote to Breton in 1922. He began to copy Trecento and Quattrocento paintings, and to study ancient treatises. In the belief that oil was harmful to paint, he ground his own colours, filtered his own varnishes, and began to paint with a calculated slowness. To their dismay, Aragon and Breton could find in this technician no trace of the great painter of inspiration who believed in ghosts, and who had once insisted, as they sat on a café terrace, that one of the customers actually *was* a ghost. They could see no trace of the cultivated man, full of paradoxes, who had said, grandiloquently: 'If a work of art is to be truly immortal, it must pass quite beyond the limits of the human world, without any sign of common sense and logic. In this way the work will draw nearer to dream and to the mind of a child.'

Chirico began to paint horses on the seashore, pieces of furniture in the open air, ruins and rocks in rooms, and all this with heavy pretensions towards classicism. When he returned to Paris in 1926 he put on an exhibition at the Galerie Léonce Rosenberg. The surrealists responded by mounting a counter-exhibition at the Galerie Surréaliste, Rue Jacques-Callot, in February 1928. In this they included all the 'good' Chiricos they owned. In the gallery's display window they arranged children's toys in parodies of his recent paintings. Aragon wrote a pamphlet called *Le Feuilleton change d'auteur* ('The serial has a change of writer'), in which he wrote

indignantly : 'One has only to see the latest work of this painter who was the theatre - and a wonderful theatre - of everything great in the world, the reflection of everything unknowable of the whole epoch, to realize how few rights the maker has over his earlier visions.' Chirico had complained that the title of one of his earlier works had been altered in *La Révolution surréaliste*; Aragon defiantly gave new titles to the eighteen works on exhibition.

Although Chirico tried to recover his former inspiration in *The Contemplator of the Infinite* (1925, Paris, private collection), *The Consoler* (1926) and *The Archaeologists* (1928, Amsterdam, Stedelijk Museum), he never again reached the sublime state which he expressed so perfectly between the ages of twenty-three and thirty. The surrealists did not acknowledge the return of his genius until the appearance of his novel *Hebdomeros* in 1929. Hebdomeros is a wandering hero, moving at random in an indefinite city whose inhabitants pass their time in the 'construction of trophies'. When Hebdomeros stands at the window to contemplate the reality of the street, he discovers that 'It was still only the dream, and even a dream within the dream.... What we have to do is to *discover,* for by the act of discovery we make life possible, in the sense that we reconcile it with its mother, *Eternity.*' This proposition was in accord with surrealism, which was interested only in discovery to the exclusion of anything else, and which insisted, with Chirico, that painters should explore unknown worlds.

49
GIORGIO DE CHIRICO
*Premonitory portrait
of Apollinaire* 1914

Surrealism and painting

When he published *Le Surréalisme et la peinture* in 1928, André Breton's intention was to give a decisive answer to those who still doubted the existence of surrealist painting, or who did not fully realize what freedoms it should claim for itself. He immediately broadened the debate and carried it into the field of mental adventure. 'I find it impossible to think of a picture save as a window, and my first concern about a window is to find out *what it looks out on...* and there is nothing I love so much as something which stretches away from me *out of sight*.' In unambiguous language he urged painters no longer to draw their inspiration from reality, even from a transfigured reality. 'Because they believed that man is able only to reproduce a more or less felicitous image of the object which concerns him, painters have been far too conciliatory in their choice of models. Their mistake has been to believe either that a model could be derived only from the exterior world, or that it could be derived from there at all.... This is an unforgivable abdication.... If the plastic arts are to meet the need for a complete revision of real values, a need on which all minds today are agreed, they must therefore either seek a *purely interior model* or cease to exist.'

To establish what this 'interior model' was, Breton defined 'the attitude of some men who have genuinely rediscovered the reason for painting'. These were Picasso, Max Ernst, André Masson, Miró, Tanguy, Arp, Picabia, Man Ray : in other words the first pioneers of the surrealist plastic arts. He casually rejected Matisse and Derain, 'old lions, discouraged and discouraging', and Braque, 'a great refugee', because they attached too much importance to what they saw. 'To see or to hear is nothing. To recognize (or not to recognize) is everything.... What I love includes what I love to recognize and what I love not to recognize. I believe that surrealism has raised itself up to the conception of this most fervent of all relationships, and has abided by it.'

Max Ernst was the only one of these painters to have taken a real

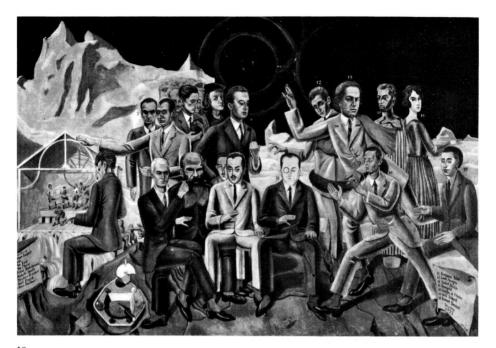

50

MAX ERNST
At the Rendezvous of Friends 1922
Seated from left to right : René Crevel,
Max Ernst, Dostoyevsky, Théodore
Fraenkel, Jean Paulhan, Benjamin Péret,
Johannes T. Baargeld, Robert Desnos.
Standing : Philippe Soupault, Jean Arp,
Max Morise, Raphael, Paul Eluard,
Louis Aragon, André Breton, Giorgio
de Chirico, Gala Eluard

51
MAX ERNST
Self-portrait 1922 (detail of *pl. 50*)

part in the formation of surrealism. Shortly after his arrival in Paris
in 1922, he painted *At the Rendezvous of Friends* (Hamburg, private
collection), which showed the *Littérature* group after the dissolution
of Dada. Ernst's qualities of inspired imagination, full of ferocity and
humour, had always led him to take pleasure in cultivating visions
of the half-sleeping, half-waking state. As a child he had seen in the

50, 51

52
MAX ERNST
*Two children
are threatened by
a nightingale*
1924

pattern of a mahogany panel in his bedroom 'a huge bird's head with thick black hair'. When he was a young man, he sometimes saw, as he fell asleep, a transparent woman standing at the foot of his bed. She wore a red robe, and her skeleton showed through like filigree work. These faculties for seeing visions led to his invention in 1919 of collage, a technique vastly different from the *papiers collés* which had been done by others before him.

89-91 Ernst began by using figures clipped from illustrated catalogues, and moved on to 'the alchemy of the visual image', working on a principle which he defined as 'the exploitation of the chance meeting of two remote realities on a plane unsuitable to them'. Paintings like

56 *Œdipus Rex* (1921, Paris, Hersaint collection), *The Revolution by Night*
60 (1923, London, Roland Penrose collection) and *Men shall know nothing of it* (1923, London, Tate Gallery) were built up in the same way as
52 his collages. In *Two children are threatened by a nightingale* (1924,

53
MAX ERNST
Le start du châtaigner
1925

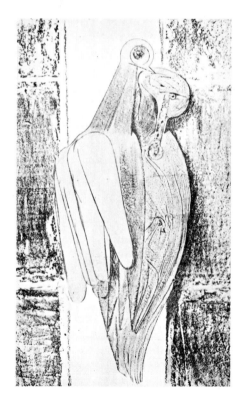

54
MAX ERNST
Conjugal diamofds 1926

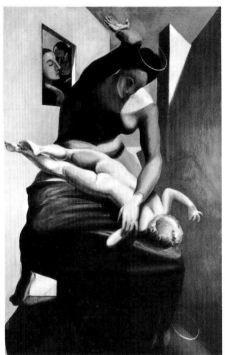

55
MAX ERNST
The Virgin spanking the Infant Jesus before three witnesses : André Breton, Paul Eluard and the artist 1928

56
MAX ERNST
Pietà, or the Revolution by night
1923

New York, Museum of Modern Art), his painting even included some real objects fastened to the canvas : a bell push and a little door. It was with some justice that he was able to say : 'If plumes make plumage, it is not glue *(colle)* that makes collage.'

His pictorial work would have been limited had it not been for his discovery of frottage, which gave him a means of self-liberation. On 10 August 1925, in a seaside inn, he was seized by an obsession with the grooves in the graining of the floorboards. He placed a piece of paper on the boards and rubbed it with blacklead so as to obtain a tracing. And from this tracing an image arose whose shape became clear to him. Frottages suggested to him forests, pampas, hordes of animals, heads. He brought these together in his collection *Histoire Naturelle* published in Paris in 1926. From this time on he regarded frottage as 'the true equivalent of what we already know

53, 54
61

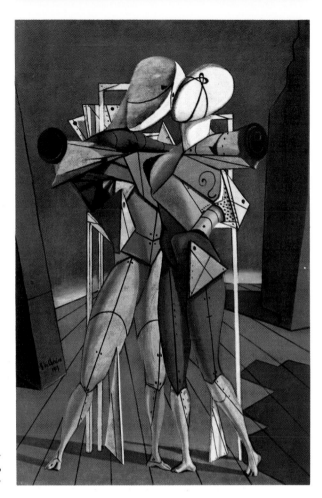

57
GIORGIO DE CHIRICO
Hector and Andromache 1917

as *automatic writing*'. He made frottages from all sorts of materials
as well as from floorboards : the leaves of trees, the unwound thread
from a spool, the ragged edges of a piece of cloth. He also used this
technique in painting, by scraping a canvas thickly covered in wet
paint, or by placing it on a rough surface. He justified this technique
by saying : 'The artist is a spectator, indifferent or impassioned, at
the birth of his work, and observes the phases of its development.'
Whatever the justification, what he gained from the use of this
technique in paintings such as *The Bride of the Wind* (1926), and
Carnal delight complicated by visual representations (1931), moved him

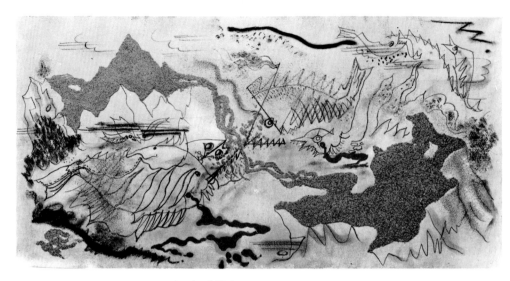

58 ANDRÉ MASSON *Battle of Fishes* 1927

towards the materialization of the imaginary, which liberated his paintings from the imitation of his collages. The 'artist as spectator' theme reappears in a purely painterly variation on the *Virgin and Child* theme which is one of his most famous (or notorious) works.

One spring day in 1924, André Breton visited the studio of André Masson at 45 Rue Blomet. He had just bought Masson's picture *The Four Elements,* and wanted to meet the painter. Masson has admitted : 'There have been few men whose first impression on me has been one which compelled such respect.' After their conversation, Masson immediately went over to surrealism. He was twenty-eight, and he was the focal point of a group which included Michel Leiris, Antonin Artaud, Armand Salacrou and Georges Limbour. As a result of a serious war wound he had been under observation in psychiatric hospitals, and he was now in permanent revolt against society. He had a lively and intelligent mind, which had been nourished on Nietzsche, Heraclitus and the German romantics. He wanted to create in order to explain the universe, and tried to put 'a philosophy into a picture'. No one painted with more violence, more fury even, than Masson, for he used every possible method to invoke a state of trance. He used also what were known as 'support words' : while he worked he would say aloud words like 'attraction', 'transmutation', 'fall', whirling'. At other times he sang. If one of his canvases failed

to satisfy him, he flung himself at it and slashed savagely with a knife. 'One must get some physical idea of revolution', he told his friends. His disorder and anarchy became legendary. He earned his living by working at night as a proof-reader on the *Journal Officiel*. He filled himself with sleeping drugs and strong stimulants, which shattered his nerves.

From 1925 on, his automatic drawings showed the power of his outbursts of passion. His paintings, obsessed by two themes, the sun and the destiny of animals, expressed the tragedy of natural instincts in the form of myth. When he was painting *Horses devouring the birds,* he announced wildly : 'I will make the birds bleed'. He tried to give this immolation the feeling of an antique sacrifice. As painting did not allow him enough freedom, in 1927 he began making pictures

62, 63

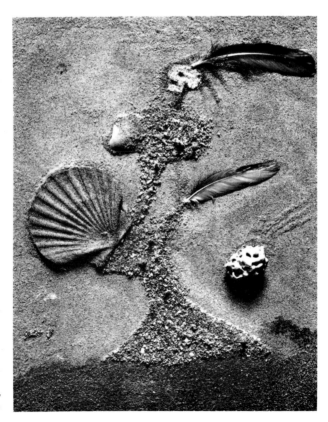

59
ANDRÉ MASSON
The Great Lady
1937

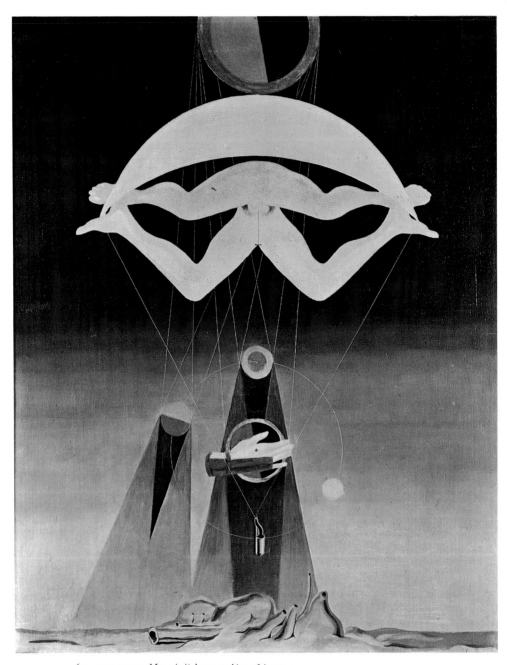

60 MAX ERNST *Men shall know nothing of it* 1923

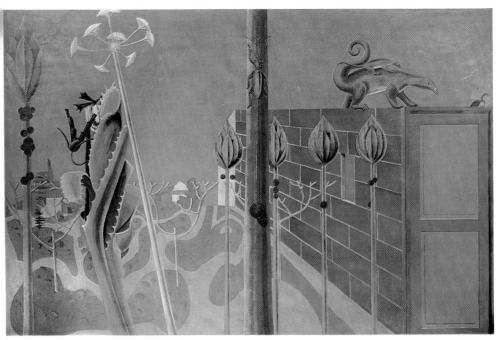

61 MAX ERNST *Natural history* 1923

with sand. The gesture with which he scattered the sand over a glue-coated canvas, and added a flashing brushstroke, amounted to a ritual. He began to introduce materials such as feathers into his paintings. When he parted company with the surrealists, from 1929 to 1936, his development did not change for the worse. He went, on in a similar spirit, intensified by his friendship with the philosopher Georges Bataille, to his series of *Massacres* and *Abattoirs* (1931), for which he made sketches in the slaughterhouses at La Villette and Vaugirard. His painting took on a multiplicity of forms - some dealt with the theme of abduction and pursuit, others evoked a journey he made on foot to Spain in 1934, yet others described insect revels, or burst out into scenes of delirium, the best example of which is *In the Tower of Sleep* (1938), or surrealistically explored the human figure. All had the same aim, a fervent desire to give a carnal presence to the sensation of the Cosmos. But above all, Masson drew. He drew tirelessly : series which made up chronicles, such as his *Mythologies* (1936), magnificent drawings in which eroticism, cruelty and sacred dedication reach a scale of epic grandeur. Some of Masson's paintings

58, 59, 69

66

193, 231

62
ANDRÉ MASSON
Furious suns 1925

SOLEILS FURIEUX

63
ANDRÉ MASSON
Automatic drawing, ink 1925

64
JEAN ARP
*Automatic
drawing, ink*
1916

may be disappointing; his drawings never. He is a passionate interpreter of the metamorphoses of Nature, the paroxysms of Being.

Joan Miró had the studio next to Masson in the Rue Blomet. Masson's virulence encouraged Miró's cautious and meticulous development. Miró had said of the cubists : 'I will break their guitar'. Since his first exhibition in Barcelona in 1918, he had constantly exerted pressure on reality, in the landscapes, portraits, nudes and still-lifes of what has been called his *détailliste* period. After paintings like *The Farm* (1921-2) and *The Ear of Corn* (1923, New York, Museum of Modern Art), he felt that he had come to a dead end. Then in the summer of 1923, when he was on one of his visits to his family at Montroig, he began to paint *Ploughed land* (Philadelphia, H. Clifford collection). Suddenly reality yielded place to the imaginary - the pine tree opened its eyes and cocked an ear, animals began to look like plants and seashells.

At the time that his style was changing, he wrote to his friend Ráfols : 'I confess that I am often gripped by panic, the kind of panic that is felt by an explorer travelling through virgin territory'. He confided to Ráfols his desire 'to express precisely all the golden sparks of our soul'. This tendency is accentuated still further in

71

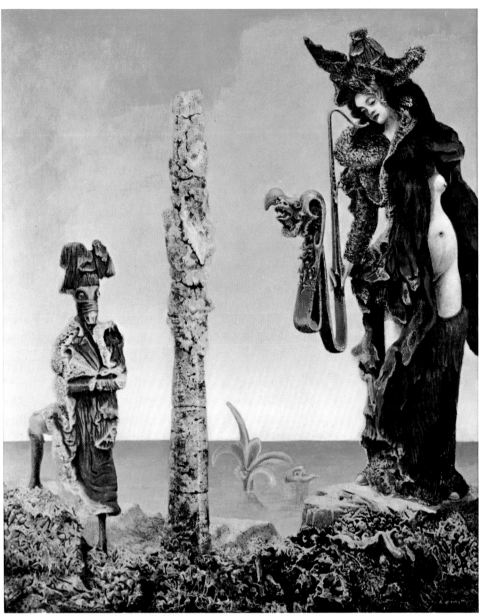

65 MAX ERNST *Napoleon in the wilderness* 1941

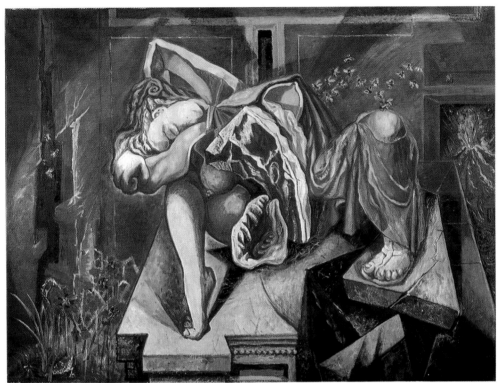

66 ANDRÉ MASSON *Gradiva* 1939

Olée (1924), and particularly in *The Carnival of Harlequin* (1924, *70*
Buffalo, Albright-Knox Art Gallery). This is an extraordinary fancy-
dress ball, where not only human beings, but also animals and
everyday objects, are wearing masks. An entire landscape has put on
a disguise. Then Miró asked Masson : 'Should I go to see Picabia or
Breton ?' Masson replied without hesitation : 'Picabia is already the
past. Breton will be the future.'

 Miró's exhibition at the Galerie Pierre in June 1925 was an
official surrealist event. The invitation was signed by all the members
of the group, and the preface to the catalogue was written by
Benjamin Péret. The private view took place at midnight, and was a
great success.

 From this time on, Miró began to play. He played a wild,
distracted game with signs which he scattered on monochrome
backgrounds of grey, blue or white. A dotted line and a blob were *72*

enough for him to create astonishing effects, as in *Head of Catalan*
68 *Peasant* (1925), *Person throwing a stone at a bird* (1925, New York,
Museum of Modern Art), *The Grasshopper* (1926), *Dog howling at the*
moon (1926). Although he claimed to want to 'murder painting', in his
case this would have had to be a *crime passionel*, for no painter has ever
produced his work with greater love than Miró. He painted as
naturally as a flower blossoms. He used all materials and techniques
with equal virtuosity. He painted on black paper, on glass paper, on
card, on wood, on sacking, on copper, on masonite. He used egg
tempera, pastel colour, either powdered or mixed with indian ink ; he
71 made poem-pictures, picture-objects, drawing-collages and wooden
constructions. He produced stunning parodies of old pictures; his
67 three *Dutch interiors,* painted in 1928, are interpretations of pictures

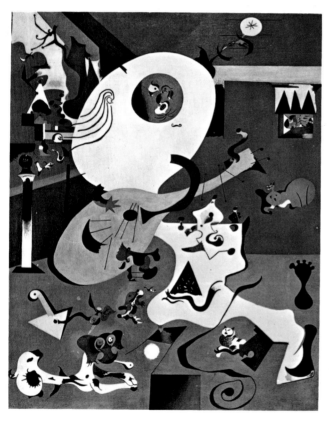

67
JOAN MIRÓ
Dutch interior
1928

74

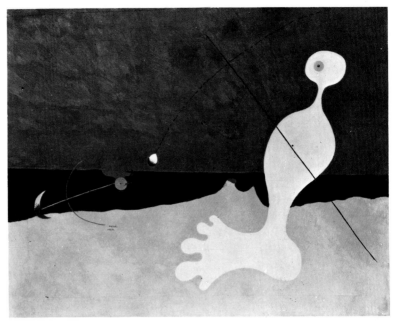

he had seen in Holland, such as *The Cat's Dancing Lesson* by Jan Steen. Various *Imaginary portraits* (1929) include a *Portrait of a Lady in 1820,* after Constable. In 1934 he began his 'wild paintings which make monsters arise'. Breton wrote : 'He could pass for the most 'surrealist' of us all'. Until 1937, when he went through a short crisis which drove him to paint from life at the Grande Chaumière, and to paint the apocalyptic *Still-life with old shoe* (James Thrall Soby collection), it was always Miró who created the finest fireworks of surrealism.

73
74

It has been said that Pablo Picasso was influenced by Miró's example. Strictly speaking, Picasso had no surrealist period; but there are several periods in which his development approaches surrealism. Breton considered that Picasso first showed a real interest in surrealism in 1926; in *Le Surréalisme et la peinture,* he took Picasso as the supreme guide. 'If surrealism ever comes to adopt a line of moral conduct, it has only to accept the discipline that Picasso has accepted and will continue to accept. In saying this, I am setting very severe standards.'

Indeed, the surrealists regarded Picasso's period of 'analytical cubism' which included paintings like *The Accordeon Player* (1911,

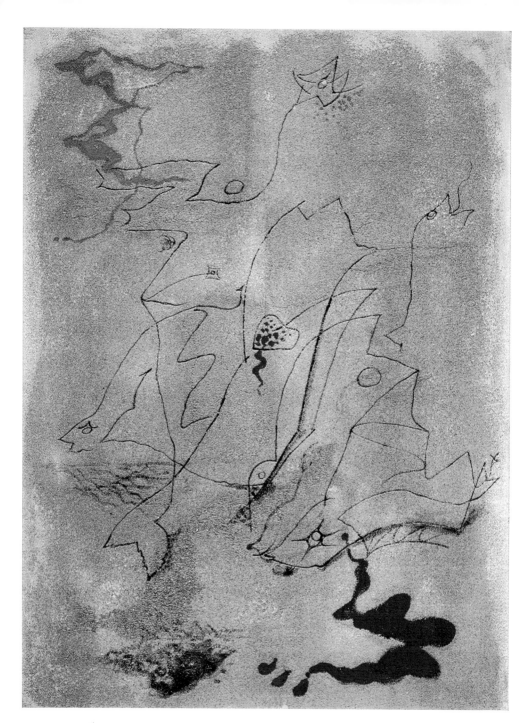

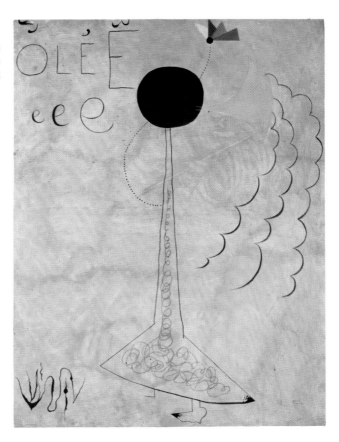

70
JOAN MIRÓ
Olée 1924

◀
69
ANDRÉ MASSON
Fish drawn
in the sand
1927

New York, Solomon R. Guggenheim Museum), as the beginning of a new form of vision. Paul Eluard wrote : 'After perpetual wanderings through dark or dazzling rooms, the irrational took its first rational step with Picasso's paintings, which have been given the derisory label of "cubist"; that first step was at last a *raison d'être.*' *La Révolution Surréaliste* reproduced one of his pen drawings made up of dots connected by lines. His Dinard period in 1928 and 1929, his *Bathers* (c. 1930), like prehistoric apparitions, his metal *Constructions* of 1930-1, and his sand reliefs of 1933, bear witness to the close links which bound him to the surrealist family. 76, 77

Yves Tanguy, who at the time claimed to be more a surrealist than a painter, had spent his childhood at Locronan, in the far west of Brittany, and had been to sea as a cadet in the Merchant Navy. He was a melancholic character, in search of amusement and excitement,

77

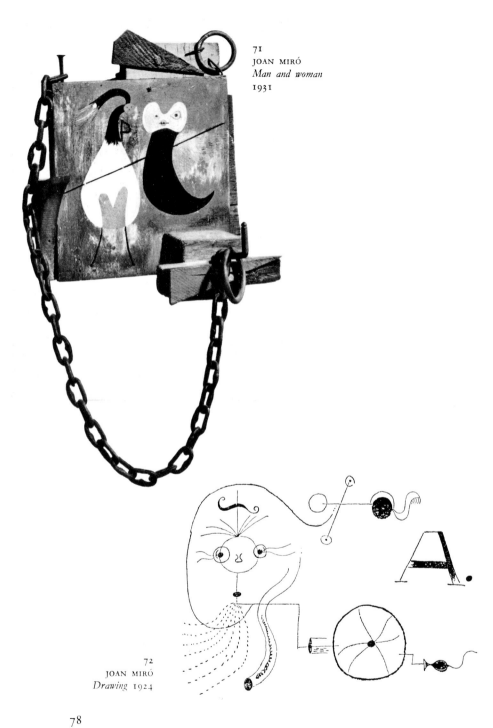

71
JOAN MIRÓ
Man and woman
1931

72
JOAN MIRÓ
Drawing 1924

78

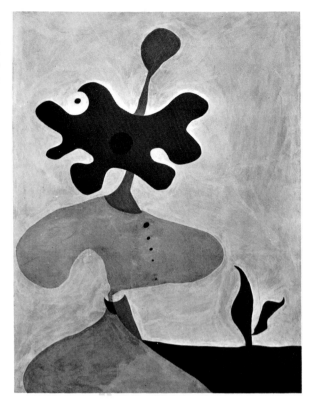

73
JOAN MIRÓ
Portrait of a Lady in 1820
1929

and his sea-inspired dreams of adventure, his memories of the Breton beaches, and his Celtic background were the reasons which prompted his escape into the marvellous. In Paris, Tanguy shared quarters with Jacques Prévert and Maurice Duhamel at 54 Rue du Château in Montparnasse, which has become a legend because of the fantasy which reigned there.

Tanguy started by doing humorous drawings which he exhibited in 1924 with the Montmartre illustrators Gus Bofa, Chas Laborde, Daragnès and Vertès. His first painting was of the wall of the Santé prison, done in the manner of Chirico. He had caught a glimpse of a Chirico painting in a gallery window from the platform of a bus, and had been dazzled by it. He met Robert Desnos in 1925, and was introduced by him into the surrealist group. In 1926 he painted *The Storm* (Philadelphia, Museum of Art), and then *Genesis*. The works of this initial period, which are very different from the later style for which he is known, describe fluid, airy spaces where imponderable

81
75

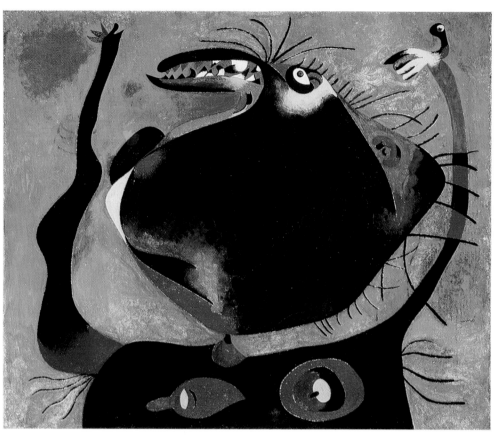

74 JOAN MIRÓ *Head of Woman* 1938

75 elements are suspended in the air. Goblins appear and disappear in a troubled atmosphere, a circle of mad sprites forms in the invisible.

 He came back to earth with such works as *The Promontory Palace* 78, 80 (1930, Venice, Peggy Guggenheim collection). In this, and in such later paintings as *Infinite divisibility* (1942) and *The Rapidity of Sleep* (1945), he travelled to a shore where strange minerals held council, and where horizons which awoke a sense of the infinite receded before the eyes. He painted like a sleepwalker, allowing the growth of images which were made even more mysterious by the fact that he never felt any need to explain them even to himself. His titles, which he often asked his friends to suggest, are not commentaries on the paintings. Without wishing to be so, Tanguy was the Watteau

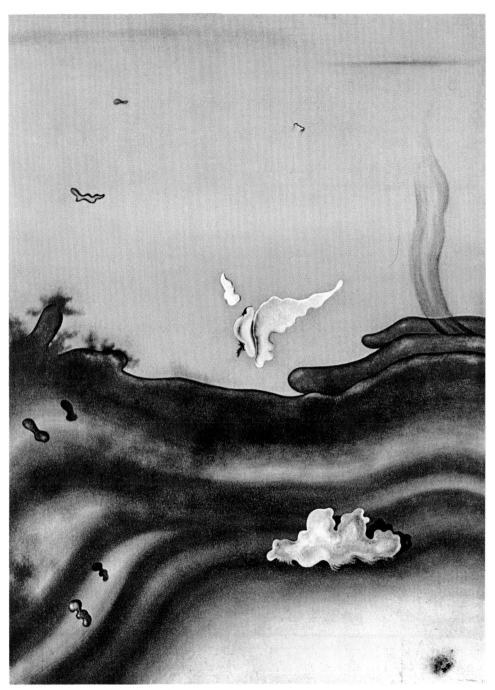

75 YVES TANGUY *Four hours of summer, hope* 1929

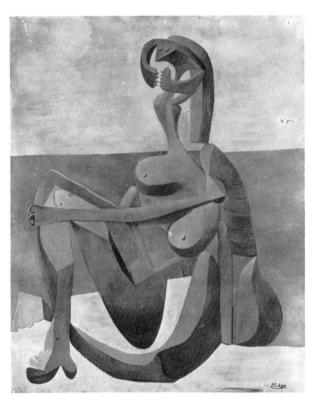

76
PABLO PICASSO
Woman bather, seated
1930

77
PABLO PICASSO
*Woman bather
playing with a ball*
1932

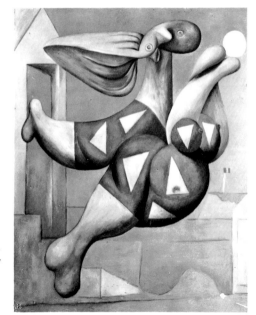

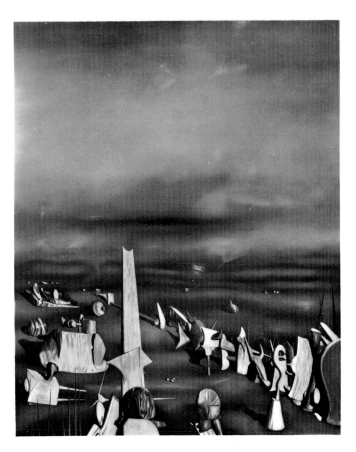

of surrealism; his pictures are 'Conversations' and '*fêtes galantes*', in which inanimate forms take on the roles of men and women who have gathered together for the pleasures of the dream.

In 1925 Arp came to Paris and moved into a studio in the Cité des Fusains, 22 Rue Tourlaque, where among his neighbours were Max Ernst, Paul Eluard, and later Miró. He began to write poems in French; previously he had written in Alsatian or German. Arp was a man of lively wit and a beautifully precise inventive sense. When he was a child, he had painted the lower part of his window panes blue, so that the houses that he looked out on would seem to be floating in the sky. On another occasion he cut a rectangular hole through the wall of a wooden hut, and put a picture frame round it. Then he invited his father to come and admire the 'landscape' he had created; the opening looked out on a rural scene. During the

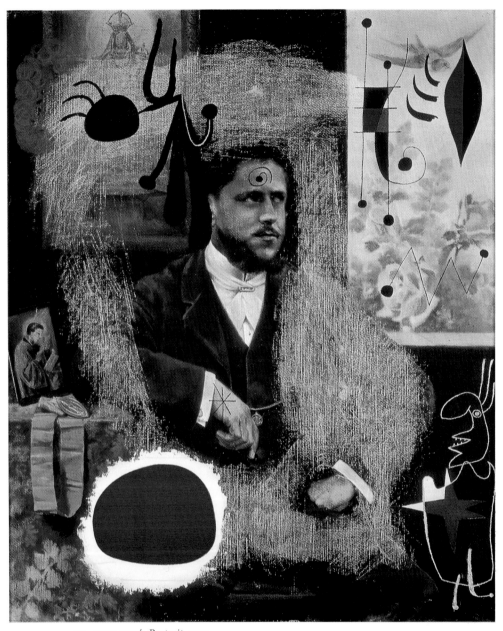

79 JOAN MIRÓ *Portrait* 1950

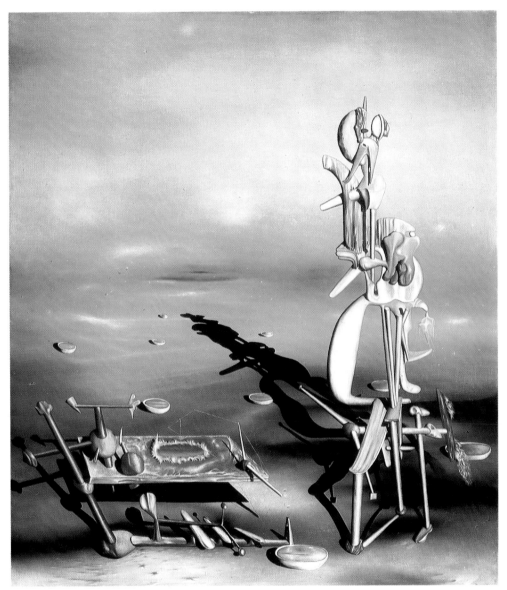

80 YVES TANGUY *Infinite divisibility* 1942

Dada period, his objects set the public by the ears. There was the
Glove (le Gant), which was a hat intended to be worn by the *Gantleman*,
not on, but in place of, his head; there was the *Navel Bottle*, a

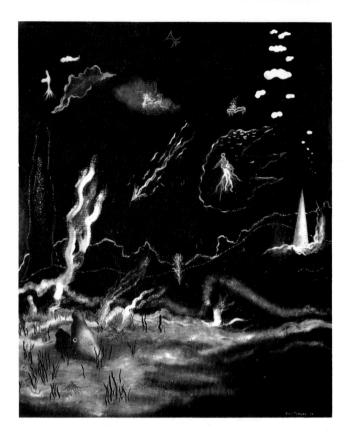

monstrous household object. Arp brought to surrealism the grace of
83, 84 his carved and painted wood reliefs - *Painted wood, Semi-Colon, Endless Moustache, Configuration.*

 In 1926 he left Paris and set up house at Meudon with Sophie
82 Taeuber. He went over completely to sculpture, and built up a repertoire of 'cosmic shapes' (the egg, breasts, the human head, the bell, and so on) which he used in his *Concretions*. In 1931 he showed his *papiers déchirés* at the Galerie Jeanne Bucher. These combined the lessons of abstract art with the demands of surrealism. Although he was a member of the 'Abstraction-Création' group, Arp's mental agility always allowed him to reconcile non-figurative art with plastic poetry. In his view, it was the artist's task to produce fruit, like a tree. To define the aims which drove him on, he once said : 'I wanted to find a new order, a new value for man in nature. Man should no longer be the standard against which everything is

measured, nor should he relate everything to his own stature. On the contrary, all things and man should be like nature, and not have any standard scale.'

Georges Malkine was not mentioned in *Le Surréalisme et la peinture*, despite the fact that he had been a member of the 'heroic wave'. *La Révolution surréaliste* published his drawn stories, his drawing *Ecstasy*, and his painting *The Valley of Chevreuse*. He was a friend of Robert Desnos, and illustrated his *The Night of Loveless Nights*. Malkine had an inventive mind which was supported by a kind of pictorial sensuality. But he was little concerned to make a career in art, being too absorbed by the vicissitudes of his life, which led him into a strange mixture of trades : violinist, photographer, street vendor of neckties, actor, fairground hand, proof-reader. Claude-André Puget, who had known him since his youth, said of him : 'His was the only genuinely surrealist existence I have known.' In 1927 Malkine's

82
JEAN ARP
Chinese Shadow
1947

83
JEAN ARP
Configuration
1930

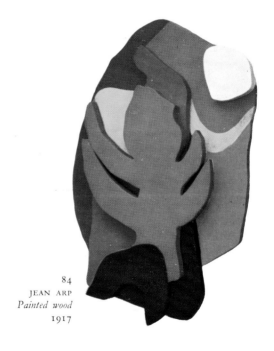

84
JEAN ARP
Painted wood
1917

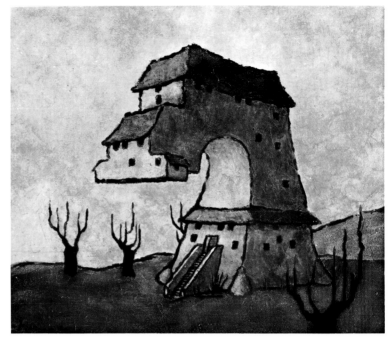

exhibition at the Galerie Surréaliste was a great success. Shortly afterwards he left for the South Seas, where he travelled for three years. He was able to get back to France only by working his passage as a dishwasher. He began to paint again in 1930 and continued until 1933, when he stopped. He did not resume painting until he went to live in America in 1949. His work has retained a vein of surrealist fantasy, as his 1966 tribute to the composer Satie (a kindred spirit) shows. *85*

Although the Galerie Surréaliste had been inaugurated, on 26 March 1926, with an exhibition of paintings by Man Ray, Breton pays greater tribute in his book to Man Ray the photographer than to Man Ray the painter. Indeed, Man Ray is above all the man who revolutionized photography by transforming it into a poetic means of investigating the world. As his pictures failed to sell, Man Ray began to practise photography to earn a living - he had combined this activity with painting for a long time previously. In 1921 he invented 'rayograms', which made phantoms of objects appear. He has *86, 87* described the technique : 'This is the principle of the rayogram, which is sometimes, in my view erroneously, called a photogram. Various objects, whatever one wishes, are placed in the dark on a sheet of

89

light-sensitive paper. This combination is then illuminated by a ray of light. The objects placed on the paper protect the sensitive surface, and so do the shadows they cast, to a degree which depends on the intensity of the shadow. When the paper exposed in this way is developed, the rayogram appears as white silhouettes and incredibly delicately graduated shadows. The effect is absolutely unique to this kind of technique.' Man Ray made rayograms with wash-tongs, drawing pins, salt, and all kinds of items.

Apart from these experiments, he took fashion pictures for the couturier Paul Poiret, did portrait photographs, and made reproductions of avant-garde works. He worked in a hotel room with rudimentary equipment. Indeed, he affected scorn for elaborate cameras and for technical skill. He wanted to photograph ideas rather than things, and dreams rather than ideas. He had no interest in landscapes : 'I think that rather than taking banal representations of a view, it is better to take my handkerchief from my pocket, twist it as I want, and photograph it as I wish.' He used the close-up at a time when most photographers never dreamed of doing so.

The Marquise Casati was most enthusiastic about a photograph he had done of her showing her with two pairs of eyes; she declared that he had taken a portrait of her soul. From that time on, Man Ray found himself with an aristocratic clientèle, and was able to set himself up in a studio. His portraits are given a kind of inner treatment - that of James Joyce, taken at a moment when the sitter was dazzled by the lights, is a demonstration of the art of giving full value to the sensitive part of the face. Man Ray began to do nudes in 1925, first of his girl-friend Kiki de Montparnasse, and then with many amateur models. He used all processes - for example solarization, which allows the values of cast shadows to be inverted - to give flesh a dream-like aureole. He treated the female body in the same way as Duchamp made a readymade. He used some personal detail to make each different from all the others. His portrait of Meret Oppenheim, naked, with one raised arm covered in black ink, behind the wheel of an etching press, is justly famous for this reason. His films, like *Starfish (Etoile de mer,* 1928), where instead of blurred outlines he aimed at a frosted glass effect, pushed his photographic successes one stage further. One of his paintings, more than eight feet wide, *Observatory Time, the lovers* (1932-4, New York, William N. Copley

86
MAN RAY
Promenade 1941

87
MAN RAY
Rayogram 1927

88
MAN RAY
Drawing 1938

91

collection), shows a giant mouth floating in the sky above the Jardin du Luxembourg. A symbol : for Man Ray, photography was a kiss given by Time to Light.

Finally, in the catalogue for an exhibition of collages which was held in March 1930 at the Galerie Goemans, 49 Rue de Seine, Aragon wrote an essay called *La Peinture au défi,* a seminal text in which he vigorously reproached painting for having become an 'anodine entertainment', and expressed his preference for collage, which seemed to him to be the ideal way of passing beyond the preoccupations of matter, subject and decoration. 'It substitutes a method of expression of hitherto unimagined strength and scope for a debased art form. ... It restores a genuine meaning to the old pictorial demands by preventing the painter from falling prey to narcissism, to art for art's sake, by bringing him back to the magical practices - the origins of, and the justification for, plastic representations - which many religions have forbidden.' In collage Aragon saw the possibility of an assault on reality by a subversive form of the marvellous, using elements borrowed from reality with the sole purpose of being used against it. This attitude shows the kind of hope which collage engendered in the surrealist group. All of them saw it as a weapon directed against everyday banalities, against the spirit of the serious.

Poets as well as painters made collages : Georges Hugnet, E.L.T. Mesens and Jacques Prévert were among them. But none of them surpassed Max Ernst, who, in his picture books, *La Femme 100 Têtes* (1929), *Rêve d'une petite fille qui voulut entrer au Carmel* (1930) and *Une Semaine de Bonté ou les sept Éléments Capitaux* (1934), unravels stories with a multiplicity of twists and turns which derive their validity from the beliefs they reflect. 'Collage is a supersensitive and scrupulously accurate instrument, similar to a seismograph, which is able to record the exact amount of the possibility of human happiness at any period', said Max Ernst. His visual novels form a fantastic mythology whose hero is Loplop, 'Superior of the Birds', one of the best of his hallucinatory fantasies. One consequence of collage was that surrealist paintings of this period took on the form of painted collages : those of Emile Savitry, before he went over to photography, are an example. Even René Magritte and Salvador Dalí, when they were starting their careers, made the content of their paintings conform to that of collages.

89
MAX ERNST
The sap rises 1929

90
MAX ERNST
*Loplop et
la Belle Jardinière*
1929

91
MAX ERNST
*Loplop and the
mouse's horoscope*
1929

Towards a revolutionary art

From 1930 onwards surrealist art became more harsh, more violent, and more impatient to influence social life. It was now aware of its methods, of its powers to disturb and to seduce, which it wished to force to serve entirely positive ends. The previous year the movement had been shaken by a crisis brought on by disagreements about the meaning of its adhesion to Marxism, a perennial question which had been first raised in 1926. Antonin Artaud had been the first to protest against surrealism's political preoccupations, when in his pamphlet *A la grande Nuit* (1927) he matched against them 'the point of view of consistent pessimism'. Later the group separated from part of its membership, whom Breton branded with a red hot iron in his *Second Manifeste du surréalisme* (1929). 'What could people who still have some concern about the position they occupy *in the world* hope to gain from the surrealist experience?' he wrote scornfully. The target he indicated to his friends was revolution; dialectical materialism now played the part which had previously been taken by psychoanalysis.

The surrealists wanted to help in the advancement of the proletariat and in the destruction of capitalist society; but they were not prepared to sacrifice any part of their basic preoccupation. The review *Le Surréalisme au service de la Révolution,* which was their organ at this time (1930-3), raised the problems of social agitation only in connection with that of finding a way for the ideal expression of the passions. In his role of militant activist, Breton acted as a true apostle, trying to persuade organizations of the Left that true revolutionary art was not simply the art which made the most of a propaganda content, but an art which took human desires into account with audacity and originality. In the lectures he delivered and the interviews he gave, this is a constantly recurring idea. In *La Position politique du Surréalisme* (1935) he writes : 'Artistic imagination must remain free. It is by definition free from any fidelity to

circumstances, especially to the intoxicating circumstances of history. The work of art must remain detached from any kind of practical aim, if it is not to cease to be itself.... We put forward, in opposition to painting with a social subject, painting whose latent content is revolutionary, whatever the subject expressed. We stress the fact that today this form of painting can derive its elements only from pure mental representation, inasmuch as this extends beyond true perception, without being confused with hallucination.'

While in public Breton was defending the rights of the artist, he urged his friends not to give way to any desire to please; the *Second Manifeste* is firm on this point. 'The approval of the public must be avoided above all. The public must be forbidden to *enter* if confusion is to be avoided. I would add that the public must be held exasperated at the door by a system of taunts and provocations.'

If ever anyone was qualified to follow this advice, and to take it to its ultimate conclusion, it was Salvador Dalí. He was later to declare : '*Le surréalisme, c'est moi*'. Certainly, before he became the popularizer of surrealism, Dalí breathed a new dynamism into the movement. From the other point of view, had Dalí not had the framework, the propitious climate which the group offered him, his personality would not have developed with so much brilliance.

Initially his eccentricity was nothing more than that of a spoilt child. His father was a lawyer from Figueras who put all his hopes in him, and nothing was spared in the encouragement of his precocious vocation. An uncle from Barcelona gave him a king's costume; wearing his crown and his ermine cloak in the wash-house he used as a studio, Dalí gloried in the idea that everything was permitted him. He went to the Escuela de Bellas Artes in Madrid in 1921, and became known for his extravagant clothes and his stubborn insistence on doing the opposite of what everyone else was doing. For this he became the hero of a group of 'ultraist' students, who included Federico García Lorca, Luis Buñuel, and Eugenio Montés. He was expelled from the school for protesting against the appointment of a professor, and even imprisoned for a few weeks. When he was released he became even more wild. But his *dandysme* led him only to futile actions, like soaking banknotes in whisky, and his painting was merely a series of stylistic exercises ranging from futurism to cubism.

With *Blood is sweeter than honey* (1927), he began to get some idea of what his future style would be. In 1928 he travelled to Paris, where he met Miró, who introduced him to the surrealists, and who abandoned his usual silence long enough to say to him : 'The important thing in life is to be stubborn. When what I want to say in a picture won't come out, I bang my head against the wall until the blood flows.'

When he returned to his family's house at Cadaqués in 1929, Dalí set out to paint a picture which would be a kind of manifesto. He set up his easel at the foot of his bed so that he would have the image before his eyes as he fell asleep and as he awoke. At this time he had a visit from a surrealist delegation - the dealer Camille Goemans, René Magritte, Paul Eluard and his wife Gala. They were taken aback by his appearance - he was wearing an imitation pearl necklace, a bracelet, and a shirt with flowing sleeves - by his sudden outbursts of hysterical laughter, and by the scatological violence of his picture, whose principal figure was a man in shit-stained underpants. Eluard

92 SALVADOR DALÍ *The Great Masturbator* 1929

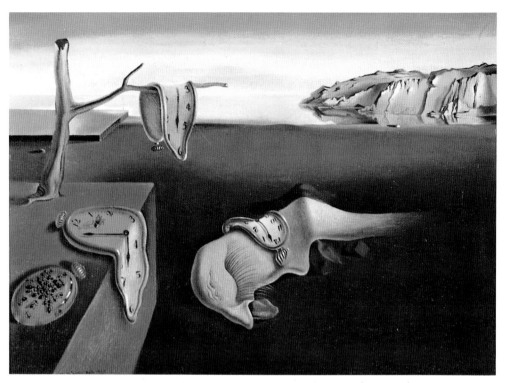

93 SALVADOR DALÍ *The Persistence of Memory* 1931

gave this painting the title of *Le Jeu lugubre (The Dismal Sport)*; it was Dalí's first step, at the age of twenty-five, along the road of surrealism. There and then was forged the union between Dalí and Gala which was to have so great an influence on his art, because she was able to prevent his worst fantasies from becoming morbid. She made him write, and herself put in order, the notes which he compiled for the composition of *La Femme visible* (1930); these notes contained the earliest exposition of his 'paranoiac-critical method'. This constant vigilance was the reason for the way he worshipped her, going as far as signing his pictures with their two names interwoven, and saying: 'Every good painter who aspires to the creation of genuine masterpieces should first of all marry my wife.'

After his Paris exhibition in 1929 at the Galerie Goemans, Dalí wanted to go further than his fellow surrealists. Eternally contradictory, he wanted to be *more than everything*: madder than a lunatic,

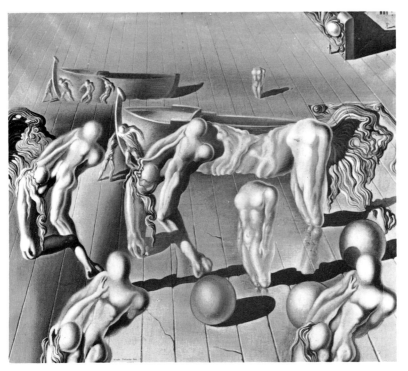

94 SALVADOR DALÍ *Dancers, lion, horse... invisible* 1930

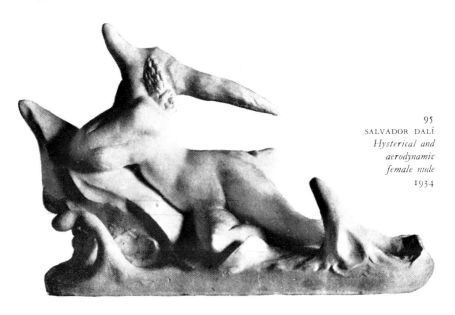

95
SALVADOR DALÍ
*Hysterical and
aerodynamic
female nude*
1934

more noble than an aristocrat, more academic than the most conventional of painters, more refined than a sybarite, and so on. So he became more surrealist than the surrealists, and sowed paradoxes in their very beliefs. Dalí was the product of a synthesis of everything the movement had acquired, but his determination to 'cretinize' the public (a reminder of Dada), his 'cannibalism' (a reminder of Picabia), and his appeal for bad taste (a reminder of Breton's statement 'I force myself to go further than anyone else in the bad taste of the age'), acquired transcendent power because of his fanatical egocentricity. He brought to surrealism not only a hyperbolic imagination, not only a pictorial technique which had been developed by frenetically hard work, but also his gift for savorous overstatement and his gift for solemn clowning. He became the protagonist of a tragicomedy of art, in which his actions and his gestures contributed to the emotional charge of his painting.

When Breton and Eluard wrote *L'Immaculée Conception* in 1930,

96
SALVADOR DALÍ
*The Ghost of
Vermeer van Delft,
which can be used
as a table*
1934

they set out to demonstrate that the mind could put every known form of madness to work in the cause of poetry. Dalí invented the 'paranoiac-critical method', and showed that an artist could obtain spectacular results by the controlled and lucid simulation of mental disease. Paranoia is an interpretative disorder with a rational basis, which, if skilfully mastered by the painter, will allow him to reveal the double significance of things. Thanks to this 'spontaneous method of irrational knowledge based on the interpretative critical association of phenomena which lead to delirium', the painter will act and think as if under the influence of a psychic disorder, while remaining fully aware of what is going on. The act of painting has no further function save that of using a perfected *trompe-l'œil* technique to make the images of this organized delirium unforgettable. It is from this that Dalí derives his definition of painting : 'photography (by hand and

97 SALVADOR DALÍ *Birth of liquid desires* 1932

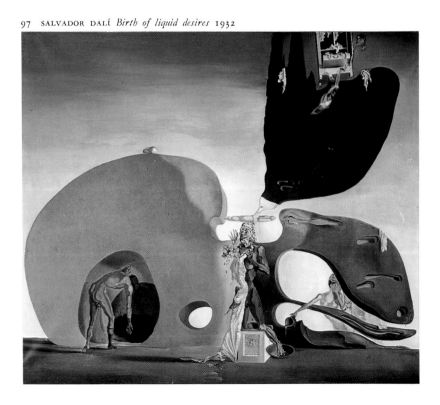

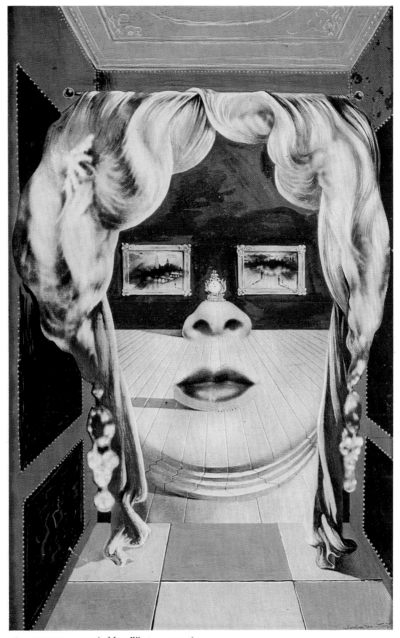

98 SALVADOR DALÍ *Mae West c.* 1934-6

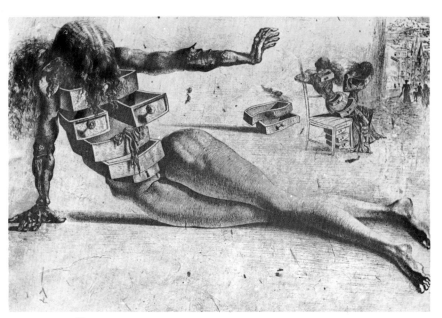

99
SALVADOR DALÍ
The City of Drawers
1936

100
SALVADOR DALÍ
Gradiva 1932

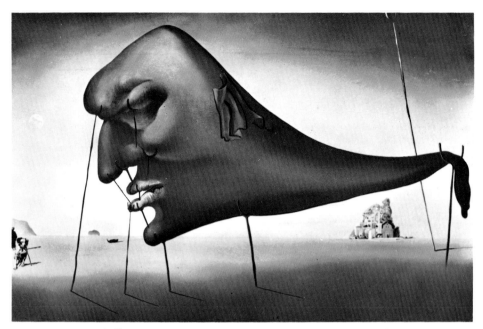

101 SALVADOR DALÍ *Sleep* 1937

in colour) of concrete irrationality and of the imaginary world in general'.

Dalí was a Renaissance man converted to psychoanalysis. In *The Invisible Man* (1929), the first picture in which he used a double image, the man in this case being also a woman at the same time, *The Great Masturbator* (1929), *Dancers, lion, horse... invisible* (1930), *Birth of liquid desires* (1932), and *Persistence of Memory* (1931, New York, Museum of Modern Art), where time is abolished by the famous 'soft watches', Dalí took a delight in painting what he called the 'psychic anamorph', defined thus : 'The instantaneous reconstitution of the desire by its refraction in a cycle of memories. Example : the instantaneous reconstitution of the desire of thirst by its refraction in a cycle of masochistic memories'.

This method, which was the art of cultivating phantasms, made so great an impression only because the phantasms were genuine. Dalí put on to canvas his panic fear of grasshoppers, his phobia of the void, his perverse eroticism, and his nostalgia for inter-uterine existence. He tore off the mask which reason puts on reality, and behind it discovered a soft world which was subsiding or

92

93, 97

92

98-100

102

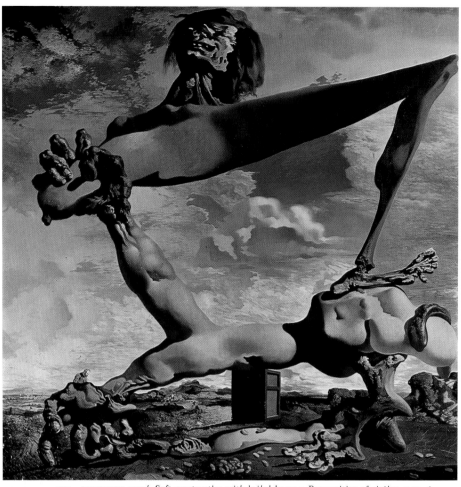

102 SALVADOR DALÍ *Soft construction with boiled beans : Premonition of civil war* 1936

101 decomposing, and which had to be propped up on enormous
crutches. His dramatic break with his father, whom he compared
with William Tell, is the reason for the baroque melodrama of *The
Old Age of William Tell* (1931, Paris, Marie-Laure de Noailles
collection), and *The Enigma of William Tell* (1933-4). The obsession
with food which drove him to paint Gala with two raw cutlets on
her shoulders gives an authentic flavour to paintings like *The Weaning
of the Furniture Food* (1934, Cleveland, A. Reynolds Morse collection),
in which he espies through an opening in the body of his nurse the

piece of furniture containing the feeding bottle, and *The Ghost of* *96*
Vermeer van Delft, which can be used as a table (1934, ibid.).

Apart from writing the scenarios of the films *Un Chien Andalou*
(1928) and *L'Age d'Or* (1930), which were marked also by the kindred *103*
genius of his friend Luis Buñuel, Dalí was also poet, librettist,
sculptor, theoretician, dress-designer, window-dresser and organizer
of carnivals. The accumulation of his 'imperialist' paradoxes, which *95*
were such as to falsify the ideas of surrealism, and his commercial
opportunism, led to his break with the group in 1939, but this did
not stop Dalí from continuing to be a surrealist. He went to live in
California, where he painted some magnificent compositions like
Geopolitical Child observing the birth of the New Man (1943, Cleveland,
A. Reynolds Morse collection), and *Dream caused by the flight of a bee
round a pomegranate a second before waking* (1944). The painting which
indicates the official end of his surrealist career is the *Apotheosis of
Homer* (1945), in which he tried to give expression to 'the visual
sensations of the blind'. Even so, in the 'mystic' period which
followed, constant references to the past can still be made out.
Dalí has perhaps had a more coherent evolution than any of the other
surrealist painters.

103
LUIS BUÑUEL and
SALVADOR DALÍ
Skeletons of bishops
1930

Alberto Giacometti brought into surrealism the resentment and anxiety of a betrayed lover. He had wanted to embrace reality in his art, and reality had become inaccessible to him. Giacometti was the son of one of the best Swiss post-impressionist painters, and painted and sculpted a number of portraits from life before he came to Paris in 1922. Until 1925 he studied under Emile-Antoine Bourdelle at the Grande Chaumière; but he found it gradually more and more impossible to translate the external world into sculpture; he called on his imagination to supply the deficiencies of the model. Up to 1928, under the influence of Laurens, Arp and primitive masks, he made 'flat sculptures', two - dimensional heads and figures, which were followed by 'open sculptures', such as *Sleeping Woman who dreams* (1929). He came into the surrealist group in 1930, the year when he exhibited sculpture-objects with Miró and Arp at the Galerie Pierre. As he could not live from sales of his work, at this period he and his brother Diego worked for Jean-Michel Franck, an interior designer for whom they made all kinds of utilitarian objects such as light fittings, lamps, wall brackets and so on. Giacometti's surrealist period included a series of 'affective' sculptures which gave concrete form to definite feelings of aggression or anguish. He

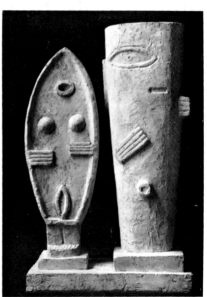

104
ALBERTO GIACOMETTI
The Couple 1926

105
ALBERTO GIACOMETTI
Suspended Ball or the Hour of Traces 1930

106
ALBERTO GIACOMETTI
The Invisible Object
1934-5

visualized each work complete in his mind, and once this vision was formulated, he executed it usually without changing anything, sometimes in no more than a day. Sometimes he made objects, like *Suspended ball or the Hour of Traces* (1930), *Circuit* (1931, Paris, Henriette Gomès collection), *Pointe à l'œil* (1931) and sometimes plastic images

105

107 like *Caress* (1932), *No more play* (1932), *The Palace at 4 a.m.* (1932,
New York, Museum of Modern Art), *The Table* (1933, Paris, Musée
106 National d'Art Moderne), and *The Invisible Object* (1934-5).

In 1935 Giacometti moved away from the surrealists and took up
sculpture from life again. Throughout the years he tirelessly made
and remade studies of heads, working from his brother Diego and
his model Rita. He was never satisfied, and while he worked on a
piece it gradually grew smaller and smaller, seeming to melt or shrink.
It was as if he were trying to find a nugget of pure reality by stripping
off successive wrappings from the work. Quite often a sculpture which
he had intended to be on a large scale ended up so small that it would
fit into a matchbox.

During this period of revolutionary preoccupations, which
Breton called the 'period of preparation', surrealism underwent a
brilliant return to pictorial automatism. One of those responsible
was Oscar Domínguez, who invented 'decalcomania without pre-
conceived object'. Domínguez was a native of Tenerife, and in 1933
he had had an exhibition there which he had described as surrealist,
although he had never met a member of the group. He did not come

into contact with them until 1934, in Paris, and when he did, he became a redoubtable figure. Every one of his pictures revolved round a shock idea, like an advertising poster (he had formerly been a poster artist). For example, in *The Hunter* (1934), he showed a bird imprisoned in a hand-shaped cage. In 1935 he did his first 'decalcomania', by laying a sheet of paper on top of another covered in black gouache, rubbing at random with the hand, and separating the sheets when almost dry. This technique, which allowed him to create fantastic landscapes, was greatly appreciated by his entourage, *108* among whom it was widely used. Domínguez also invented 'lithochronism' or 'solidification of time', a form of sculpture which involved wrapping, to form a bundle, one or more three-dimensional bodies. If one placed a typewriter and some ornament together, and then wrapped them in stretch material, this latter would become a 'lithochronic surface'. Domínguez' imagination was fertile in this kind of discovery, but he too often wasted his possibilities. He

108
OSCAR DOMÍNGUEZ
Decalcomania 1937

109 OSCAR DOMÍNGUEZ *Nostalgia for Space* 1939

109 painted his best pictures just before the war, when he went through a 'cosmic' period - *Nostalgia for Space* (1939) and *The Memory of the Future* - and evoked extra-terrestrial landscapes with crazy vege-
119 tation. His 'concrete irrationality' - as in *Los Porrones* (1935) - is less savage than Dalí's.

Wolfgang Paalen, who also played a part in the revival of auto-matism, had a fine, meditative mind, rather given to philosophical speculations. He had been born in Vienna, and had spent his youth travelling in Austria, Germany and Italy. He settled in Paris in 1928, and belonged first to the Abstraction-Création group. He joined the surrealists in 1935, and presented them with a 'new method of forcing inspiration': fumage. This process involved the interpretation of marks left on a surface by a candle flame, and Paalen used it in the composition of handsome nocturnes showing phantom-like beings in murky landscapes *(Battle of the Saturnian Princes,* 1938).

Paalen had theories about the 'super-conscious', a state of ecstasy which he felt that surrealism should encourage. He said 'The super-conscious, beyond the unconscious and the conscious, is the third rung of the ladder of intellectual behaviour'. He cut himself off from the surrealists for a time because he disagreed with their analysis of Hegel's thought, and because he believed they failed to attach enough importance to Einstein and to modern physics; but after he had founded the ephemeral 'Dynaton' movement in Mexico, he returned to surrealism, which he enriched by new experiments in what he called 'multi-dimensional space'.

André Breton was delighted by the arrival on the scene of Victor Brauner, who was brought into the surrealist circle in 1933 by his friends Giacometti and Tanguy. Breton immediately recognized in him the kind of painter he had been appealing for since the *Second Manifeste,* and wrote a vibrant preface highly praising the works that Brauner exhibited at the Galerie Pierre in 1934. Brauner was Romanian, and ever since his first exhibition held in Bucharest in 1924, when he was twenty-one, he had shown an acute sense of the fantastic image. One of his pictures, *Leisures,* showed men playing

110
VICTOR BRAUNER
Self-portrait 1931

football with their own heads. When he arrived in Paris in 1930, he immediately set about studying every possible transformation of the human face. He painted canvases divided into multiple compartments, and showed in each a different metamorphosis of a being : *Morphology of man* (1933); *The Strange Case of Monsieur K.* (1933).

116

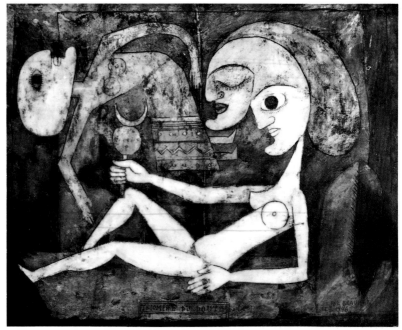

113
VICTOR
BRAUNER
*The Triumph
of Doubt*
1946

One of the strange things about him was his preoccupation with mutilation of the eyes. He had painted a self-portrait in 1931 in which he showed himself with one eye crushed and his cheek covered in blood. He never knew what made him paint this picture in this way. He subsequently painted figures with horns coming out of their eyes, and others who looked in despair at an eye which had been plucked out. In *The Last Journey* (1937), a man sits sadly on a giant eye, while a monster rushes away with another eye clutched in its fingers. On 27 August 1938, at a studio party, Brauner tried to separate two friends who were quarrelling, and was struck in the face by a bottle thrown by Domínguez. His left eye was put out. Everyone was stupefied, and felt that Brauner had announced years ago that this accident was going to happen — the more so since in 1932, in *Mediterranean landscape*, and in 1935, in *Magic of the seashore*, he had shown himself with his eye pierced by an instrument with the letter D, Domínguez' initial, on its handle. Never had the surrealist idea of the mediumistic 'message' been as conclusively vindicated as in Brauner's case. Every one of his paintings was a message which had matured in the light of his presentiments.

110

112

111

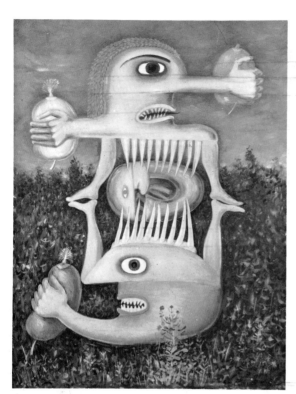

114
VICTOR BRAUNER
Totem of wounded subjectivity
1948

*Two wicked Victors stop
the 'little' Victor from living*

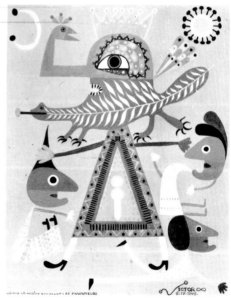

115
VICTOR BRAUNER
*Victor Victorios crushing
the casters of spells*
1949

*The ego has opted for
the strength of real subjectivity,
and violently pulverizes
those who impede
the triumphal march of
its heroic exploits*

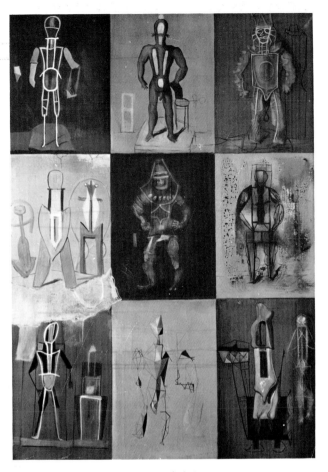

After this event, which revealed to him his powers of clairvoyance, Victor Brauner's painting changed, left the realm of cruel satire, and turned towards the universe of magic. He delved into the spirit of witches' spells, and studied the treatises of Cornelius Agrippa and Paracelsus. After the hypnotic paintings of his 'period of Chimaeras' with their mysterious apparitions in the dusk (such as *The Inner Life*, 1939), he began to make extraordinary pictures in wax, which *114, 115* expressed abstruse, hermetic myths with a conviction and eloquence which had rarely been achieved before him by other artists who shared his interest in the occult.

When Hans Bellmer showed the surrealists his *Doll (Poupée)*, in *120* this too they recognized an example of the revolutionary art for

which they longed. This was a love-hate object, symbolizing all the fascination which the female body inspires and all the rejections of the real world. The *Doll* was born as the result of Bellmer's revolt against his father and against society. In Berlin, where he lived, he worked as an industrial designer. For his own amusement he drew sketches of little girls, and of tiny scraps of waste which he picked up in the street. After seeing Max Reinhardt's production of *The Tales of Hoffmann*, he was inspired by the story of the automaton Coppelia to build an artificial girl.

In 1933 Bellmer began to build his *Doll* with the help of his wife, his brother and a young girl cousin. Initially it was composed of

117
HANS BELLMER
Landscape 1800 1942

116

some broom-handles fastened together and articulated. Bellmer wanted to give it an inner life by making six 'panoramas' which could be seen by pushing a button on its breast. While he was working on the *Doll* he studied unusual physical attitudes and then made a first naturalistic version which he photographed. An object which he made at this time, *The Machine gun in a state of grace,* a weapon whose barrel is a female body, is a clear indication of his intention to use his creations to repel the invading forces of the world. Then he returned to his favourite theme and made a new *Doll* with two pairs of legs arranged round the central core of a 'stomach ball'. The photographs he took of this in a garden inspired Paul Eluard's prose poems *Les Jeux de la poupée* (1938).

In 1938, after the death of his wife, Bellmer took up permanent residence in Paris. His drawings and paintings, which all start from the theme of the doll, expressed his 'interanatomic dreams'. He dissected what he called the 'physical unconscious', the images which a man can create for himself of his own body or of that of the woman he desires. He composed hybrid women, most frequently by giving concrete form to various attitudes in one image. 'If, instead of selecting only three or four moments of a movement (as is done, for instance, in manuals of gymnastics), all these movements are added integrally and in the form of an object, the result is a visual synthesis of the curves and surfaces along which each point of the body moves', he wrote in his *Anatomie de l'image* (1957). He also evoked 'the strange object, the tragic and mysterious trace which would be left by a nude thrown from a window on to the pavement'. All these bodies, made up of a head and limbs which are split or transposed, are plastic anagrams, menacing variations on the theme of desire.

A number of key formulae have been used over the years to define the work of the surrealists. These are not orders, given by Breton, and used as recipes; they are the cardinal virtues of surrealism in which all its artists were steeped, and on which they were all brought up. The first among these is 'convulsive beauty', the beauty which results from a sharp conflict between movement and immobility, and which implies an extreme tension of the being, and a delirious agitation kept secret or compressed by circumstances. Breton has given as an example of this a locomotive abandoned in a virgin forest. The second value is 'objective chance', that is the sum total of the coincidences which control a destiny. The third is 'black humour'. This form of humour has nothing derisive about it; on the contrary, because of its tragic undertones, it constitutes a kind of poetic terrorism. The fourth value, *amour fou*, 'extravagant love', is easily enough understood. It is this that ensures that in most surrealist works the image of woman shines out like that of a guardian goddess. Naturally no surrealist painter ever set out with the intention of creating a picture of 'convulsive beauty' or 'black humour'. The surrealists expressed these values almost despite themselves, because of the forces which animated the action of the group, and which as a result demanded that the temperament of the group should exalt certain qualities in preference to others.

Across the world

From 1935 to 1938 André Breton and Paul Eluard led a vigorous propaganda campaign aimed at 'the internationalization of surrealist ideas'. Their lectures and their contacts with the leaders of the avant-garde in many countries showed that the Paris group was looking for a universal audience, and trying to ensure the widest possible availability of precise information about the ideology of surrealism. But world-wide interest in surrealism had been aroused long before this, and the movement had attracted supporters throughout the world.

At the urging of the poet Marko Ristic, Yugoslav surrealism was born as early as 1924, the year in which the first *Manifeste du surréalisme* was published. The Yugoslav surrealists set out their principles in the *Belgrade Declaration* of 1930, a document whose signatories could hardly have suspected that fifteen years later they would be holding high office in public life : Kosta Popovic was to become Foreign Minister, and Marko Ristic ambassador in Paris. In 1931 their review *Nadrealizam danas i ovde* ('Surrealism here and now') presented experiments similar to those which were being conducted by their Parisian friends. For example, there was an 'essay in the simulation of paranoiac delirium' in which six painters and poets each gave their interpretation of an old wall. They carried out a survey on the question 'Is humour a moral attitude?' Among the painters in the Yugoslav surrealist group were Zivanovic-Noe and Vane Bor, who wrote an open letter to Dalí explaining that he chose his colours for their smell, their name, and the shape of the tube.

In Belgium too, surrealism found an immediate echo. A group was formed in 1926 by the poets E.L.T. Mesens and Marcel Lecomte, the theoretician Paul Nougé, the dealer Camille Goemans, and the painter René Magritte. They founded a review, *Variétés,* in 1928, in which they set out their position *vis à vis* the 'Modern Spirit'.

The man who dominated Belgian surrealism from the start was the incomparable René Magritte, who created the most astounding

visual dialectic of our time. Magritte had been a reluctant student at the Académie des Beaux-Arts in Brussels, and in 1922, the year in which he married, he became a designer in a wallpaper factory. Magritte spent some time doing abstract painting in association with Victor Servranckx. But by chance he came across a magazine reproduction of *The Love Song* by Chirico, which showed him the way he was to follow. In 1924 he painted the picture which he considered to be his point of departure. This showed a window seen from inside a room, with, outside the window, a hand trying to catch a bird in flight. Another picture which he did shortly afterwards showed a woman with a rose in place of her heart.

In 1926, the support which Magritte got from the Galerie 'Le Centaure' enabled him to take up painting full time. He lived in France from 1927 to 1930, first in Paris, where he contributed to *La Révolution Surréaliste,* and later in Perreux, north-west of Lyons. During this period he produced a great many pictures, some of them of enormous size. He outgrew the influence of Chirico, which is still apparent in *The Difficult Crossing* (1926) and *The Flying Statue* (1927).

123 In *Threatening Weather* (London, Roland Penrose collection), which has a female torso, a tuba, and a chair suspended over the horizon, Magritte tried to explain the 'why' - or rather the 'why not' - of the exterior world. His shapes were still crude, and his colours of a mineral hardness.

In *The Passer-by* (1929), a cloud-flecked sky-blue silhouette outlined against a wall, he began to use a kind of contrast which he always valued. He invented a repertory of 'problems', which implied 'object lessons', and used telling combinations to make the familiar strange. He based himself in this on the following principles : enlargement of a detail (an immense apple or rose filling up all the space in a room), the association of complementaries (the leaf-bird or the

122 leaf-tree, the mountain-eagle, etc.), the animation of the inanimate

128 (the shoe with toes, the dress with breasts), the mysterious opening (the door swinging open on to an unexpected view), material transformation of creatures (a person made of cut-out paper, or a stone bird flying above the rocks of the seashore), and anatomical surprises (the hand whose wrist is a woman's face).

André Breton wrote later in *Les Vases communicants :* 'The highest endeavour to which poetry can aspire is to compare two objects as

OSCAR DOMÍNGUEZ
Los Porrones 1935

120
HANS BELLMER
Doll 1936
(Cast in aluminium, 1965)

remote as possible from one another, or, by any method whatsoever, to bring them into confrontation in an abrupt and striking way'. Magritte was totally committed to this task, and constantly varied its possibilities. He was also able to bring two closely related objects together and to bring out the differences between them, or to put an object at odds with the name used to describe it. This confrontation between the word and the object, between the drawing and the writing, enabled him to give the spectator the kind of revelatory shock which can be seen in *Vertigo* (1943), where he painted a female nude with the word 'Tree' written across her stomach.

Magritte was often moved by brief flashes of illumination. One day he saw his wife eating a chocolate bird, and immediately produced an image of a young woman eating a live bird, with its blood flowing over her hands. On another occasion a glimpse of the lathe-turned feet of a table inspired him to paint the huge wood-turnings of the landscape in *Annunciation* (1928, Brussels, E.L.T. Mesens collection).

121

121 RENÉ MAGRITTE *Annunciation* 1929-30

122 RENÉ MAGRITTE *The Companions of Fear* 1942

Magritte is a painter of revelations. His painting excludes symbols and myths, and he is not a prospector of the invisible. He transmits faithfully what is revealed to him by his attentive contemplation of reality. Even when he changes its meaning, he bases himself on the object which inspires him. In 1934 he wrote in the Belgian periodical *Documents* : 'We must never, at any price, depart from the reality of the element which has delivered up its secret to us. This is a point of reference.'

In *The Human Condition* (1934, Paris, Claude Spaak collection), a painting on an easel allows us to see, by its apparent transparence, the landscape exactly behind it. This picture is the essence of Magritte. He paints transparent enigmas, and his mysteries are always crystal clear. Every one of his paintings is an act of poetic reflection on the nature of the world. He does not try to find new solutions to old problems, but sets new problems which bring back into play all the solutions which have already been found. *Perpetual motion* (1934), *The Rape* (1934) and *The Amorous Perspective* (1935, Brussels, Robert Giron collection) were the first masterpieces of this wholly committed

124

123 RENÉ MAGRITTE *Threatening Weather* 1928

style. Like Dalí, Magritte needed a scrupulously academic technique to give maximum precision to the extraordinary content of his paintings. From 1940 to 1946, the period which his friend Scutenaire described as 'full sunlight', Magritte tried to paint like the impressionists, playing with the efflorescences of colour. Fortunately he reverted to his normal style, where technique is the servant of the idea. Towards the end of his life Magritte experimented with the transposition of the idea from one medium to another. *(La folie des grandeurs*, 1961-6).

Paul Delvaux came across surrealism in 1936. Before this, he had studied architecture at the Académie des Beaux-Arts in Brussels, and had then painted in a naturalistic impressionistic style. He showed paintings in this style in his first exhibition at the Galerie Manteau in 1926. But at a group exhibition at the Palais des Beaux-Arts, he was deeply impressed by works by Chirico and Magritte. He set off on a parallel road, and first broached the style which was to become

his own in *Procession in Lace* (1936, Brussels, Jean Giron collection), clothed women moving towards a triumphal arch, and in *Woman with a rose* (1936), who bends down to pluck a flower in a corridor, and in *The Sleeping Town* (1938, Brussels, Robert Giron collection), a weird night scene observed by a man from the threshold of his house.

Delvaux visited Italy, where his study of the painters of the Quattrocento confirmed him in his taste for linear perspective, for architecture, and for women of ideal proportions. In *Nocturne* (1939) and *The Visit* (1939), he showed flesh as a function of enchantment; his naked women are materializations of moonbeams. In *Dawn over the town* (1940) and *Entry into the town* (1940, Brussels, Robert Giron collection), he produces an astounding contrast by introducing into a crowd of naked women and youths an austerely dressed man who remains totally indifferent to his surroundings. When he brings skeletons into scenes of this kind, they seem to be tamed and

124 RENÉ MAGRITTE *Perpetual motion* 1934

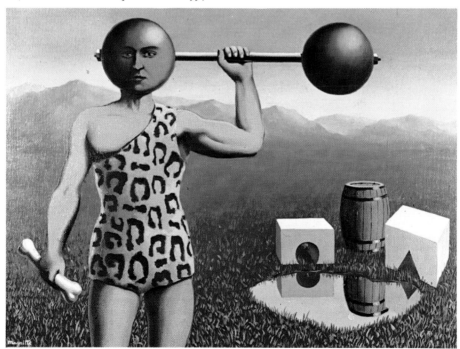

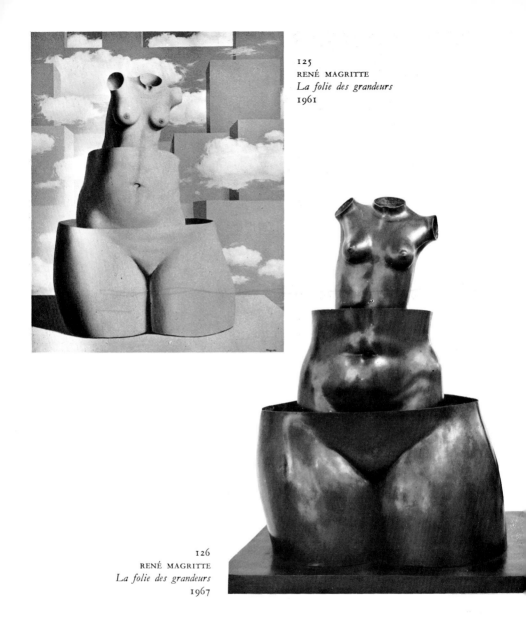

125
RENÉ MAGRITTE
La folie des grandeurs
1961

126
RENÉ MAGRITTE
La folie des grandeurs
1967

vanquished by the splendour of the nudes. The war inspired him to paint *The Anxious Town* (1941, Brussels, Dr Demol collection), where almost a hundred characters in a city are in a state of panic, as if a storm were approaching the Earthly Paradise. So many of Delvaux' pictures - *The Hands* (1941), in which one of the clothed figures is the

130

127 PAUL DELVAUX *The Sabbath* 1962

painter himself, *The Echo* (1943, Paris, Claude Spaak collection), *Iron* *130*
Age (1951, Ostend) - show him to be a painter who has best *133*
succeeded in combining modern beauty and the beauty of antiquity,
and in giving all his anxieties and all his hopes the radiant appearance *127*
of the women of his dreams.

 Belgian surrealists also included Raoul Ubac, who published an
album called *L'Invention collective* with Magritte in 1935, and who from
about this period composed 'photo-reliefs', in which a relief effect *132*
is produced by printing from positive and negative transparencies
superimposed and slightly out of register. In these photographs nudes
and statues seem to be completely fossilized. He later tried to transfer
this kind of effect into his burin engraving. Subsequently he went on
to sculptures in slate which have only a remote connection with his
surrealist period.

 In Sweden, the *Manifeste du surréalisme* had inspired the poets
Lundkvist, Ekelöf, Vennberg and Asklund and an anthology of
surrealist poetry, *Spektrum*, was published in 1933. Work on the
visual aspects of surrealism was carried on by the *Halmstadgruppen*

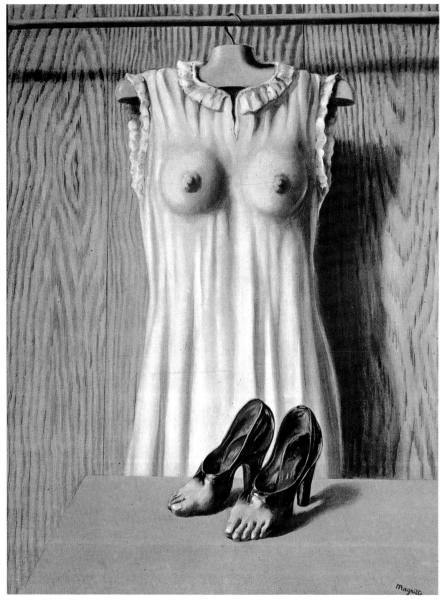

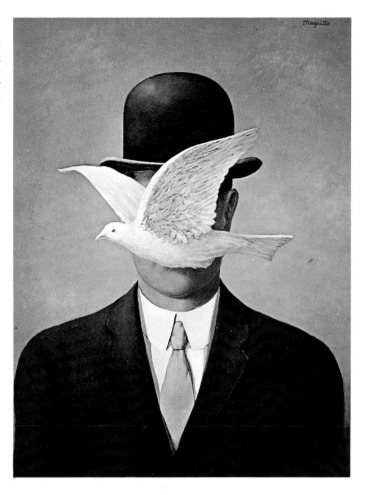

(a group from Halmstad, a Swedish Baltic coast town), which was led by G.A. Nilson, and included the painters Stellan Mörner, Erik Olson, Esaias Thoren, Sven Jonson, Waldemar Lorentzon and Axel Olson. These painters, after having originally defined their position as orthodox, took up an eclectic imagery full of romantic reminiscences. These artists stayed together, and in 1954 produced a collective set design for the Halmstad theatre.

In Denmark there was a group whose views were contained in the review *Konkretion,* which first appeared in 1935. The group, which took part in the 'Cubist Surrealist Exhibition' in Copenhagen, included the painters Henry Carlsson, Elsa Thoresen and Rita

Kernn-Larsen, and the sculptor Heerup. But the two outstanding members were Wilhelm Bjerke-Petersen, who organized various surrealist exhibitions, and who often wrote about the movement, and the greatest of Danish surrealists, Wilhelm Freddie.

In 1930, when he was twenty-one, Freddie showed his picture *Liberté, Egalité, Fraternité* at the Copenhagen Autumn Salon. This was the signal for the scandal which was aroused by the introduction of surrealism into Denmark. Freddie was a follower of Dalí in his use of aggressive phantoms; but, unlike Dalí, he was not able to develop a personality eccentric enough to allow him to carry off his artistic audacity. The English customs refused to admit *Monument to war* and other pictures he sent to the London Surrealist Exhibition in 1936. In 1937 there were angry scenes at his Copenhagen exhibition 'Sex-Surreal', which included 'sado-masochistic interiors' and 'sensual objects'. One protester was so infuriated that he hurled himself on

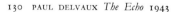

130 PAUL DELVAUX *The Echo* 1943

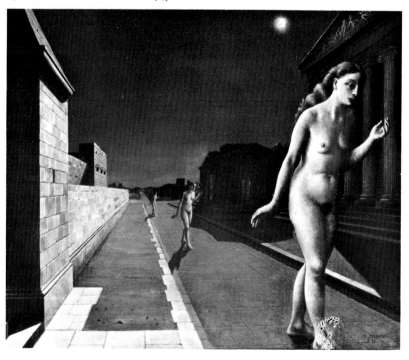

132
RAOUL UBAC
Fossil 1938

Freddie on the day of the opening and tried to strangle him. The gallery was closed by the police, who confiscated the works on show, some of which, including *Monument to war*, went to their 'black museum', from which Freddie was not able to retrieve them until much later.

Freddie began to impose his personality in 1940. His new exhibition in Copenhagen drew an enormous public, and his ballet, *The Triumph of Love,* staged at Elsinore, established his reputation. But the Nazi occupation of Denmark brought him more troubles. He was wanted by the SS because of the attack he had made on Hitler in his large picture *Meditation on anti-Nazi love,* and was forced first into hiding and then to flee to Sweden. Not until after the war was Freddie able to work without restrictions and to be judged at his true worth.

Czechoslovak surrealism, which grew out of the 'Devetsil' group which combined all avant-garde tendencies, was formulated in 1933

at the instance of the theoretician Karel Teige and the poets Vitezslav
Nezval and Konstantin Biebl. Breton and Eluard had an enthusiastic
reception at the international surrealist exhibition in Prague in 1935.
The Czechoslovak group included the sculptor Makovsky, who used
all sorts of materials - stone, canvas, card - in his reliefs, and the
painters Jindrich Styrsky and his wife Toyen. Styrsky, born at
Cermna in 1899, began his career by illustrating the 'poetist' trend
in Czechoslovak painting. But in 1934 he began an extraordinary
series of collages, *The Removal Office*. Later he showed a series of
paintings - *Roots* - but returned to collage during the war, working
on violently anti-clerical themes. He died in 1942, and a retrospective
exhibition of his work was held in Prague in 1946.

Styrsky's wife Toyen was initially an abstract painter, but rapidly
developed towards a form of figurative painting which recalled
folk imagery. A major work in this style is *The Dancers* (1925),
immense figures in transparent veils, who parade before minute

133 PAUL DELVAUX *The Iron Age* 1951

134 PAUL DELVAUX *The Hands (The Dream)* 1941

spectators who are holding bouquets and turning their backs on the
dancers. Toyen played an active part in the foundation of
Czechoslovak surrealism, and she became the country's greatest
surrealist painter. In one period of her work she showed a cracked
and fissured universe : the human silhouette in *The Red Spectre* (1934)
and the night bird in *The Voice of the Forest* (1934) are both covered
in a network of cracks as if they were about to disintegrate. Her first
major exhibition in Prague in 1938 was accompanied by the publi-
cation of monographs about her work and about that of Styrsky.
Her paintings are held together by her outstanding draughtsmanship,
which shows brilliantly in her series of drawings *The Spectres of the
Desert* (1937), *The Shoot* (1940) and *Hide, War* (1944). Her painting,
with its subtle dreamlike quality, creates an outlandish atmosphere *137, 140*
by the use of sober means ; a dress lifted at the window of a house,
showing on the wall the impression of a woman's body ; the sky

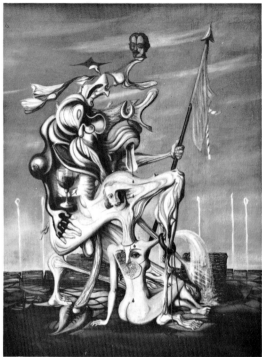

135
WILHELM FREDDIE
Monument to war 1936

138 forms an angle from which a bird's nest is suspended; lips and hair form a stifling erotic dream-world; she makes any number of discoveries which bring the surreal into action. Her self-effacing attitude may have resulted in her name being left off the lists of the great surrealists, but there is no doubt that she is an artist of the first rank, who brought to painting something of what Kafka gave to literature.

There was no real surrealist group in Italy. The review *Surrealismo*, published by the writer Curzio Malaparte, was not the mouthpiece of a group, but merely a selection of various international writings about the movement. But some Italian painters were inspired by the trend. Alberto Martini, a painter born in 1876, had illustrated the works of Mallarmé, Poe and Rimbaud as early as 1911; his extraordinary paintings, his albums of lithographs *(Mysteries* and *Fantasies bizarre and cruel)*, his designs for sets and costumes for a 'theatre on

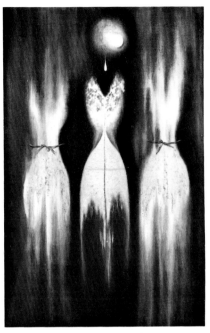

137
TOYEN
Silken feasts 1962

138
TOYEN
In the warmth of the night
1968

the water' all marked him out as a precursor of surrealism. He was
the first to hail, in an Italian periodical *(Il Perseo),* the birth of
surrealism. He came to Paris in 1924, and fell in with the artists of the
group. The survey on love, run by *La Révolution surréaliste,* influenced
the content of his work. He painted canvases expressing sight, such
as *The Mind Works* and *The Eyes of Love,* several portraits, including
one of André Breton, and a series of *Butterfly-women.* From 1935 to
his death in 1954 he regressed, and locked himself up in evocations
of the Atomic Age or the Life of Christ.

Although there were other painters, such as Bruno Capacci and
Fabricio Clerici, who may be regarded as surrealists, the only one
who rates as a master is Alberto Savinio, the brother of Giorgio de
Chirico. Savinio had his own form of genius, on which his elder
brother had little influence. He was at first a musician and poet, of

139
ROLAND PENROSE
Portrait of Valentine
1937

140 TOYEN *The Mirage* 1967

whom rumour had it that he had smashed pianos by the enthusiasm
and vigour of his performance. He gave a concert in Paris in 1914,
organized by *Les Soirées de Paris* with the support of Apollinaire,
who announced to the audience : 'You will see him play his piano.
He sits there in shirtsleeves, his monocle in his eye, and screams
and yells while the instrument does what it can to reach the musician's
enthusiastic range.' Alberto Savinio wrote music for operas and
ballets, including *The Death of Niobe,* produced in Rome in 1925. He
also wrote a poem-cycle, *Chants de la Mi-Mort* (1914), and astonishing
stories, including the *Introduction à une vie de Mercure.* He returned to
Paris, and lived there from 1926 to 1934; during this time he began
to paint, holding his first exhibition at the Galerie Bernheim-Jeune
in November 1927. His pictures were always perfect irrational *141*

images, and there is much in Henri Parisot's opinion that he was 'the Fuseli of the twentieth century'.

The appearance of English surrealism was marked by the opening in June 1936 of the 'International Surrealist Exhibition' at the New Burlington Galleries in London. This had been organized by Roland Penrose, the painter and collector, who himself made collages and objects. More than sixty artists took part. The star of the English section was Paul Nash, who might have been the best English surrealist painter, had not his versatility led him to try every genre. Another leading exhibitor was Humphrey Jennings, painter and film-maker, who painted oddly sophisticated pictures. Henry Moore showed sculptures which stood at the frontiers of dream and reality. Some of the others who stood out were Eileen Agar, with her poetic objects, and the caricaturist Edward Burra, whose paintings were derivative of those of Max Ernst. On the evening of the private view the guests were joined by a 'woman with a head of flowers', whose head was entirely hidden in a bouquet of roses. Salvador Dalí turned up to lecture wearing a diving suit and holding two white greyhounds on a leash. The success and influence of this exhibition were remarkable. In 1938, E.L.T. Mesens moved to London and took on the direction of the London Gallery. Until June 1940 he published the *London Bulletin* and used his expertise to support English surrealism.

A surrealist group was founded in Romania in 1933, but showed no original, individual development until much later, when it adopted an attitude to life and art which was, systematically, delirious. The moving spirit of this group was the poet Gherasim Luca, who invented a new form of collage which he called 'cubomania'. This consisted of cutting squares from illustrations and joining them up in an arbitrary pattern. He got unexpected results from this, and brought together a selection of these strange puzzles in his album *Les Orgies des Quanta* (1946). He exhibited cubomanias in Bucharest and in Paris, where he went to live.

In Japan, surrealism developed almost immediately, thanks to the tireless proselytizing of the poet Shuzo Takiguchi, who began to spread surrealist ideas, through his articles and publications, as early as 1927. At first he disseminated the ideas of surrealist poetry, but from 1930 on, he contributed to the rapid development of the visual side of the movement, particularly by his translation of what

André Breton and Aragon had written about painting. A group of artists formed around the review *Mizue,* in which Takiguchi published an essay on 'Art and Surrealism'. From 1934 to 1936, the movement won a large following among the Japanese public, and influenced painters and sculptors through the formation of the Shin-Zokei ('New Plastic') association. In June 1937, an International Surrealist Exhibition in Tokyo was a huge success, and was put on in three other Japanese cities. A 'Surrealist Album', with many reproductions, was put together for the occasion by Takiguchi and Yamanaka. Takiguchi published a book called *The Metamorphoses of Modern Art* in 1938, and monographs on Dalí (1939) and Miró (1940). After an eclipse due to the war, he resumed work and in 1958 set up a Centre of Surrealist Studies in Tokyo. The best known Japanese surrealist painters are Fukuzawa, Otsuka, Shimozato, Ayako Suzuki, Shigeru Imai and Taro Okamoto.

Okamoto, who was in close touch with the Paris group, is an especially representative figure. His father, Ippei, was a satirical draughtsman, and his mother, Kanoko Okamoto, was a novelist. He was born in Tokyo in 1911, and moved to Paris in 1929; in 1932 he exhibited at the 'Salon des Surindépendants'. His work developed in two directions, that of non-figurative art (he belonged at first to the Abstraction-Création movement) and that of fantastic imagery. He painted numerous pictures, heavy with tragic irony, on the theme of ribbons entwining bodies and holding them captive in enormous knots, as if to show humanity imprisoned in the silken bonds of frivolity : examples are *The Dolorous Hand* (1935) and *The Woman Beribboned* (1936). On his return to Japan in 1940, Okamoto continued to work in his half-abstract, half-visionary style. Of all Japanese painters, he is among those who have most thoroughly assimilated the message of the Western avant-garde.

In other countries, including Egypt, Turkey, and (after the war) Spain and Portugal, there were groups which claimed to be surrealist, and which published periodicals, but all of them concentrated more on verbal work than on visual creation. This spread of surrealist activity throughout the world is a sufficiently convincing proof that surrealism was far from being the concern of a closed circle, but was a response to a profound hope which had a universal place in man's sensibilities.

The object

The object is an even more typically surrealist creation than the collage. Surrealism imposed the object on modern art, and brought it into competition with sculpture, which was thus forced to redefine itself on the basis of the object. Connoisseurs of objects had existed in the past, but their choice was limited to curios and antiquities. The writer C.C. Lichtenberg was the first to set out - in the 'pocket almanach' of Göttingen, 1798 - a list of a collection of absurd instruments, including 'a double children's spoon for twins', 'a mobile bed for moving around the bedroom in, during the night', and, most famous of all, 'a bladeless knife with the handle missing'. The aim of this list was to pour scorn on the ignorant collectors of the day, who were prepared to buy anything. Following his example, the surrealists at first pursued a satirical aim. They wanted to question the utility of domestic objects, and the worth of *objets d'art,* by comparing them with products of pure fantasy.

It was only later that they renewed the psychology of the object by giving it a deeper significance and increasing its extension to human life, and by making it indispensable to the development of thought. To understand the cult of the object, which came about without any aesthetic intention, one must first know of its multiple variations, which fall into clearly defined categories. In 1936 the first group exhibition of objects was held at the Galerie Charles Ratton in Paris, and an attempt was made on this occasion to present the works in some form of classification. This classification today seems inadequate, and needs corrections in the light of the whole range of surrealist inventions. I shall therefore analyse point by point the different genres of objects which have been used or invented since the start of the movement.

The found object (objet trouvé). Surrealism has often urged the intrinsic worth of the found object, and the only purpose of those frequent forays down to the Flea Market which Breton extolled at the time of *Nadja* (1928) was the discovery of such objects. The found

object is one which when seen among a large number of other objects possesses an attraction - the art of the *jamais vu*, the '*never before seen*'. It is usually an old-fashioned manufactured object, whose practical function is not evident and about whose origins nothing is known. There is an element of passion in the impulse to acquire it or to stop in front of it. Surrealist commentaries showed that the found object was capable of providing a surprise solution to a problem which one had been trying in vain to solve. In this way an old fencing-mask, which Giacometti found, enabled him to resume work on a sculpture which he had left unfinished.

The natural object. This may be a root or a seashell, but the surrealists always preferred stones. Breton organized group walks to look for stones, sometimes on the banks of the Seine; he saw in the mineral kingdom 'the domain of signs and indications'. The interpretation of the stones which one finds is considered to satisfy and develop the poetic sense, which needs to be educated in man. In *La Langue des pierres*, Breton stated the methods of the cult : 'Stones - particularly hard stones - go on talking to those who wish to hear them. They speak to each listener according to his capabilities; through what each listener knows, they instruct him in what he aspires to know.' The discovery of a bed of stones on a drizzly day

142
MARCEL DUCHAMP
Why not sneeze
Rrose Sélavy?
1921

in the country gave Breton 'the perfect illusion of treading the ground of the Earthly Paradise'. The divinatory nature of stones, and the 'second state' which they induce in the connoisseur, are found only where the stones have been discovered as the result of a special expedition. Breton said that an unusual stone found by chance is of less value than one which has been sought for and longed for.

The interpreted found object. This is most frequently an ornament or a utensil which has been converted by sleight of hand into a bizarre object. Domínguez was particularly gifted in this way : *Arrival of the Belle Epoque* (1936) is a statuette of a woman cut in two, with the hips separated from the body by a picture frame. *Never* (1938) is an old phonograph, painted white, with a woman's legs emerging from the horn. *The Surrealist Elephant* is Dalí's transformation of a little coral elephant by the addition of bird's feet, lobster's antennae and the shell of a sea-snail ridden by a wax mahout.

The interpreted natural object. In this case, a poetic camouflage either entirely conceals the characteristics of the root or the stone on which it is based, or on the other hand faithfully follows its suggestions. *The Garden of Giacometti after Max Ernst's Visit* is the best example. At Majola in 1934, Max Ernst took chunks of granite from a stream close to Giacometti's house, and turned them into objects by colouring them or slightly hollowing them out. These were among the origins of his first major sculptures.

The readymade. This term can be applied only to an industrially mass-produced object whose function is altered, and which is dragged from its context of automatic reproduction in the most ingenious way possible. In 1916 Marcel Duchamp took a grey steel comb and wrote on it : '3 or 4 drops of height have nothing to do with savagery'. With this addition, there would be a reluctance to use this comb for combing one's hair. It has become to a certain degree untouchable, because the artist has made it into the receptacle of his thought. This is the readymade, the art of turning the most material thing into a thing of the mind. Duchamp refined this idea, and designed the 'mythological readymade', such as *Why not sneeze* (1921, Philadelphia, Museum of Art), a bird-cage containing imitation sugar lumps made of marble, a thermometer and a cuttlefish bone. Marcel Duchamp, the inventor of the genre, was followed by other

creators of readymades: Man Ray's *Gift* (1921), a flat-iron with its ironing surface bristling with nails, was a remarkable example.

The assemblage. This is made up of natural objects or found objects arranged to form a sculpture. In 1939 André Masson made some handsome assemblages - *Bottom of the Sea, Caryatid* and *The Great Lady* - from material he found washed up on the beaches of Brittany. Max Ernst's best assemblage, *Are You Niniche?* (1956), was made by using two yokes and a printing plate.

The incorporated object. This is an object associated with a painting or a sculpture in such a way that it cannot be removed without depriving the work of its *raison d'être*. Miró has made a number of famous picture-objects, such as *The Spanish Dancer* (1928, Chicago, private collection), where a hatpin and a feather are fastened to the virgin canvas. This kind of use of the object is close to collage.

The phantom object. Described by André Breton in *Les Vases communicants* (1932) on the basis of the 'envelope-silence' which he had designed with one side bordered with eyelashes and a handle to hold it by, the phantom object is an object which might be made, but which is instead merely suggested by a verbal or graphic description. The oddest phantom object is Luis Buñuel's *Giraffe*. He imagined the construction of a wooden effigy of the animal with the spots on the body mounted on hinges so that they could be opened, each revealing a different spectacle similar to the dreamlike sequences of his films. The phantom object can also be an object which does not exist, but whose existence, by some subterfuge, is made to be felt and its absence regretted. For example, *The Invisible Object* (1934-5), by Giacometti, is a woman whose hands clutch at empty space, holding something which does not exist but to which the sculptor seems to have given volume, although it cannot be seen. Another example is Man Ray's *Destroyed object,* which he burnt, photographing all the stages of its destruction.

The dreamt object. According to Breton, this corresponds to 'the need, inherent in the dream, to magnify and to dramatize'. It is a humble, familiar object, which by some caprice of desire is given a sumptuous appearance. The most remarkable is Meret Oppenheim's *Cup, saucer and spoon in fur* (1936, New York, Museum of Modern Art). The *Wheelbarrow* (1937) decked out in red satin by Domínguez, and Kurt Seligmann's winged soup tureen are also dreamt objects.

143
MERET OPPENHEIM
*Cup, saucer and
spoon in fur*
1936

144
JOSEPH CORNELL
Taglioni's jewel casket 1940

145
MAN RAY
Destroyed object 1932

144

146
JOSEPH CORNELL
*Set for making
soap bubbles*
1948

147
MAN RAY
Gift 1921

148
WOLFGANG PAALEN
Leafy furniture cover 1936

145

By extension this term can also be applied to any object in which a fantastic *mise en scène* is used.

The box. This object comprises the arrangement of various elements brought together in a box. Joseph Cornell was the greatest creator of boxes; although he always wanted to stay independent of surrealism, he remained associated with it by his creative experience and by his friendships. In 1930 Cornell began to make collages, inspired by Ernst's *La Femme 100 Têtes,* and his first box, shown in 1936 in the exhibition of 'Fantastic Art, Dada and Surrealism', was followed by many others which he showed in New York in 1939. Cornell's glazed boxes, whose bottoms are lined with newspapers or astronomical prints, contain flasks, glasses, crystal cubes, balls, feathers, all set out in a striking arrangement. Some of his boxes evoke imaginary streets or hotels, others are bird cages or jewel caskets containing coloured sand on which various pieces of débris rest.

The optical machine. In 1920 Marcel Duchamp worked in New York on his first optical machine (New Haven, Yale University), whose motor turned five glass plates on which white and black lines created an optical illusion. The second optical machine, *Rotary demi-sphere,* commissioned and financed by the couturier Jacques Doucet, was

89-91

144, 146

Why a box?

made in 1925. This was a glass globe surrounded by a copper disc which bore an inscription. The *Rotoreliefs* which Duchamp showed at the Concours Lépine in 1935 were a series of six cardboard discs whose front and rear surfaces bore twelve spiral-based designs. When these discs were spun on a gramophone turntable, they gave the impression of expanding forms, like flowers coming to life and dancing.

The poem-object. Invented by André Breton, who was in fact the only person to provide valid examples, this is a kind of relief which incorporates objects in the words of a poetic declaration so as to form a homogeneous whole. For example, in *Communication relative to objective chance* (1929), a text written at the top of the panel has numbered references, each of which is represented below by an object. *149*

The mobile and mute object. When he made *The Hour of Traces* (1930), Giacometti launched the idea of a 'mobile and mute object'. A wooden ball with a notch was suspended by a violin string over a crescent. The spectator was tempted to slide the notch in the ball *105*

150
ANDRÉ BRETON
*Symbolically
functioning
object*
1931

along the edge of the crescent, but the length of the string allowed him to slide it only part of the way. So we have an irritating, disconcerting object, one element of which moves although the necessity for the movement is not clearly perceptible. Giacometti designed several 'mobile and mute objects' for *Le Surréalisme au service de la Révolution*, no. 3, and accompanied them by commentaries in which he associated them with childhood memories. Giacometti soon lost interest in this kind of object, but the genre continued to exist. It is recalled by Calder's *Mobiles*, which are likewise objects whose movement teases and intrigues the spectator.

The symbolically functioning object. This was invented by Dalí, inspired by Giacometti. Dalí has defined it as an object produced by an 'objective perversion', which expresses a repressed desire or allows a compensatory satisfaction of the libido. He made one consisting of a woman's shoe inside which was placed a glass of milk. The 'symbolic function' took the form of putting into the milk a sugar lump on which the picture of a shoe had been painted. The object was complemented by various accessories, including a box of spare sugar lumps. Dalí also made *The Aphrodisiac Jacket* (1936), to which were attached fifty glasses of peppermint, *The Atmospheric Chair*, whose seat was replaced by bars of chocolate, and one of whose feet rested on a door handle so as to make the chair unstable, and *The Hypnagogic Clock*, which consisted of twelve inkwells baked into a loaf of bread, each of them containing a quill pen of a different colour. He proposed subdivisions of symbolically functioning objects : transubstantiated objects (straw watches), objects for throwing (made to be hurled violently against a 'pedestal wall'), wrapped objects (which could not be seen), etc. 'Museums will become full of objects whose uselessness, size and cumbersomeness will make it necessary to build special towers to house them in the deserts', he said ironically. Valentine Hugo made a symbolically functioning object which included two hands - one white, and holding a dice, and the other red, placed together on a green roulette cloth, and caught in a network of white threads.

The objectively offered object. This was the term used by Gherasim Luca in his book *Le Vampire passif* (1945) - a document which illustrates the psychology of the object in the surrealist movement - to denote a kind of object made while thinking of the person for whom

it was intended. In this way the object can be used as a vehicle for sentimental or intellectual exchanges, and becomes a qualitative description which can be interpreted like a rebus.

The being-object. This too was invented by Dalí, who describes it in one of his articles in *Minotaure* ('Being-objects are strange bodies of space'), and cites as a model a statue of Marshal Ney in a fog. In

this article he shows how to give a person the various characteristics of a symbolically functioning object. Although Dalí donned masks to produce in the spectator 'the mysterious vertigo of strange bodies', the 'being-object' would have remained only a mental conception had not Dalí's ideas been carried through and corroborated by his successors. Jean Benoît created being-objects in the shape of bizarre ceremonial costumes. On 2 December 1959, for the 'Execution of the Will of the Marquis de Sade', performed in Paris specially for the surrealists, Jean Benoît donned once again the costume he had made in 1950. This consisted of a jumper, a medallion, a mask, wings, 'anti-eurythmic' shoes, and crutches, and enabled him to incarnate a 'totem of man-liberty'. Benoît explained : 'All the items of the costume interlock, fit to one another, or superimpose themselves one on another. They can both 'unfold' themselves for the wall, and form a vast panoply'. By extension, any object of human appearance, such as Bellmer's *Doll,* can be described as a 'being-object'.

This list does not include 'mathematical objects', which were dear to Man Ray and Max Ernst, who singled them out at the Institut Henri Poincaré : these are only a variety of found object. Nor does it include primitive objects, which belong to a different category of interest. I have excluded jewel objects (Meret Oppenheim and Calder produced some examples), for they can clearly be included among dreamt objects. Many non-surrealist painters have added new elements to the tradition of the object which the surrealists established. Rauschenberg's 'combine painting' and Arman's 'accumulations' prove that the most original results are still attributable to the ideas mentioned above. There would not have been such a vast range of possibilities in this field had it not been for surrealist action. We would not have passed beyond the Dada object, which was limited to one variety, and which, in order to provoke the idea of destruction, set out to be horrible, whereas the surrealist object set out to be sumptuous while using the simplest means, and to exalt the nuances of analogical thought.

Festivals of the imagination

The surrealist artists did not confine their originality to their works : it was also evident in their methods of presentation. They always took the view that one-man and group shows should be something more than a series of paintings displayed on a gallery wall; each of their shows was embellished and given individuality, at least in the catalogue, by some new poetic discovery. They could imagine nothing more boring than the usual long line of visitors to a museum walking slowly and impassively past a collection of works of art. For them, an exhibition was an opportunity to invite the public to a festival of the imaginary which would excite and confuse them, so that all taking part would be torn between amusement and anger, enthusiasm and indignation. It was a matter of creating a stimulating environment, an atmosphere which would enhance the spectator's receptiveness and arouse in him at the same time laughter, revulsion and desire, so that he was bound to approach the painting and sculpture in a state of emotional disturbance.

When he opened the Galerie Gradiva in the Rue de Seine in 1937, Breton had already hopes of making it 'a place from which it may be possible to overcome the retrospective viewpoint that people are accustomed to adopting with regard to true creativity in the arts', in other words, 'a timeless place, no matter where, so long as it is outside the world of reason'. It would also contain books, but 'the shelves to hold them must really be rays of sunlight' (the French word *rayon* means both 'shelf' and 'ray'). All the painters in his circle helped Breton to do up the building : Duchamp designed a door in the shape of a double human silhouette, while Tanguy, Paalen and others decorated the mouldings with emblems.

The 'Exposition Internationale du Surréalisme' which was held at the Galerie des Beaux-Arts in Paris in January 1938 provided an opportunity for the movement to make a collective statement which outdid anything that it had hitherto undertaken. The visitor's first surprise was in the courtyard, where he encountered Dalí's *Rainy* *155*

Taxi, a ramshackle vehicle inside which rain poured down on two dummies'a blonde covered with snails and a chauffeur with a shark's head. Next the visitor entered the Rue Surréaliste, a long corridor with street signs marking out the different sections; these were given either the names of actual streets of historical significance - the Rue de la Vieille-Lanterne, where Nerval committed suicide, the Rue Vivienne where Lautréamont lived - or names which were purely imaginary : Rue de Tous-les-Diables (All Devils' Street), Rue Faible (Weak Street), Rue de la Transfusion-du-Sang (Blood Transfusion Street), Rue Cerise (Cherry Street), etc.

At intervals along this corridor, visitors were received by shop window dummies of women - *mannequins* - each one created and clothed by one of the painters. Max Ernst's *mannequin* was dressed in black veils and trampled the figure of a man underfoot; the one

154
'Exposition
Internationale
du Surréalisme',
Galerie des
Beaux-Arts,
Paris 1938 :
Never, an object
by Domínguez;
the brazier;
the sacks of coal

designed by Paalen was covered in moss and fungi and had a bat on her head; Man Ray's wept crystal tears, and wore a headdress of pipes with glass bubbles emerging from them; Duchamp's figure wore a man's jacket with a red electric light bulb in the breast pocket in place of a folded handkerchief. The most spectacular of all was Masson's *Girl in a black gag with a pansy mouth;* she had her head in a *156* wicker cage and wore a *cache-sexe* covered with glass eyes.

Then the visitor reached the central hall, which had been designed with masterly success by Marcel Duchamp, the 'generator-arbiter' of the exhibition; Breton and Eluard were the 'organizers', with Man Ray as 'master of the lights', Paalen in charge of 'water and brushwood', and Dalí and Max Ernst as technical advisers. The hall was arranged to resemble a grotto - the floor was covered with a carpet of dead leaves; 1,200 sacks of coal hung from the ceiling. In

153

the middle stood an iron brazier, symbolizing the gathering of friends round a hearth, and in each of the four corners an enormous bed offered an invitation to dreams and love. Part of the area was cut off from the rest by a pool with water-lilies and reeds. A number of astonishing objects, such as Seligmann's *Ultra-furniture* (a stool made of four female legs) contributed to the spectacular effect.

On the opening day, after a speech made by Paul Eluard wearing a frock coat, a dancer gave a performance entitled *The Unconsummated Act,* which she interpreted first on the edge of the pool, and then in it. The atmosphere was pervaded with 'scents of Brazil': the smell of roasting coffee. It was announced that the automaton Enigmarelle would walk across the Gallery 'in false flesh and false bones', but this was only a hoax designed to arouse a sense of anticipation. A 'concise dictionary of surrealism' *(Dictionnaire abrégé du surréalisme),* which appeared at the time of the exhibition, contained some strange definitions *(lie* - a parasol on a muddy road; *Moon* - a marvellous glazier; *Rape* - a love of speed), and a curious comment on himself by Breton : 'His dearest wish was to belong to the family of the great undesirables'. It caused a great sensation, but the remarks of the press showed that the underlying reason behind this behaviour was sometimes misunderstood. It was less that the surrealists were set on originality for its own sake than that they wished to introduce a sense of adventure into the confrontation between the spectator and the work of art.

At about this period, a number of newcomers joined the ranks of the originators of surrealism. Max Ernst had met Leonora Carrington, a young upper-class Englishwoman, in London, and from 1937 until 1940 she lived with him at Saint-Martin-d'Ardèche, in a house which he decorated himself with frescoes and bas-reliefs. The black humour and strange inventiveness of her fantastic stories, such as *La Maison de la Peur* (1938), is echoed in her paintings, among them *Lord Candlestick's repast* (1938) and *What shall we do tomorrow, Aunt Amelia?* (1938). Whimsically confused memories of her own early life, such as the scenes in which she depicts herself as a white horse, lend particular charm to her painting.

Richard Oelze, a German painter who had studied at the Bauhaus in Weimar, came to Paris in 1932 and threw in his lot with the surrealists. In his paintings he managed to create unexpected effects

155
SALVADOR DALÍ
Rainy Taxi 1938

156
ANDRÉ MASSON
*Girl in a black gag
with a pansy mouth*
1938

157
KURT SELIGMANN
Ultra-furniture 1938

from day-to-day realities, as in *Expectation* (1935) and *The Dangerous Desire* (1936). He made use of 'frottage' in a very individual way, and although he was obliged to give up his work for ten years, he took up his experiments after the war along exactly the same lines.

Valentine Hugo began her career with a series of twenty-four wood engravings (1926) for an edition of *Romeo and Juliet* designed by Jean Hugo. She then attracted attention with a number of lithographic portraits, of Raymond Radiguet, Princess Bibesco, Georges Auric, and others. She took part in the surrealist movement from 1930, and was noted particularly for her illustrations, in which she created an intangible world with pastels and gouaches, as in the illustrations for *Les Chants de Maldoror* (1932-3) and Achim von Arnim's *Contes bizarres* (1933). For Paul Eluard's *Les Animaux et leurs hommes* (1937) she used drypoint. She also produced a series of allegorical paintings based on the Rimbaud legend.

Dora Maar was a painter and photographer of Yugoslav origin; she was for some time Picasso's 'muse', and then joined the surrealists from 1935 to 1937, but later turned her attention towards mysticism. Maurice Henry came into the movement in 1932 and produced humorous drawings, mainly on the theme of ghost stories, which foreshadowed the graphic experiments of his later albums *Les Métamorphoses du Vide* and *Les 32 positions de l'Androgyne*. Esteban Francés was a Spanish painter whose use of the technique of 'grattage' resulted in a pure automatism which was much admired. Gordon Onslow-Ford, an English painter who had spent some time in the Royal Navy, became interested in surrealism in 1937; his subsequent development soon led him towards abstraction.

Kurt Seligmann was born in Switzerland, where he had made a collection of documents concerning witchcraft and had written a history of magic. He exhibited at Basle and Berne, and then published a series of fifteen etchings entitled *Cardiac Protuberances* (1934). While working with the surrealists, he was particularly interested in creating objects, and many of his drawings were inspired by heraldic emblems. In some of his paintings he gives a highly mannerist interpretation of classical mythology, using automaton-like figures.

Kay Sage was American and had studied painting in Milan, where she held an exhibition of abstract works in 1926. She arrived in Paris in 1937, and concentrated on creating representations of the

158 RICHARD OELZE *Expectation* 1936

fantastic; she attracted the attention of Yves Tanguy, whom she
married, and with whom she returned to live in the United States in
1939. Her treatment of imaginary towns was particularly striking,
as in *Tomorrow is never* (1955, New York, Metropolitan Museum). *159*
 Minotaure, founded by Albert Skira, had become surrealism's *161*
official publication. The 'review with a beast's head' first appeared
in May, 1933, the month which saw the last issue of *Le Surréalisme
au service de la Révolution*. On account of its luxurious format and
its wit, *Minotaure* provided an opportunity for the beauty of surrealism
to be defined more clearly than ever before. At first, under Tériade's
editorship, it dealt with classical and modern art in an eclectic manner,
but Breton soon imposed on it his own particular line.
 Minotaure set out to stimulate interest in the unexpected in
art, the study of rare documents, anything off the beaten track. In

159　KAY SAGE *Tomorrow is never* 1955

162　their photographs, Brassaï, Man Ray, Raoul Ubac and Dora Maar
succeeded in using reality as a trap in which to capture the marvellous.
The first signs of surrealism in the past were outlined in articles
on the baroque, Géricault, Botticelli, Urs Graf, Uccello and Piero
di Cosimo. Maurice Heine, the defender and exponent of the ideas
of the Marquis de Sade, contributed items on the illustrations of the
English Gothic novels and those of the works of Sade's contemporary
Restif de la Bretonne, in which the engraver Binet depicted an
idealized 'Sylphide' type of woman; on Jean Duvet's *Apocalypses;*
and on the Tibetan gods. The 'united front of poetry and art' which
the surrealists sought to establish was given support in Paul Eluard's
article 'Physique de la poésie', a study of painters who illustrated
the works of poets. By means of his collection of postcards, 'those
treasures of nothingness', Eluard also helped to draw attention to
minor art forms which throw unexpected light on the meaning of
beauty. Breton showed a collection of mediums' drawings, while
Péret contributed poems singing the praises of armour, ruins and
automatons.

158

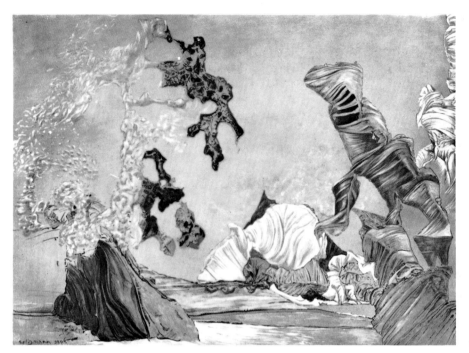

160 KURT SELIGMANN *Souvenir of America* 1943

Finally, *Minotaure* decided to demonstrate that even fashion was a subject worthy of the attention of poets and painters, and it published some extracts from *La Dernière Mode,* the women's magazine founded by Mallarmé. Crevel discussed the connection between fashion and fantasy, while Tzara, who had made his peace with Breton after the *Second Manifeste* and now supported surrealism with the same zeal with which he had launched dadaism, wrote an unusual article on the unconscious mechanisms governing a woman's choice of a hat : 'D'un certain automatisme du goût'. Dalí expounded a theory of the 'new colours of spectral sex-appeal'.

In the spring of 1938, before leaving for a trip to Mexico, Breton addressed the readers of his review as follows : 'Follow *Minotaure,* and in addition : beware of imitations, rubbish from the second-hand market, hot-air balloons.'

In Mexico he met Leon Trotsky and the painter Diego Rivera, who had designed the impressive frescoes on the Palacio Nacional and many other public buildings. With them he wrote the manifesto

'For an independent revolutionary art' *(Pour un art révolutionnaire indépendant),* which set out in eloquent terms all the ideas he had fought for over the years. In the face of the current threats of war and oppression, Breton demanded an 'artistic opposition' to be manned by all the available artists in the world. But he emphasized that such an opposition would be effective only if the powers of imagination were allowed free rein : 'To those who would persuade us, now or in the future, that art should submit to a discipline which we consider totally incompatible with its methods, we reply with an unconditional refusal, and our determination to adhere to the principle : *all freedom in art.'*

With this in mind, Breton created, on his return to Paris in July, 1938, the International Federation of Independent Revolutionary Art (F.I.A.R.I.), whose short-lived publication *Clé* had as its editorial secretary Maurice Nadeau, who was later to write a *Histoire du surréalisme.*

The Second World War brought this spiritual quest to a temporary halt, and gave the surrealists an opportunity to define clearly the role of art in such circumstances. At the end of 1940 they gathered at the Château Air-Bel, near Marseilles, under the auspices of the American Committee for Aid to Intellectuals; there, despite the uncertainty and disturbance they all felt, they set about inventing a new set of playing-cards. Breton had stated : 'Historians of the playing-card all agree that throughout the ages the changes it has undergone have always been at times of great military defeats'. They therefore evolved a system in which the four suits were replaced by symbols representing their chief preoccupations : Love (Flame), Dream (Black Star), Revolution (Wheel and blood), and Knowledge (Keyhole). The cards consisted of Ace, Genius, Siren, Magus, Ten, etc., and portrayed some of the intellectual heroes of the surrealists : Hegel, Sade, Baudelaire, Freud, Novalis, Lautréamont, Hélène Smith (the medium), etc. These cards were made by Frédéric Delanglade from designs by Jacqueline Lamba, André Breton, André Masson, Victor Brauner, Wifredo Lam, Jacques Hérold and Oscar Domínguez. They illustrate the desire constantly proclaimed by the surrealists to preserve, in the face of everything, even in the most tragic circumstances, the delicate flower of inspiration which is the chief adornment of life.

163

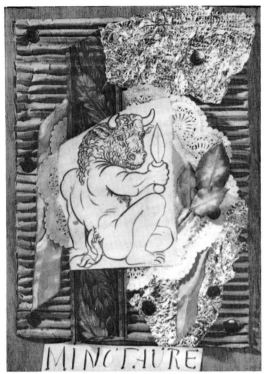

161
PABLO PICASSO
Composition for the cover
of *Minotaure* 1933

162
BRASSAÏ
Photograph of graffiti 1933

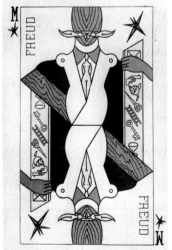

163
OSCAR DOMÍNGUEZ
Freud, Magus of Dream (knave of spades)
1940

In the United States

Surrealism burst on the United States between 1941 and 1946. In America the surrealists redefined their course of action and established a climate of opinion which had an influence on a number of native American artists. The American public had in fact an opportunity of becoming aware of the surrealist experience before this, when a touring exhibition - 'Fantastic Art, Dada, Surrealism' - was organized in 1936 by the New York Museum of Modern Art. This eclectic collection of almost seven hundred works went beyond its chosen theme by including work by many abstract or constructivist painters, such as Malevich and Moholy-Nagy; the show was essentially an evocation of avant-garde art in general. But, at all events, it was the first exhibition in which any attempt was made to form a section devoted to the 'Forerunners of Surrealism'. This was a rather random selection ranging from the *Grotesques* by Wenzel Jamnitzer (1563-1618) to the fantasies by Grandville (1803-47), from architectural drawings by Oronce Finé (1494-1555) to costumes by Larmessin (who died in 1694), and which included allegories, rebuses, and paintings of anamorphoses.

Despite the merits of the range of 'Fantastic Art, Dada, Surrealism', which gave an important place to Picasso, Chirico, Duchamp and other major pioneers, it could be no substitute for an exhibition arranged by the surrealists themselves. Salvador Dalí had indeed come to the United States as a surrealist ambassador, but his only influence had been on publicity. He was asked to arrange one show-window for a store, and in 1939 at the New York World's Fair he was allowed to stage only a part of *The Dream of Venus,* an underwater ballet performed in an aquarium with girl swimmers incarnating symbols of pre-natal life. So it was only the presence in America during the war of artists in exile, among them Max Ernst, André Masson, Matta, Marcel Duchamp, Kurt Seligmann, Leonora Carrington and Yves Tanguy, which allowed surrealist art to establish a firm foothold.

André Breton arrived in New York in August 1941, and two months later the magazine *View,* run by the poet Charles Henry Ford, brought out a special number on surrealism. This was followed by several instalments which were evidence of the movement's newsworthiness. The surrealist review *VVV* was founded in 1942. The three Vs of the title represented the triple Victory, 'over everything which stands in the way of the emancipation of the spirit, for which the first precondition is the liberation of man', the triple View, which results from a synthesis of the view of the inner world with the view of the outer world to create a 'total view' which should interpret all the reactions of the eternal on the actual, of the psychic on the physical, and take into account the 'myth' which is being formed under the veil of events. The chief editor of *VVV* was David Hare, who made strange photographs using a technique which consisted of warming up negatives after development so that the gelatine melted. When he later became a sculptor, Hare moved from the fantastic to abstraction.

The New York Surrealist Exhibition, in October and November 1942, held under the sponsorship of the Coordinating Council of French Relief Societies, was designed by Marcel Duchamp. Throughout the exhibition halls he stretched a network of white cord covering the works on show, which could only be glimpsed through the meshes. This also formed a kind of labyrinth which constantly obliged the visitor to stop and retrace his steps, passing work which he had already seen.

The front cover of the catalogue, *First Papers of Surrealism,* showed a wall with five bullet holes, and the back a piece of gruyère cheese. Breton wrote in the catalogue : 'Today more than ever to speak abstractly in the name of freedom or to praise it in empty terms is to serve it ill. To light the world, freedom must become flesh and to this end must always be reflected and recreated in the *word.*' Breton outlined the repertory of myths which he believed to be significant, and illustrated them by associating each of them with a surrealist painter : the Philosopher's Stone with Matta : the Artificial Man with Seligmann; the Soul-Sister with Leonora Carrington; The Regicide with Masson, etc. The difficulty of getting hold of photographs of some of the exhibitors inspired the idea of 'compensation portraits', in which the names of painters were placed under

anonymous photographs chosen for a real or imagined likeness to their nominal subjects.

164, 169

The activity of the surrealists brought to light the work of some painters who would probably otherwise never have been discovered. The most outstanding of these was Morris Hirshfield, a naive painter who had started life as a shoemaker in New York. Then in 1902 he had established a shoe factory, the E.Z. Walk Manufacturing Company, which eventually had almost three hundred employees. Ill health forced Hirshfield to retire from business in 1917, and in 1937, at the age of 65, he took up painting; from then on until his death in 1946 he painted naked women surrounded by flowers or animals. Less often, he did landscapes from picture postcards. Hirshfield was adopted by the surrealists because of the extreme ingenuousness of his inspiration, and the luxuriant imagination with which he embroidered exterior reality.

Max Ernst, who had arrived in New York in July 1941, now began to make paintings by using the 'decalcomania' technique; then he invented 'oscillation', which consisted of swinging a pierced can of liquid paint on the end of a string over a canvas laid on the ground, and interpreting the trace of the paint marks so obtained. He showed this process to Jackson Pollock, who turned it into the 'drip' technique.

In 1942 Ernst met Dorothea Tanning, whose artistic personality was to blossom as a result of her contact with him. Dorothea Tanning had come to New York from Chicago in 1935, set on making a career as a painter. She had been deeply moved by an exegesis of Picasso's *Guernica* which she had heard Arshile Gorky deliver in a New York gallery. The influence of Max Ernst hastened her development towards surrealism. She held her first one-man show in New York in 1944, and in 1945 designed the sets and costumes for *Night Shadow*, a ballet by Balanchine to music by Rieti. Ernst and Dorothea Tanning were married in 1946, and went off to live in Sedona, a small township in Arizona. Initially her painting showed a universe of little girls in revolt against a puritanical education, a prey to nocturnal fears, or unleashed in wild games. Her memories of her own childhood with her two sisters in Illinois helped her to give these scenes a feeling of authenticity. Her perverse little heroines tear drapes off a wall, while the inanimate body of a companion

164
MORRIS HIRSHFIELD
Nude with cupids
1944

165
DOROTHEA TANNING
Les Petites Annonces faites à Marie
1951

lies nearby *(Children's Games,* 1942); they watch a giant sunflower creeping towards them in a corridor *(Eine Kleine Nachtmusik,* 1946, London, Roland Penrose collection); and yet again they form themselves into a human pyramid by climbing on one another's shoulders right up to the ceiling *(Palaestra,* 1947, New York, William N. Copley collection). Always they move in an atmosphere of anguish and pleasure. Max Ernst acquired a bitch, Katchina, who soon became the main character in Dorothea Tanning's paintings. She made it into the Beast which has become divine, and who embraces Beauty for a symbolic Waltz *(The Blue Waltz,* 1954). The surreal power of animals is exploited also in the perverse 'Annunciation' of 1951.

165

It was only on his arrival in the United States that the painting of Matta came to its full brilliance, and burst like a storm into a world which he constantly thereafter explored. Matta had first joined the surrealists in 1937, when he arrived in Paris from his native Chile to study architecture with Le Corbusier. He showed some work to Breton at the Galerie Gradiva; Breton bought two drawings from him and invited him to take part in illustrating *Les Chants de Maldoror,* published by Editions G.L.M. In 1938 Matta painted six big canvases, *Psychological Morphologies,* which were the point of departure for his whole development. These spaces choked with matter in fusion show the interior of the conscious mind as a vitreous mass, full of glaucous glows and sparkling brilliance. As a result of his stay in the United States from 1939, with the added advantage of some travelling, particularly a visit to Mexico in 1941, Matta was able to broaden his experience, and to bring it up to the scale of the civilization which he found before his eyes. He unfolded huge galactic panoramas, and studied the life of the psyche as if he were prospecting the surface of a planet, in *The Earth is a Man* (1941, New York, William Rubin collection), *The Disasters of Mysticism* (1942), *Elinonde* (1943), *The Vertigo of Eros* (1944, New York, Museum of Modern Art), *Space and the I* (1944). His paintings became screens on which he projected his mental film. Monstrous, tentacled, clawed figures, like giant anthropomorphic insects soon moved into his crackling universes. In *The Players of Heart* (1945), *The Pilgrim of Doubt* (1946) and *To be with* (1946), a mythical, cruel and anxiety-ridden people engages in panic brawls and scuffles.

172

In New York Matta became a disciple of Marcel Duchamp, whose

imperturbability was the opposite of Matta's effervescence. Like Duchamp, Matta formed an intellectual attitude based on word-plays. As he believed that the reconstruction or disintegration of the world was connected with a reconstruction or disintegration of language, Matta invented a vocabulary of neologisms to stimulate his pictorial inspiration. He claimed to be engaged in *'Conscienture'* (the painting of the consciousness), and said, in his own idiom : 'I am going to make a tour of the I, from the South to the Rmis'. To show that some of his pictures were explorations of the depths of the ego he entitled them *Je m'honte* and *Je m'arche* (punning titles, turning *je monte*, 'I ascend', or *je marche*, 'I walk', into reflexive verbs). There is a temptation to see his pictures in terms of science fiction, with extra-terrestrial battles and galactic flights, but this is too simple an inter-

pretation. There was a period in which Matta launched into fantastic epic; in his Paris exhibition in May 1949 he showed a mythology which included *Ermala the Scepticide, Marzana the Llium of envy, the Oïgu of peace, Atyarth insolent, Icrogy fecundated, Rghuin monstrous triumphs,* episodes of a chronicle worthy of the novels of H.P. Lovecraft.

Matta had another aim : the destruction of what Duchamp had called 'retinal painting'. At this time, Matta said to me, in a private conversation, 'I want to make pictures which leap to the eye'. And with his hands raised like a tiger's claws, he made as if to seize an invisible spectator. The figures in his paintings are not necessarily inhabitants of a parallel universe; they are men, or rather the distorted reflections of men in the mirror of a disturbed, frightened or aggressive unconscious mind. Matta is a cosmic painter, who tries to interpret the human condition face to face with infinity, and not as it nestles in the bosom of day to day reality.

In 1942 and 1944, Wifredo Lam had two exhibitions at Pierre Matisse's gallery in New York, exhibitions which definitively established his personality. Lam, a Cuban, had worked for a long time in Spain, where he had painted tragic *Mother with Child* groups. In

167 ROBERTO MATTA *Venus' walk* 1966

168 ROBERTO MATTA *The Unthinkable* 1957

169 MORRIS HIRSHFIELD *The Lion*

Paris in 1938, Picasso gave his pictures a warm, enthusiastic reception. Lam can indeed be regarded as the only true continuer of Picasso's work; he was not an imitator, for he was able to re-create the Spanish master's freedom of form for his own use. Lam left France in 1941, on board the ship which was taking Breton to Martinique, and returned to Cuba. The mastery of technique which he had acquired enabled him to confront the world of nature which he found there without any fear that his hand would betray him. Lam painted totemic landscapes, where amid the luxuriant bush, trees uproot themselves, plants come to life, lianas stretch or contract, and divinities of light or shade come and go.

203
166 In *Malembo* (1943, New York, Pierre Matisse collection), *The Jungle* (1943, New York, Museum of Modern Art), *Song of the Osmoses* (1944, Indiana, J. Cantor collection), and *The Watching Spirit* (1946), he formed the obsessive style to which he was thereafter to remain
173 faithful. His art is a visual incantation; he acclaimed the jungle as if it were a person, giving plants the appearance of animals, and animals a lapidary form. In his painting, plants have breasts like women, fruit is a round head with horns, bamboo has feet which look like hands, the insect blossoms, the wild beast has roots, and man is hewn from wood or from the rock of the earth which gave him birth. During a stay in Haiti, Lam studied the Voodoo cult, drew inspiration from the *vevers,* the symbolic patterns drawn in

170
ALEXANDER CALDER
Profile of a man
c. 1928-30

flour around the central pillar where the rites take place, and began
to make allusions to deities such as Ogoun Ferraille, the god of war,
or Papa Legba, master of the crossroads. Yet there is no exoticism
in Lam, no geographical limitation. Although he was a passionate
observer of the jungle and the rituals which he evokes in his paintings,
they do not remain in their aboriginal form. The primitive earth as
a whole, the primeval world, with its virgin forests, arises in his
paintings like a challenge to the civilization of the cities.

The retrospective show of the work of Alexander Calder at the
Museum of Modern Art in New York in 1943 established his role and
his importance in modern art. Since 1933 Calder had lived on a farm
at Roxbury in Connecticut. In 1938, he built, next door to the house,
a huge studio where he tamed metal into geometric shapes,
doing it all by kindness. Like Arp, Calder belongs to abstract art as
much as to surrealism, and he is attached by bonds of friendship to

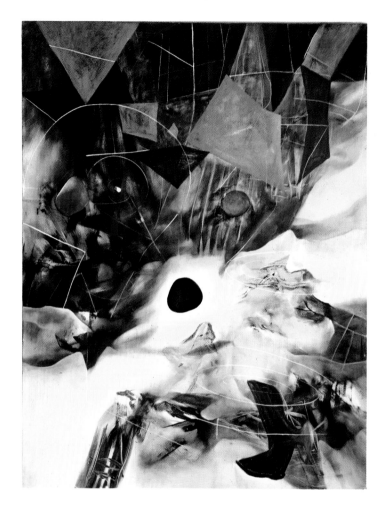

both schools. His wit, which always retained a child-like freshness, his humour, and his longing to give life and movement to the inert and non-figurative, assured him a place of honour among the surrealists. It is easier to understand what Calder was about if one knows that as a young man, after he had got his engineering diploma, he spent every evening for a year at Barnum's circus, making sketches of the show. He was enchanted by the animals, and the quality of his observation of them is proved by his collection of drawings *Animal Sketching* (1926) and his illustrations for Aesop's Fables (1931). Calder conceived the idea of making a circus in miniature from pieces of wire, corks and scraps of wood. His dual talents as engineer

and artist enabled him to create a miniature world of acrobats, jugglers and tightrope-walkers, who ran, jumped, and performed tricks. In Paris in 1926-7, he gave highly successful private shows of his circus to audiences of writers and artists. Subsequently Calder moved on to geometrical sculptures - the 'stabiles' - made of discs and spheres painted black, white, blue and red in the spirit of neo-plasticism. Next he did animated sculpture; in his 'mobiles', which in their initial form were put into motion by hand or by a motor, several elements are set moving in a burlesque way, almost like an animated cartoon. His first wind mobile dates from 1932-3. From this time on, contraptions with metal leaves, trembling and spinning *174* at the slightest breath of air, flowed from him like joyful songs. 'My dear old Sandy, the tough guy with the soul of a nightingale', was Miró's affectionate description of him. He was always to be a man of the circus, but on the scale of the Universe, reproducing

173 WIFREDO LAM *Jungle* 1944

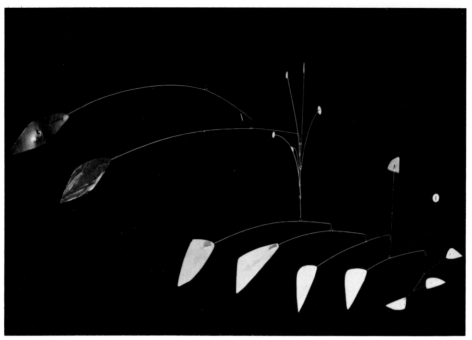

174 ALEXANDER CALDER *One black leaf, one blue, three red, five yellow, five white discs and one yellow* 1963

abstract circus turns with lyrical toys. Calder returned to the stabiles in 1942 with *Morning Star,* and gave them the lightness of his mobiles. *171* Then he did *Constellations,* stabiles fixed to the wall or ceiling. These were arrangements of elements of different materials, colour and shape. Thus, during this period in his Roxbury studio, Calder established all the factors in the evolution which he was to pursue after the war in France, in his studio in Touraine.

The painter who profited most from the presence of the surrealists in the United States was Arshile Gorky. When he came into contact with them, all his genius, which had already passed through a number of successive phases, was unleashed in a lyrical explosion. Gorky was born by Lake Van in Turkish Armenia, and he had spent his childhood in a landscape of mountain and forest. At the outbreak of war in 1914 his mother died, and the family lost its wealth. He went to Georgia and became a student at the Polytechnic Institute in Tiflis. In 1920 he emigrated to America, and completed his education by his own efforts. He spent long hours in museums and

174

galleries, and attended evening classes in various schools. In 1926 he became a teacher in New York, mainly at the Grand Central School of Art.

After a figurative period, represented by *The Artist and his Mother* (1926), he was gripped by a passion for cubism, and in 1931 he said: 'The twentieth century - what intensity, what activity, what restless nervous energy! Has there in six centuries been better art than Cubism? No. Centuries will go past - artists of gigantic stature will draw positive elements from Cubism.' Later Gorky went through an abstract period under the influence of Kandinsky. He carried out huge frescoes for airports in New York and New Jersey, and for the Aviation Pavilion at the New York Exhibition in 1939.

When he had assimilated the experiences which modern art had to offer, Gorky received from Masson, from Matta and from Breton, whom he worshipped, the stimulus he needed to get him really launched into flight. In 1943 he came back into contact with nature. He worked in the open air in the Virginia countryside, and did a

175 ARSHILE GORKY *The Liver is the Cock's Comb* 1944

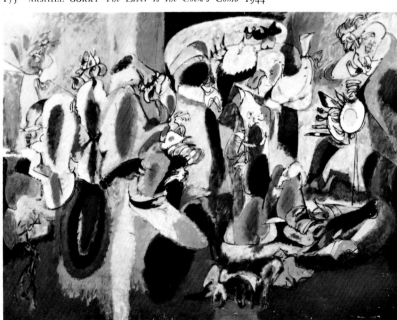

number of drawings of leaves and flowers, but in a transfigured form.

175 In *The Liver is the Cock's Comb* (1944, Buffalo, Albright-Knox Art Gallery), Gorky, with sweeping gestures which seemed to embrace the universe, launched into the feverish monologue which he was to continue from painting to painting until his death by suicide in 1948. Gorky was able to adapt an abstract language to the most subtle sensations, to the most confused psychic states, as in *176* *Agony* (1947, New York, Museum of Modern Art). The interplay of lines and signs, punctuated by brilliant splashes of colour, on a carefully worked background, expresses the outpouring of the unconscious, the unfathomable mystery of nature. Gorky's freedom of expression, which is close to automatism, was never mere improvisation; he never reached the definitive version of a painting until it had passed through a number of successive preliminary versions. He was to become the master of the New York school, to which he transmitted surrealism in a personal translation which had retained the essence of the movement.

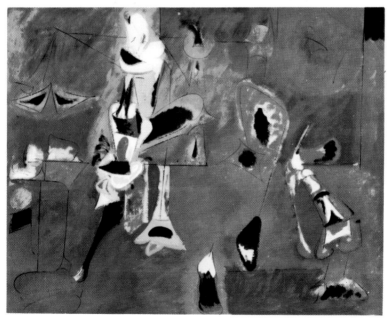

176
ARSHILE GORKY
Agony
1947

Surrealist architecture

Surrealist architecture includes : designs for towns or for houses which the painters and poets of the movement set out in their works : the work of both classical and contemporary architects whom they admired; and finally various constructions from the designs of decorators and builders who were connected with the surrealist movement. It is an irrational architecture which does not fall in with any ideas of comfort; it is figurative, even metaphorical. Its aim is to make habitable monumental pieces of sculpture, preferably representing creatures or objects.

The surrealists were always interested in architecture; but, before making any practical proposals for this form of art, they used it mainly to achieve an effect of exile, of disorientation, in their painting and poetry. Many of their paintings are based on fantastic architectural landscapes, as detailed as the engravings of Piranesi. In *La Peinture au défi* (1930), Aragon remarked that 'a juxtaposition of the early paintings of Chirico would result in the creation of a town whose plan could be drawn'. André Masson and Max Ernst both made drawings of imaginary cities, and in the canvases of Dalí, Delvaux and Kay Sage there are all manner of unexpected buildings. In his series of *Dwellings* (1966), Georges Malkine evokes imaginary houses conceived as particularly suitable for various famous people.

The poetic nature of this kind of speculation is established by the survey 'Sur certaines possibilités d'embellissement irrationel d'une ville', published in 1933 in the last issue of *Le Surréalisme au service de la Révolution*. This set out to discover how the best-known monuments in Paris would have to be altered in order to turn it into a surrealist city. For example, André Breton said that the Place Vendôme column should 'be replaced by a factory chimney with a naked woman climbing up it', and that the Egyptian Obelisk should 'be moved to the entrance of the Abattoirs and held by an enormous gloved female hand'. Tristan Tzara suggested that the Panthéon 'should be cut in half vertically, and the two halves set fifty centimetres apart'.

Paul Eluard, commenting on the replies to this survey, predicted that 'one day houses will be turned inside out like gloves', and he envisaged the arbitrary decoration of different sites. 'The most conventional statues would be a marvellous embellishment of the countryside. A few marble female nudes would create a fine effect in a ploughed field. Animals in streams and groups of solemn characters in black ties in rivers would make charming reefs to contrast with the monotony of the water. Dancing figures in stone would be a delightful adornment to the mountainsides. And, since mutilation is indispensable, the ground would be strewn with heads, the trees with hands, and the stubble with feet.'

Thinking along the same lines, André Pieyre de Mandiargues wrote a collection of poems, *Incongruités monumentales* (1948), describing the various constructions which he dreamt of creating : a fountain for a school playground in the shape of a gigantic bronze revolver, a lighthouse shaped like a woman's leg with a pink shoe for the base. In one chapter of *Belvédère* (1958), Mandiargues also describes the monsters of Bomarzo, the product of a whim of an Italian Renaissance nobleman, the Duke Orsini, who ordered the transformation of the landscape he could see from the windows of

177 NICOLAS LEDOUX *Perspective engraving of the farm guards' house at Maupertuis*

his house at Orto in the province of Viterbo. The basalt rocks all down a hillside were carved into giant figures forming a sacred grove; the confusion thus created between art and nature was the result of an eminently surrealist intention.

The classical architect whom the surrealists saw as one of their most important precursors was Claude-Nicolas Ledoux, a magni- *177, 178* ficent visionary. His utopian theories were tempered by many positive and progressive ideas, which were far ahead of his time, particularly on the sanitation of towns. Ledoux started his career in the reign of Louis XV; he designed a pavilion at Louvenciennes for Madame Du Barry in 1771, and was then appointed inspector of salt-works for the province of Franche-Comté, and architect to the king. In 1775 he began the construction of the salt-works at Chaux, despite the criticisms which were levelled at his ambitious plans. Ledoux considered that luxury was by no means the prerogative of the nobility, but should be applied as much to a craftsman's workshop or to a barn as to a château. The sumptuous buildings for the salt-works were laid out in a circle; the houses for the clerical workers were palatial, and even the forges had Doric columns. He was obliged to give up the project in 1779, but he kept on producing audacious plans : his 'aqueduct-house' and his bridge over the river Loue, with piers in the forms of triremes rowed by oarsmen, were both outshone by his plans for a 'social city'. In this city all the public buildings, such as the Pacifère (or Temple of Conciliation), the Oïkema (or Temple dedicated to Love), the Panarétéon (or School of Morals), houses and workshops, stock exchange, public

baths and market, were reflections of a theory of architecture based

177 on pure form - pyramid, cube, cylinder, sphere - with displays of fountains and flames, urns and statues erected for the sake of the shadows they would cast, or for their effect on spatial perspective. Other contemporary architects who were dismissed as 'megalomaniacs' - Etienne-Louis Boullée, with his cenotaphs, his city gates, and his library, and Jean-Jacques Lequeu, with his spherical Temple of the Earth - proposed a similar masterful use of symbolism and of the sphere in town planning.

Surrealism brought about a revaluation of the work of the Art Nouveau architects, who had been either forgotten or discredited by the time Dalí wrote his celebrated article on the 'terrifying and edible beauty of Art Nouveau architecture', 'De la beauté terrifiante et comestible de l'architecture modern' style'. Dalí was seized with

179 enthusiasm for Hector Guimard's decorations on the Paris Métro station entrances, and had them photographed by Brassaï to support his views. Above all, he revealed to his friends the originality of Antoni Gaudí, the greatest of the proto-surrealist architects after Ledoux. Gaudí worked in Barcelona; he wished to free himself of the conventions of previous styles and to draw directly on nature

179
HECTOR GUIMARD
*Decoration of
a Métro entrance*
c. 1900

180 ANTONI GAUDÍ *Casa Milá* 1905-10

- animals and plants - for his decorative forms. It was not enough
for him to reproduce the appearance of natural forms; he studied their
internal structure and the laws governing their organic development
in order to improve his representation of them. In 1883 he started
the church of La Sagrada Familia in Barcelona; abandoning the
flying buttresses of the Gothic Revival style, he substituted a new
method of supporting the diagonal thrust: an inclined pillar. The
Parque Güell (1900-14), on a hillside near Barcelona, is an amazing *182*
garden laid out in terraces winding along for several miles, with
spiral-shaped seats decorated with ceramics, walls following the
undulations of the hillside, and viaducts supported by trees carved
from stone. Not only did Gaudí make masterly use of polychromy,
but he also used architectural collage by incorporating real objects,
such as bottles, cups or dolls, in some of his surfaces. The Casa *180, 181*
Milá (1905-10), also in Barcelona, is a piece of genuine sculpture,
both in its façade and in the details of the roof, chimneys and
staircase exits, which are not visible from the street.

181
ANTONI GAUDÍ
Chimney of Casa Milá 1905-10

182
ANTONI GAUDÍ
A pillar plant-holder 1900-14

Finally, it is in the realm of 'naive' architecture that the spirit of surrealism is most truly found. The marvellous emerges in the raw state in buildings made by men with no knowledge of construction, but who relied on the force of inspiration to make concrete the dwellings of their dreams. The greatest of these naive architects was Ferdinand Cheval, a postman from Hauterives, in the department of Drôme, who had always dreamt of an imaginary castle which he thought could never be built. But one day in 1879, when he was forty-three, he was making his round in the country when he stumbled upon a stone whose shape entranced him; he then found others, just as beautiful, in the same place, and decided to make a start on his ideal palace. Each day after delivering the mail he would collect the stones in a wheelbarrow and work tirelessly into the night, undeterred by the mockery of the neighbours. In

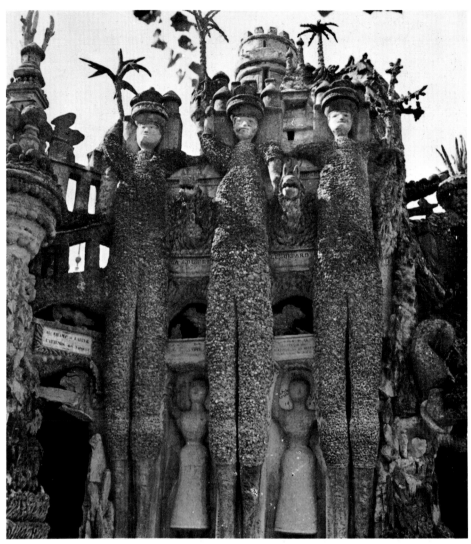

183 FERDINAND CHEVAL *Palais Idéal* 1879-1912 (detail : the Tower of Barbary)

1912, after thirty-three years of daily labour, this extraordinary
construction, the Palais Idéal, was finished. In its construction
Cheval had used a mixture of many styles : a mosque topped with
minarets, a Hindu temple, a Swiss chalet, the Maison Carrée in
Algiers, and a medieval castle. The highest part is thirty feet high,
and the main façades, twenty-eight yards long, have niches

183, 184

containing sculptures. In this profusion of shapes - there is even a 'Tower of Barbary' supported by three giants - Cheval had made use of the most unusual types of stone, each one in its natural form and selected with loving care. The Palais Idéal is the supreme example of what the unsophisticated imagination can achieve when it is stimulated by a desire for greatness.

Another naive architect was Simon Rodilla, a Neapolitan tiler who emigrated to the United States and built the Watts Towers (1921-51) near Los Angeles. These are huge metal scaffold cons-tructions covered with concrete and encrusted with pieces of broken glass and china. Gilles Ehrmann's book *Les Inspirés et leurs demeures* (1962), with a preface by André Breton, contains some other examples of 'naive' architecture : the shell-covered Maison de la Sirène, built by a ferryman in the Vendée, another house built and clad with mosaic by a cemetery worker, and the garden in which a market gardener in Brittany grew plants and flowers all over figures of horsemen and birds.

184
FERDINAND CHEVAL
Palais Idéal
1879-1912
(detail of
Cheval's tomb)

185 ROBERTO MATTA *Minimal House of the Awakened Man* 1962

Some of the surrealist painters decided to put their ideas about architecture into practice. In 1933 Marcel Duchamp invented a door for his apartment in Paris which, in defiance of the French proverb 'a door must be either open or shut', could in fact be both open and shut at the same time. When it was opened to enter the bedroom, the bathroom was closed, and when the bathroom was open, the studio was closed. Salvador Dalí, whose conception of architecture was that it should produce 'true realizations of solidified desires', produced a design for an interior representing the face of the actress Mae West (1936, Art Institute of Chicago); the pink divan shaped *98* like a mouth was in fact made from this design by Jean-Michel Frank for the Baron de l'Epée. In 1938 *Minotaure* featured a plan by Matta for an apartment intended to create psychological effects : the staircase was without banisters (so that the user would learn to overcome vertigo), the walls were as limp as damp sheets, the

furniture was movable and could be formed into different shapes, and spatial effects were created by the placing of mirrors. Later on, Matta made a study of various plans for dwellings, and following on this he designed his 'minimal house for the awakened man' in 1962. This is a suspended construction in copper and aluminium, consisting of monastic cells linked by bridges, gangways and corridors. It has neither doors nor windows : some of the walls are transparent and slide open.

Many architects have made plans for a dream-architecture. In his book *Alpine Architektur* (1919), which contains thirty drawings, Bruno Taut showed how it would be possible to decorate mountains; he envisaged a 'flower valley', with its sloping sides covered with multi-coloured glazed frames which would sparkle in the light. Hermann Finsterlein, in his proposals for the 'Casa Nova' (1919-20), suggested a 'house-sculpture' with a floor in relief and walls which could be inflated to form wardrobes; his 'House of Contemplation' (1920) was to be a marble pyramid topped with a sphere of pink majolica, with windows made of smoked quartz. In his plans for an imaginary country town, 'Broadacre City', Frank Lloyd Wright gave full rein to the forward-looking vision of his poetic genius. Paolo Soleri, one of Wright's disciples, reconciled utopia and reality in his plans for 'Mesa City' and his models of 'habitable bridges'.

The most surrealist of all was Bruce Goff, an architect in Bartlesville, Okla. He was a theoretician of 'absolute architecture', which does not accept utility as its aim, and he created buildings whose extravagance is supported by great technical skill. His masterpiece was the Spiral House at Norman, Okla. (1951-7), which consists of a stone wall which winds in a logarithmic spiral around a central pillar. The main rooms are circular wooden volumes, while the first floor is linked directly with the garden by means of a bridge.

All these, however, were 'surrealists despite themselves', while the great architect Frederick Kiesler was an open adherent of the surrealist movement. He had already formulated his basic theories before he met André Breton in New York, where he illustrated Breton's *Ode à Fourier,* and took part in the production of *VVV,* but his contacts with the movement led him to expand his work. Kiesler was Austrian by birth, and had studied in Vienna, where he had been a friend of Adolf Loos; he was devoted to the theatre,

186 FREDERICK KIESLER *Endless House* 1933-1960

and in 1922 he produced Eugene O'Neill's *The Emperor Jones* with moving scenery. For a festival of drama and music in Vienna in 1924 he projected a double shell building of moulded glass, inside which hotels, car parks and gardens were laid out among a system of ramps which rose to the roof. Instead of lifts there were three platforms which ascended and descended, coming together at each level. In 1926 he went to New York, where in 1927-8 he built a cinema with four screens. The picture could be transferred from one to the other, or even projected on to the ceiling.

In 1933 he finally elaborated his 'Endless House', a project *186* which he was never to be able to bring to fruition. Kiesler wished to create a 'continuous architecture' : he was opposed to the rectangular room, to the box-shaped house, to the use of beams and filling materials. The 'Endless House' is a concrete shell, with walls and ceilings incurving to give a perfectly enwrapping interior. The inside of the house, which appears to be made up of linked cave-like structures, was meticulously worked out. The windows are all of different shapes and sizes, and three kinds of lighting are available.

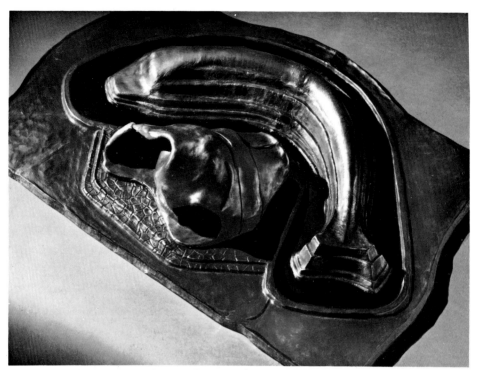

187 FREDERICK KIESLER *Grotto of Meditation* 1966

The furniture is in the form of sculptures integrated with the architecture. There is no bathroom, as each bed has a bath associated with it in the bedroom. The total effect is intended to produce 'inner peace'. Arp, who was a great friend of Kiesler's, wrote : 'In this egg, in these egg-shaped spheroid constructions, human beings will now be able to shelter and live as in the womb of their mother.'

Despite his fame, very few of Kiesler's plans were executed. In 1942 he built the Art of This Century Gallery in New York for Peggy Guggenheim. His first idea was to do away with frames for the paintings, and to replace them by the walls themselves, which he curved and lengthened with wooden supports. In his design for this gallery Kiesler defined 'the eighteen functions of the chair'. He made seats which would stand any way up, and which could also be used as tables, benches and trestles. At this time he came to uphold a style which he called 'correalism', to show that it reconciled different aspects of reality, such as the elements, life and space. He

even drew up a *Manifesto of Correalism,* in which, in opposition to Le Corbusier and the Bauhaus, he denies being utopian : 'Enough bookish architecture has been invented. We don't want to bring out the latest, and the even later edition. We want buildings which are as flexible as the functions of living.'

Starting from the premise that the content of architecture is more important than its structure, he advocated 'houses which are not just walls with or without adornments, and whose foundations do not rest on a barrack-like mentality'. Instead of using a skeleton framework in a building, he substituted 'continuous tension', and made use of veils and membranes. He was fond of using the word 'galaxy' to show that his architecture consisted of a constellation of differing and contrasting spatial unities. There are examples of 'galaxies' in his plans for a 'universal theatre', which he worked on intermittently throughout his career.

In 1947 he superintended the staging of the 'Exposition Internationale du Surréalisme' in Paris, and himself designed the Hall of Superstitions. He took this as an unexpected opportunity to make known his conception of the synthesis of the arts. Unlike Gropius or Villanueva, for whom the synthesis of the arts is subordinated to architectural necessity, Kiesler insisted that it should be used in the service of poetry. This exhibition, whose ideological theme was outlined by Breton, was thus an attempt to include poetry in the synthesis of the arts, and Kiesler stressed the importance of this attempt : 'This collective work, created not by artists drawn from one single field, but by the Architect-Painter-Sculptor group, plus the Poet (the author of the Theme), represents - even if it fails - the most stimulating prospect for development in our plastic arts'. The design of the exhibition made manifest Kiesler's genius, and it also gave a new direction to his development. In 1953, when I spent a holiday with him at Golfe-Juan, he showed me sketches of a number of audacious projects, including a 'horizontal skyscraper'. From the ideas which he set out in *Le Surréalisme en* 1947, a catalogue published by the Galerie Maeght, right up to his last project - a Grotto of Medi- *187* tation at New Harmony, Ind. - Kiesler has never ceased to oppose functional architecture and to preach the principles of a 'magical architecture', which, making use of the techniques and materials of our time, is the most convincing evidence for surrealism in architecture.

The post-war period

The 'Exposition Internationale du Surréalisme' which was held at the Galerie Maeght in Paris in July 1947, under the direction of André Breton and Marcel Duchamp, was a 'spiritual parade', planned to the last detail to establish the directions that members of the group were to follow on the threshold of the post-war period, and to take stock of everything that surrealism had acquired since its beginnings. The exhibition brought out into the open a need which until then had remained unvoiced : the need to create a collective myth.

The layout of the exhibition was conceived as a series of ritual tests, reduced to a minimum, through which the visitor had to pass before he could look at the works on show. Progress from one room to another was intended to help in the gradual transformation of the neophyte into an initiate. So the visitor gained access to the upper rooms by climbing a red staircase made up of twenty-one steps in the form of spines of books, whose titles - the *Sermons* of Master Eckhardt, Frazer's *The Golden Bough,* Rousseau's *Les Rêveries du promeneur solitaire,* Swedenborg's *Memorabilia* etc. - indicated the degrees of ideal Knowledge. This staircase was swept from above by the light of a small revolving lighthouse, and above it, Calder's mobiles trembled from the ceiling. Next the visitor passed into the Hall of Superstitions, designed by Frederick Kiesler. This hall was a synthesis of major superstitions, which the spectator was forced to overcome before continuing his visit. Yellow and blue light created a disturbed and disturbing atmosphere, and around the *Black Lake* painted on the floor by Max Ernst were ranged shapes which represented the atavistic fears of mankind. The walls were hung with dark drapes, through openings in which the visitor could catch mysterious glimpses of the paintings. Some of the sculptures in this sanctuary had been made to Kiesler's designs - for instance David Hare's *Anguish-Man* and the *Totem of Religions,* made by

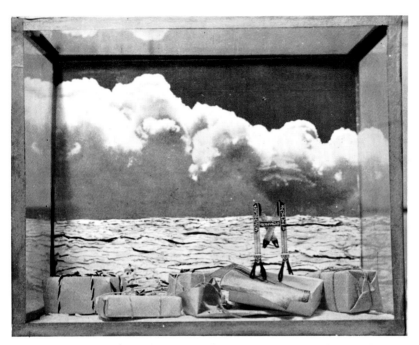

188 MARCEL DUCHAMP *The green ray (or shelf)* 1947

Etienne-Martin. (Incidentally, the considerable influence of Kiesler's *Dwellings* on Etienne-Martin has not been fully recognized.)

The visitor came next to a hall divided into two parts by 'curtains of rain' which poured down on to a floor of duckboards. This room housed magnificent paintings by all the masters of the movement. The only way out of the room was by going round a billiard table, which should have been in constant use — an idea which could not be maintained. Then came the initiatory labyrinth, where visitors were guided by a transparent Ariadne's thread. Here, twelve octagonal recesses, like the cells of a honeycomb, were set out as altars, dedicated, after the pattern of pagan cults, to beings or to objects capable of being endowed with a mythical life. So they were consecrated to animals *(The Condylura, or Star-nosed mole,* or *The Secretary-Bird),* to phantom objects *(the Wolftable,* by Victor Brauner, which he used in several of his paintings, the *Window of Magna sed Apta,* which had been described by George du Maurier in his book *Peter Ibbetson),*

189, 190

191

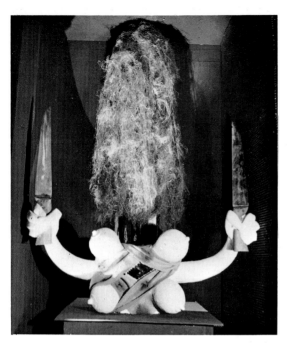

189
WIFREDO LAM
Altar for 'La chevelure de Falmer'
1947

190
ROBERTO MATTA
*Altar dedicated to
Marcel Duchamp's
'He who takes
care of gravity'*
1947

and to fictional characters (Jeanne Sabrenas, the heroine of *La Dragonne* by Alfred Jarry, or Léonie Aubois d'Ashby from Rimbaud's poem *Dévotion*). An electric bell rang continuously. Surprise followed surprise - the visitor passed from canvases to sculpture, from masks *192* to 'objects' of every kind, and the whole was surrounded by a

luxuriance of feathers, glass, mirrors, light and shadow. Works by newcomers to the movement, including Gerome Kamrowsky, Braulio Arenas, Maurice Baskine, E.F. Granell, Seigle, Isabelle Waldberg and Isamu Noguchi, were scattered everywhere. The fact that surrealism had not rejected Dada was shown by the presence,

among the exhibitors, of the former leader of the Lyons dadaists, Emile Malespine, who showed 'kissograms' or mouth prints. The last room was crammed with documents, photographs, pamphlets, first editions, and still more objects. Eighty-seven artists from twenty-four different countries took part in this major exhibition, quite apart from the writers who contributed to the catalogue.

Preparations for the exhibition took place in an atmosphere of intense intellectual excitement, and impassioned discussion went into the smallest details. I recall an entire evening being spent in deciding what should go into the show-window in the Avenue de Messine; everyone put forward ideas for a symbolic display. The choice finally fell on a sculpture by Victor Brauner, *Conglomeros,* three bodies with one head, which never lost its power to shock passers-by.

It was at this time that Antonin Artaud, who had been discharged from the Rodez asylum, spoke out with a prophet's voice, producing drawings which were like cries in which he expressed the human face, and René Char, Julien Gracq, Jacques Prévert and Aimé Césaire produced coruscating examples of the purest surrealist language.

In 1947, to cope with the world-wide interest in surrealism, André Breton founded *Cause,* an action bureau which had the job of coordinating manifestations of interest in surrealism from every country. *Cause* was charged with the publication of two pamphlets, *Rupture Inaugurale* (1947) and *A la Niche* (1948), which defined the distance which separated surrealism from politics and religion. The surrealist group, which met each week at the Café de la Place Blanche, was swamped by such a flood of visitors that, in an attempt to eliminate the merely curious, Breton instituted a questionnaire which was submitted to every poet or painter who wanted to join the movement. This questionnaire, which was drawn up in a collective session, consisted of eight questions, including : 'What exactly, at the present time, do you expect of surrealism?' and 'What confidence do you put in rational means of knowledge?'

The review *Néon,* which set out to be a kind of poetic newspaper, was founded in 1948. Responsible for its layout was the Czechoslovak poet Jindrich Heisler, who had some most delightful inspirations. Finally, in autumn 1948, another exhibition, 'Solution surréaliste', at the Galerie du Dragon, offered itself as a meeting-place for young artists who were moving towards surrealism, and provided a register

193 JOSEPH CRÉPIN *Painting* 1940

for them to enter their claims. So everything was ready for surrealism to become an effective organ of action which would absorb by synthesis the ideas which were in the air at the time.

A series of exhibitions in Paris from 1947 to 1950 confirmed the reappearance of surrealist artists such as Yves Tanguy, Victor Brauner, Francis Picabia and Toyen. Maria's exhibition in 1948, at the Galerie Drouin, gave Breton an opportunity of further formulating his thought. Maria (her full name was Maria Martins) was the wife of a diplomat. During a stay in Japan she had made ceramics in the local tradition, but in 1939 she decided to turn to sculpture, and the spirit of her native Brazil became apparent in her work. The curves and entanglements of her bronzes are derived from the vegetation of the Amazon forests, and evoke 'the quest for a liberation which must, above all, never be obtained'. Breton saw in Maria an example of the message which the tropics have for the Occident, and said 'What is important is that Maria's development has led her from the macrocosm to the microcosm, and has not made her follow the road in the opposite direction, where its path is strewn

with ambushes and decoys. It can never be said often enough that it is the universe which must be questioned about man, and not man who should be questioned about the universe.'

There were some painters who were caught up with surrealism, but who soon sheered off in an opposite direction. This happened to Jean-Paul Riopelle, a Canadian painter whose work Breton and other members of the group found very attractive, although he did not share their worship of the image. Riopelle was born in Montreal, and had been a disciple of Paul-Emile Borduas, the founder in 1944 of a Canadian group called the 'automatists', who derived their inspiration from surrealism. When he arrived in Paris, Riopelle shared a show called 'Automatisme' with the Canadian painter Leduc, and he took part in the surrealist exhibition at the Galerie Maeght. In pictorial automatism Riopelle was seeking freedom and breadth of gesture; his robust nature gave a special sensibility to his interlacing of colours. When he held his first major exhibition at the Galerie du Dragon in March 1949, Elisa, André Breton and Benjamin Péret contributed a portrait in dialogue to the catalogue. 'For me, his is the art of a superior trapper', said Breton, to which Péret added : 'Everything in the work of Riopelle is lit by the sun of the great forests, where the leaves fall like a biscuit of snow soaked in sherry.' When Riopelle abandoned surrealism for lyrical abstraction in 1950, he was one of the most regretted of all the defectors.

Another was Enrico Donati, an Italian painter who had come to Paris in 1934, and left for New York in 1940. Helped by his friendship with Marcel Duchamp, he stood out among the surrealists in exile in America; Donati was an exponent of a fluid form of painting, with colour glazes diluted on automatist principles, which vaguely evoked rockets or shadows in a night sky (*The Cabal,* 1944, *Gore et Mandro,* 1946). This seductive art, which was however rather slight, demanded some form of evolution. Donati turned towards the abstract in 1950, dividing each painting into stripes of granitic or coal-like matter.

In September 1948, André Breton took part in the foundation of the Compagnie de l'Art Brut, which initially held its meetings in the basement of the Galerie Drouin in the Place Vendôme. Jean Dubuffet had been the first, in 1945, to start collecting 'works by people unscathed by artistic culture'. In October 1949, Dubuffet organized a big exhibition at the Galerie Drouin, as a preface to

194 JOAN MIRÓ *The Poetess* 1940

which he wrote a pamphlet on *l'art brut* (art in the raw or crude state) and its superiority to 'cultural art' : *L'Art brut préféré aux arts culturels*. The style of this pamphlet recalls Tzara's eulogy of idiocy. 'The wise men would have to commit the great harakiri of the intelligence, launch themselves on the great leap into superlucid imbecility; that's the only way their millions of eyes would ever start to grow.' Breton encouraged this action, and took an interest in the *brut* painters like Miguel Hernández and Aloïse, and in the Scots-Canadian *naïf,* Scottie Wilson, whose meticulous and disturbing *Hand-made pen drawings* are made up largely of minute parallel hatchings within firm outlines.

Breton was fascinated most of all by Joseph Crépin, a plumber who had run a musical society, and who had subsequently discovered that he had the gift of healing. He treated his patients by sending them cut-out paper hearts which they had to lay on their chests. At

193

195
JOAN MIRÓ
*People and dog
before the sun*
1949

the beginning of the war Crépin began to paint a long sequence of
pictures, all of exactly the same size, because he had heard a voice
which had told him : 'The war will end on the day when you have
painted three hundred pictures.' He took a great delight in saying
that he finished the three-hundredth on 7 May 1945. The same voice
instructed him again in 1947 : 'You will paint forty-five marvellous
pictures, and then the world will be at peace.' When Crépin died
in 1948, he was working on the forty-second. His paintings consist
of an infinite number of what he called 'points', which look like
studs of colour.

The beginning of the post-war period saw the blooming of the

196
ANDRÉ MASSON
From a native land
1967

197
HANS BELLMER
Drawing 1965

199

198 YVES TANGUY *Multiplication of arcs* 1954

great masters of surrealism, who became international masters of
modern art and whose influence can be seen in the new tendencies
which formed at that time. Some of them isolated themselves, others
stayed in close relationship with the movement, but all of them, even
those who seemed to have broken away, moved towards the climax
of an evolution which had begun or matured within the group.

194 After Miró had produced his *Constellations,* in 1940-1, he went
on in 1945 to large canvases with white or black backgrounds, which
195 were followed in 1949 by a double alternating series of 'slow' and
'spontaneous' paintings, and then by extremely poetic pictures,
whose light gracefulness is carried over into their titles : *The Jasmines
embalm the dress of the young girl with their golden perfume* (1952), and
*Rhythm of the passage of the serpent attracted by the breath of the unloosed
tresses of the setting sun* (1953). In 1954 he stopped painting in order
to make a series of ceramics in association with the potter Artigas;
then in 1956 he left his Barcelona studio and moved to a house in
216 Palma de Mallorca, where he picked up the thread of his inspiration,
working, as he said, 'like a gardener'.

Those who kept in faithful contact with Breton often did so from a distance. At his home in Connecticut, Yves Tanguy, starting from pictures like *The Rapidity of Sleep* (1945, Art Institute of Chicago), set off *en route* for those vertiginous enumerations of stones which ended with *The Multiplication of Arcs* (1954, New York, Museum of Modern Art), and which seem to describe the depths of the abyss. Hans Bellmer did not lose sight of his *Doll* theme, but now he carved and polished the image of woman like a rough diamond, as if he were trying to make the strangest jewel in the world. Wolfgang Paalen, in an attempt to found a 'plastic cosmogony', did a series of paintings on the theme of 'Ancestors to Come', and expressed the forces of nature and mankind without using symbolism or figuration. René Magritte pursued his mental adventure, image by image, using the methods which he had perfected to discover the 'never before seen' - the *jamais vu* - in the banal and commonplace. Max Ernst,

78
198
197
199

199 RENÉ MAGRITTE *The Amiable Truth* 1966

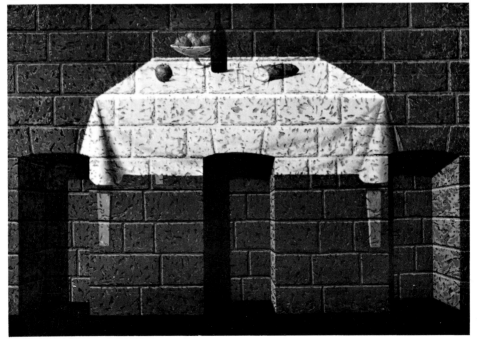

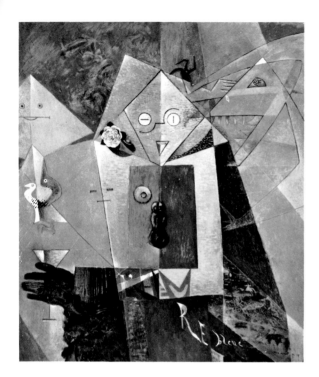

200
MAX ERNST
The Blue Hour
1946-7

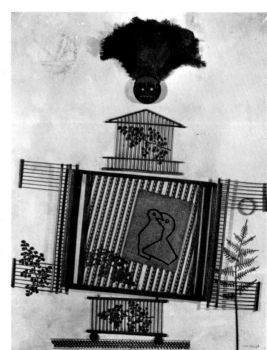

201
MAX ERNST
Aeolian harp :
First Thought
1965

202

202
MAX ERNST
The moon is a mute nightingale
1963

203
WIFREDO LAM
The Sombre Malembo
1943

204
VICTOR BRAUNER
*A being retracted,
refracted, spied
on by his conscience*
1951

200-202 who moved with Dorothea Tanning in 1955 to Huismes in Touraine, abandoned anti-painting in favour of painting. His etchings and his sculptures completed his statement of a universe 'in the interior of the view'. Wifredo Lam, who had a studio in Milan and another in Paris, was constantly on his travels, using his vocabulary of forms to evoke immemorial nostalgia.

André Masson and Giacometti forged links with the existentialist writers, but their work did not acquire new meaning as a result. From 1947 Masson lived near Aix-en-Provence, and drew his inspiration from the surrounding countryside. He did many etchings and lithographs which formed sequences such as *Féminaire* (1956). Then in 1962 he returned to his former paroxysmic manner with 196 *The Drunken Man*, and then a series of India ink drawings. When

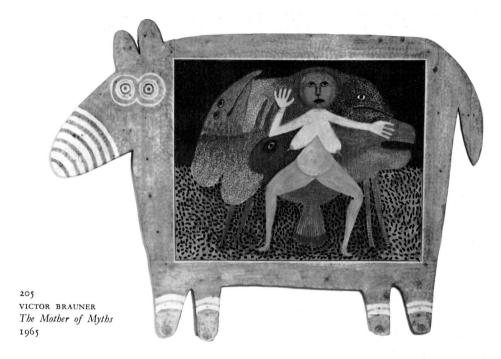

205
VICTOR BRAUNER
The Mother of Myths
1965

206
VICTOR BRAUNER
The Silent Light
1964

*I am the humanized-dehumanized
assemblage, and beyond the
circumstantial tumult,
I am inorganic peace.
No ray pierces the screen of
occultation, and my light
remains silent*

Giacometti returned from Switzerland, where he had met his wife Annette, he resumed work at his Paris studio in 1945 on nudes and heads, which, as before, became smaller and smaller the more he worked on them. From 1949 to 1951 he made groups of static or moving figures. His avidity for perfection led him to seek the impossible even in certainty and reality.

Victor Brauner, who stood apart from surrealism from 1948 onwards, moved out of his magic period to the evocation of an extremely varied personal mythology, with astonishing heroes, in a style which was predominantly calligraphic. From *A Being retracted...* (1948) to *The Mother of Myths* (1965), he contrived to enclose a poetic or philosophical story in every painting.

Matta lived in Rome in 1949-55, and his painting drew nourishment from his political preoccupations. In *Think no more of fleeing* (1953) and *Cover the earth with a new dew* (1955), he tried to achieve

207
SALVADOR DALI
Don Quixote overthrown
1957

208
JACQUES HÉROLD
Whirlwind of signs
1946

'the marximum of being' without changing his style at all. His draw-
ings - as in the series of 1955, *Mattamorphose (intérieure et exté-
rieure)* - became graphic serial stories.

Salvador Dalí's 'mystic period', which began with *The Madonna
of Port Lligat* (1950) was nothing but a continuation of his 'revolu-
tionary' period. Both periods derive from the 'paranoiac-critical
method'. When in 1951 he published his *Manifeste mystique* in Latin
and French, Dalí painted a *Soft self-portrait with grilled bacon* (1951),
which shows the skin of his face hanging on a branch like an empty
envelope. The Dalí who in the past had said 'Beauty will be edible
or will not exist', and who delivered a lecture in Barcelona with a
loaf fastened on his head, is still there *in toto* in the Dalí who, in a
Sorbonne dissertation in December 1955, drew an analogy between

209
JACQUES HÉROLD
The Initiatrix
1959

207 the rhinoceros and the cauliflower, or in the Dalí who, in 1956, illustrated *Don Quixote* by using a blunderbuss with bullets filled with ink.

Some painters who had been attached to the surrealist group for many years made their presence felt only late, in the post-war period. Jacques Hérold was a Romanian painter who had joined the movement in 1934, soon after his arrival in Paris, at the urging of Tanguy, whom he admired. When he failed to make the kind of contact with Breton and the group which he had hoped for, Hérold stayed on the fringe of the movement until 1938. At first his canvases showed flayed animals. In his own words he was moving towards 'a systematic flaying, not only of characters, but also of objects, landscapes, the

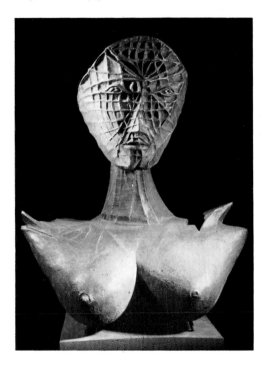

210
JACQUES HÉROLD
La femmoiselle 1945

211
JACQUES HÉROLD
The Pagan Woman 1964

atmosphere'. He even wanted 'to tear the skin from the sky'. Then he
became haunted by crystal, and his forms took on a stratified, vitrified *210, 217*
appearance, with facets or cutting edges. 'As crystallization is a
resultant of the coming together of form and matter, painting should
strive towards the crystallization of the object. In particular the
human body is a constellation of fiery points from which crystals *208, 209*
radiate', he wrote. *Dante and Beatrice* (1939) is one of the earliest

examples of this style, which later, in *The Eagle Reader* (1942), in *Whirlwind of signs* (1946) and in *The Nurse of the Forests* (1947, Paris, private collection), was applied to poetic subjects. In 1951 Hérold broke with surrealism, and conceived the ideal of 'painting the wind', which led him to effects of dispersion and luminosity which can be seen in *The Initiatrix* (1959) and *The Pagan Woman* (1964). He illustrated several books, and published a 'Maltreatise on painting' *(Maltraité de peinture)*, a series of notes and drawings, in 1957.

209, 211

Clovis Trouille's painting emerged gradually from the shadows, where he had been peacefully cultivating it, and became the delight of a group of connoisseurs. In 1930 his painting *Remembrance* was exhibited at the Salon des Artistes Révolutionnaires, and was noted by the surrealists, who henceforth claimed Trouille as one of themselves. Trouille was a Sunday painter - and what Sundays! - who worked in a Paris factory which made wax dummies for shop windows. His style was inspired by the Belle Epoque, in which his youth was spent, the gay 1890s and the Edwardian era. His imagery

212 CLOVIS TROUILLE *Dialogue at the Carmel* 1944

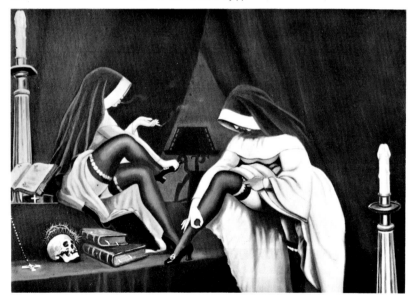

213 CLOVIS TROUILLE *Oh! Calcutta! Calcutta!* 1946

recalls the films of Méliès, Art Nouveau posters, Grand Guignol, picture postcards, and the 'news in brief' columns of *Le Petit Journal*. *213* Clovis Trouille wanted to be an 'arbitrary colourist' and to illuminate scenes of passion to the ultimate degree. 'I use academic forms and themes for subversive ends. That is what I find piquant', he has said. He painted 'anti-everything' pictures, to which he returned year after year to perfect some detail, and which he refused to sell. His painting *My Funeral* caused a sensation at the 1947 surrealist exhibition, and he has done two other versions which are just as remarkable. In 1942, in *The Drunken Ship* (*le Bateau Ivre*), where he shows convicts fleeing from a ship which has been wrecked, he painted Cézanne clutching a mast and trying to dodge a sailor's boathook. Since then, he has gone on producing strange and humorous pictures which are all evidence of his wit, which remains *212* fresh, vital and sharp, and of his skill as a painter. In his work the unexpected bursts out like a cymbal clash.

Outside the surrealist group, properly so called, there were several painters who, while not really sharing its spirit, contributing to its debates or submitting to its disciplines, appropriated its methods

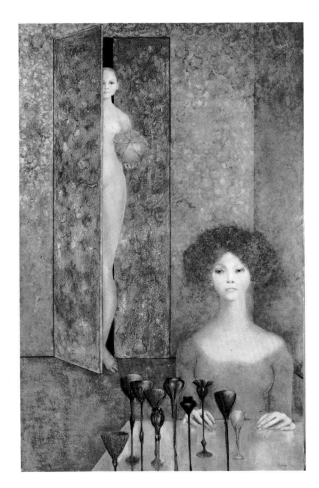

to lead a parallel existence. They battened on to what was most obvious in surrealism, the way in which it used fantastic imagery, and sometimes they achieved results which led the public to believe that they, as much as say Magritte or Tanguy, were part of the pictorial revolution which was carried out at the instigation and under the control of André Breton.

The most notable of the figures on the fringe of surrealism is Léonor Fini. She was born in Buenos Aires in 1908, spent her childhood and youth in Trieste, and finally settled in Paris. In 1936 she took part in the London 'International Surrealist Exhibition', and in 1937 the catalogue of her one-man show at the Julian Levy Gallery in New York included a preface by Chirico. Initially she

drew her inspiration from Italian mannerism, with the addition of a modernist accent derived from the influence of Max Ernst. She placed a showy style at the service of an inspiration whose favourite subjects were sphinxes, vampires, witches and ghouls with strange accessories, masks and seashells : *The Shepherdess of Sphinxes* (1941, Venice, Peggy Guggenheim collection); *Sphinx Regina* (1946); *The end of the world* (1949). Her painting, which is inclined to show Woman reigning over a world of artifice and guile, employs curious effects which can be found in her other work, such as her illustrations for *Juliette* by de Sade (1944), and her sets and costumes for the play, *Le Mal court* by Audiberti (1956). Her evolution finally brought her to produce female apparitions treated in the style of Viennese Art Nouveau (*Jugendstil*), which are similar to Gustav Klimt's figures, and which are certainly her best paintings : *The Secret Festival* (1964), *214* *The Window pane from the other side* (1965).

Félix Labisse, who was born at Douai in 1905, is another of these *215* painters who while fluttering around surrealism, and superficially

215 FÉLIX LABISSE *Charlotte Corday* 1942

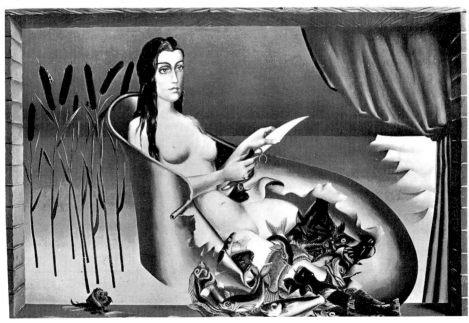

215 FÉLIX LABISSE *Charlotte Corday* 1942

coming under its influence, remain 'painters of the image' whereas genuine surrealists wished to be 'painters of the unimaginable'. In 1923 Labisse went to live in Belgium, first at Heyst-sur-Mer and then at Ostend, where he became a pupil of James Ensor. Later he moved to Paris, and began to work as a theatrical designer. He designed Jean-Louis Barrault's first production at the Atelier in 1934, *Autour d'une mère,* after Faulkner. He was a friend of Robert Desnos, who encouraged him from the start. Desnos wrote : 'His paintings already stand out for their sense of theatre, their lyrical inspiration, and, if I dare use the term in speaking of easel pictures, for their feeling of the open air'.

His painting speculates on the theme of metamorphosis, and he plays on the contrast which derives from placing an animal's head on the body of a woman. In this idiom he showed a woman with the head of a praying mantis - *Snatched Portrait* (1942) - or with the head of a lioness : *The Happiness of being loved* (1943). In a collection of drawings with an explanatory text, *Histoire naturelle* (1948), Labisse described a series of hybrid animals he had invented : The Rose-Tears, the Wyvern-Guénégote, the Adrouide, the Arthus of the Sands, and many others, including the Fluviot, a fish in the shape of a human face. He has always remained faithful to this kind of effect, with some variants. His figures later became tree-trunks in human form, as in *The Inconstancy of Jason* (1955); or his women were concealed behind a veil, as in *The Mourning of Salome* (1961). When he eliminated figures from his paintings he moved on to the evocation of 'libidoscaphes', which are a kind of meteor fallen in a desert space : an example is *Libidoscaphes in a watchful state* (1962).

Around 1950, surrealism had to take up a definite position on abstract painting. Until this time, the requirements of abstract art had been so fundamentally different from those of surrealist art that the surrealists had not even felt any need to define their position relative to abstractionism; this did not prevent Breton from admiring Kandinsky, or from claiming that Mondrian's *Boogie-woogies* were surrealist paintings. But after the war, geometrical abstraction gave place to lyrical abstraction : the painting of artists like Wols and Mark Tobey, which implied some inner drama or cosmic preoccupations, escaped from the aestheticism which the surrealists so detested. Action painting, which was derived from American abstract expres-

sionism, involved the use of pictorial automatism, and so the surrealists were obliged to examine this automatism to see whether or not it could correspond to their views.

Their reaction at first was unfavourable. Benjamin Péret, writing in *L'Almanach surréaliste du demi-siècle* (1950), expressed it in categorical arguments. In his view, abstract art was an abdication of the mind, and he claimed that it was 'an *ersatz* for plastic science', but not an art. 'In reality, no abstract art can exist, as art tends to represent figuratively either the artist's inner world, or the exterior world, or an interdependence between the two.'

But the critic Charles Estienne, who hovered on the fringes of surrealism, encouraged the development of free abstraction as opposed to geometrical abstraction, which was still dominant. He pushed some young painters, who had been complaining that they had been badly hung in the Salon de Mai in 1952, to found as a protest the Salon d'Octobre, which brought together some abstract pictures of the kind which are known under the designation of *'art informel'*, in the context of a tribute to Marcel Duchamp. Shortly afterwards, in an article entitled 'Abstraction et Surréalisme', Estienne wrote : 'If we take into account the death - which to me has obviously occurred - both of decorative abstraction and of surrealist imagery, I think that in the acutest abstract art, and in a surrealism which, far from being broadened, is brought back to its first principles, we hold the two vital keys of modern art, both of that which has already been created and of that which is now in the process of being created.'

André Breton gave his assent to this conception. The surrealist gallery, A L'Etoile Scellée, 11 Rue du Pré-aux-Clercs, opened in December 1952 with a group show, which was followed in January 1953 by the first one-man show of Simon Hantaï, whose sixteen large paintings were saluted by Breton in the catalogue : 'Once more, as happens perhaps once in every ten years, we see a great beginning'. Hantaï, a Hungarian painter who had been living in Paris since 1949, was at this time making picture-objects such as *Solidified Dew* (1953) and *Collective Narcissus* (1953), in which figuration tended to disappear under a riot of colour. In March 1953 Breton mounted a show at L'Etoile Scellée of four members of the October group, Jean Degottex, Duvillier, Marcelle Loubchansky and Messagier.

At the end of this year the second and last Salon d'Octobre, put

on at the Galerie Craven with a tribute to Francis Picabia, showed a possible way of fusing surrealism and abstraction. To this, Charles Estienne gave the name of 'tachism'. This was not his own word, but had been invented by Pierre Guéguen, a critic on the periodical *Art d'Aujourd'hui,* who had used it in a general sense. Charles Estienne gave it the meaning which *he* wanted; and in an article in *Combat,* 1 March 1954, he sets out the history of tachism. 'It is plain that if the tachists make *taches* [blobs] they do so in the same way and to the same extent that the *fauves* [literally, 'the wild beasts'] were denizens of the zoo, or that the cubists made cubes.... The enemies of October know perfectly well that the "blobs of October" have little to do with daubs and smears, but everything to do with a total freedom of expression which starts again from zero every time.'

This birth certificate of tachism provoked all manner of protests from painters and critics who wrote back to *Combat.* One of them said : 'Surrealism, vintage 1954, running out of invention, has discovered a new recipe, the blob, tachism, for painters, poets and citizens.' Charles Estienne wound up the debate in his article 'Dont Acte' ('Duly noted') on 5 April 1954, which showed that he was only the indirect cause of the uproar. 'It all blew up when surrealism, by which I mean Breton, said that he was in agreement - and all tachism, as everyone certainly knows, goes beyond the principle of unification of the two tendencies in painting today : lyrical abstraction and pictorial surrealism, as they are represented in the work of Hantaï and Paalen, for example.'

This attempt to reconcile two movements which were so radically divergent was bound to end in failure. Hantaï, to whom Breton had looked to bring it about, joined up with Georges Mathieu, with whom in 1957 he organized a series of exhibitions, commemorating the heresy of Siger de Brabant, which the surrealist group had anathematized in their pamphlet *Coup de semonce.* The word 'tachism', which no longer defined any kind of abstract surrealism, became synonymous with informal abstraction, and Mathieu himself used it to describe his painting. Breton overrode all these distinctions and returned to the line he had traced long before, proscribing 'the ribbon-work of art, at so much a metre', and praising the 'work of art as event', the only form which surrealism had always sought to produce.

216
JOAN MIRÓ
Blue 2 1961

217
JACQUES HÉROLD
Heads 1939

Occultation

As early as the *Second Manifeste* Breton had written of his quest for 'the profound, real occultation of surrealism', a process which he saw accomplished in the last ten years of his life. By the 'occultation' of the movement he meant its transformation into a secret circle, a closed group, with the task of cultivating the idea-forces of the modern world in an ideal climate, much as the esoteric sciences were practised in the Middle Ages. Towards the end of Breton's life, the freedoms which the surrealists had won for themselves had become accepted truths, some of which had been assimilated by society, while avant-garde artists and theorists drew benefit from all of them (without always admitting it). From now on surrealism sought to appeal only to adepts, and to conduct its affairs in such a way that those who approached the movement would be obliged to submit to some kind of initiation before they were admitted to it. André Breton did his utmost to keep the revived group to the fundamental principles of the movement, and at this level to discuss the facts of the present and future of artistic creation.

A succession of periodicals - *Médium*, *Le Surréalisme, même* and *La Brèche* - are evidence of the activity of this spiritual college. They include surveys similar to those of the early days, on strip-tease or on the possibility of interplanetary travel. One particularly interesting survey, 'Ouvrez-vous?' ('Will you open the door?'), asked participants what they would do if 'noble visitors', for example, Balzac, Cézanne, Seurat, Goya or Robespierre, were to ring their door-bell. The surrealists still carried out 'interventions', which were almost all intended to protect the memory of some poet or artist against false interpretations. They also invented new games, like 'Analogy Cards', which was a variant of the Portrait Game, and in particular 'One into Another'. Breton, who developed this game with Benjamin Péret in his house in Saint-Cirq-la-Popie, was very fond of it, and described the rules as follows : 'One of us went out of the room, and had to decide on a particular object (for example, a staircase), with which

he would identify himself. While he was out the rest of us had to agree on another object which he would have to represent (for example a bottle of champagne). So he had to describe himself in terms of a bottle of champagne, but with such peculiarities that gradually the image of the bottle would be eclipsed and finally replaced by the image of the staircase.' But games of this kind, aids to collective knowledge, no longer had such clear repercussions on painting as the invention of Exquisite Corpse had had in 1926. *40, 42*

During this period of 'occultation', the studies which surrealist art pursued began to probe into magic, maybe not in the hope of deriving direct inspiration from it, but at least to use it as a system of reference. This transition was a result of Breton's interest in Celtic iconography, which developed after he had read *L'Art gaulois dans les médailles* (1954), by Lancelot Lengyel. He saw Celtic iconography as a formal proof of the stupidity of the quarrel between figurative and non-figurative artists, and as a reason for choosing works from the past on the basis of the extent to which they were opposed to Graeco-Roman culture. In 1955 he took part in organizing the exhibition 'Pérennité de l'Art gaulois' at the Musée Pédagogique. This exhibition included ancient Gallic medals side by side with modern paintings which shared with them 'only a common desire to shake off the Graeco-Roman yoke'. He was aware that this law of proximity was inadequate, whereas the idea of magic was flexible enough to reconcile the apparently irreconcilable tendencies in art.

Breton's book *L'Art magique* (1957) was an attempt to create a movement of opinion and to purify the sources of aesthetic judgment. 'If the epithet "magic" is deliberately applied to the word "art",' he wrote, 'this increases the scale of the demands of art'. This concept allowed the construction of a new hierarchy of values, and a 'dignification' of the work of art beyond the formal or intellectual criteria which normally locate it. It also made it possible to encompass works which belong to different categories, as the illustrations to Breton's book show. These include examples of the archaic arts, alchemists' signs, the Tarot symbols, Tibetan banners, and scenes from films such as *The Bride of Frankenstein* and *The Golem,* Postman Cheval's Palais Idéal, and paintings by Goya, Monsù Desiderio and Watteau. Breton drew a parallel between 'magic in practice', as it was in the past, and works which have a magic power without evincing doctrine

or ritual. These latter include 'all those whose power over us is greater than might be expected from the means which they disclose'.

One might be led to believe that Magic Art had taken the place of Revolutionary Art, which had been the ideal proclaimed in the past, and that surrealist art had fallen into two stages, one directed towards Revolution, the other towards Magic. In fact Revolution and Magic are merely dominant factors in their particular periods. 'Magic implies protest, in other words revolt', said Breton. Breton does not allow the artist to sacrifice his liberty of creation to the cause of magic : 'We will be obliged to retain here as *specifically* magic art only that which goes some way towards recreating the magic from which itself was created.' He confesses that when he looks at ancient works which have resulted from magic practices, he is aware above all of their power to disconcert : 'With some few exceptions, their hold over us is not a result of the magic with which they were originally impregnated, but of the beauty which flows from them, even though this beauty may not have been consciously sought, but may have arisen only incidentally.'

Revolution and Magic are the two values which surrealism used to conceal its unconfessed *raison d'être,* which was to make a religion out of poetic inspiration. These two values constantly succeeded each other, turn and turn about, like day and night, in surrealist thought, whose contradictions are a direct result of the impossibility of reconciling them. Whenever the surrealists settled for one or the other of these two values, they did so in almost identical terms; the works which Breton regarded as magic move in the same direction as those he regarded as revolutionary.

One of the painters on whom Breton counted to illustrate his conception of a pictorial magic which would not necessarily allude to aspects of alchemy was Pierre Molinier. Molinier, who was born in 1900, was proud of his past as an adventurer and a bartender, which he had combined with his painterly vocation; this had developed early. In 1925 he did a number of drawings of châteaux, and in 1929 he produced his first abstract picture, *The Blonde Lady*, which consists of two strokes, one yellow and the other black. In 1940 he began to paint strange domineering women's faces. These heroines gradually became actresses in his mental theatre, rehearsing for a tragedy which was destined to be played out behind the curtain.

MAX WALTER SVANBERG
Portrait of a star.
Portrait III
1952

Molinier got in touch with Breton in 1950, and from Bordeaux kept up a protracted correspondence with him. In 1955 Molinier's exhibition at L'Etoile Scellée was hailed by Breton as a triumph of surrealist art. Breton wrote: 'The virtue of his art, which sets out to be deliberately *magic....* is that it breaks the law which says that every painted image, no matter how evocative it may be, nevertheless remains an object of conscious illusion, and cannot aspire to a plane on which it makes an active intervention in life'. Molinier's painting is based on a single obsession, and evokes a kind of succuba, a *219* radiant and cruel figure which stretches its limbs over the world, and which, like a female octopus, forms a single, monstrous body

with the prey which it absorbs. What Breton considered to be magic in Molinier was his demonstration that it was possible for painting to create a confusion which disorientates ideas and directs desires.

Max Walter Svanberg, another post-war surrealist discovery, also weaves mottled variations of a female apparition which shows itself and then slips aways, disguises itself or multiplies, which sometimes has several heads, and flesh like bedecked and braided cloth. In 1948 Svanberg had founded the 'imaginist' group in Stockholm. The group appealed to lyricism and to the fantastic, but Svanberg found no difficulty in leaving them when in 1953 the *218* surrealists noticed his painting *Portrait of a Star* in a Paris exhibition, and got in touch with him. There was a tribute to him in one number of *Médium* (no. 3, 1954), and an exhibition of his paintings was held at L'Etoile Scellée in 1955. 'My painting is a hymn to woman', he wrote, 'to that strange hybrid of visions and reality, of convulsive *220, 222* beauty and chaste temptations'. Svanberg's women are stars or birds *223* as well, decked out in delirious finery which seems to be made of

220 MAX WALTER SVANBERG *The Toys of Unreason* 1958

butterflies' wings. To show them still more luxuriantly, he sometimes made 'bead mosaics'.

218

Breton admitted that Svanberg's work fascinated him, and went on to make an admirable analysis of the effects of a 'fascinating' painting. 'It immediately brought me into a cone of light which is blind and disturbed, pierced at frequent intervals by a dart. In this cone all is giddiness, and the being moves forward despite itself, moving in short stages, under the impulse of an irresistible attraction, and inspired by absolute danger.' In this Breton showed his constant conviction that a painting should be 'inhabitable', and should arouse eddies in the spectator's unconscious mind. Svanberg is certainly the greatest Swedish surrealist painter, although he remained a solitary. Indeed he did not come to Paris and meet Breton and his friends until 1964.

222
MAX WALTER SVANBERG
*Offering to the ladies
of the moon* 1957

Enrico Baj, an Italian painter who in 1951 was an initiator of
the 'nuclear movement' in Milan, is in a different category. His
painting makes a virtuoso use of collage, and has a satirical intention.
There is a great deal that is childlike in Baj, and this had led him to
make game of his anxieties, and to imagine a bogeyman whom he
strips of his powers by disfiguring him. In *Tralali Tralala* (1955)
and *Little Chamber Animal* (1955), he began to introduce the character

whom he named 'Signor Olo', who consists of a head and legs, but no body or arms. He made 'ultra-bodies', caricatured figures which are both clownish and serious in intention, from scraps of wallpaper and cloth. In 1961 he produced a series of picture-objects which are parodies of period furniture - cupboards, tables, chests with drawers which do not open - using rosewood veneers and marquetry, and in this way creating human figures in the shape of furniture : an example is *Profile of an aristocratic lady in the style of the First Empire* (1961). His most famous series, and rightly so, is that of the *Generals,* whom he covered in real medals from his collections : *Man with decorated nose* (1961); *Military parade in the Bois de Boulogne* (1963). Baj has done some highly unconventional illustrations for Lucretius' *De Natura Rerum.*

The 'X^e Exposition Internationale du surréalisme' opened on 15 December 1959 at the Galerie Daniel Cordier in Paris on a theme

223
MAX WALTER SVANBERG
Illustration for
Les Illuminations
by Arthur Rimbaud
1958

which had been chosen with the intention of being anti-aesthetic :
'Eros'. In his letter to the exhibitors Breton described eroticism as
'a privileged place, a theatre in which incitement and prohibition
play their roles, and where the most profound moments of life make
sport'. He reminded them that eroticism, 'far from necessitating the
representation of scabrous scenes, derives a great deal from equivo-
cation and can readily undergo many transpositions'. He supported
his choice of theme by pointing out the need to show the public
that the work of art, which had been consumed by concerns of a
purely formal nature, had to rediscover the emotional power which
it had lost. 'Then - and certainly only then - can the *organic link*
between exhibitor and spectator, more and more lacking in today's
art, be established by means of perturbation.'

The setting of the exhibition, which was designed by the architect
Pierre Faucheux, gave the idea of 'a sumptuous ceremony in an

225
MERET OPPENHEIM
Cannibal feast
1959

underground cavern'. The visitor passed through a grotto, with its walls draped in red velvet and the floor strewn with fine sand, to a Fetishist Room organized by Mimi Parent. The ceiling/belly, one of Marcel Duchamp's ideas, throbbed and palpitated, and a soundtrack played back sighs recorded by the poet Radovan Ivsic. Meret Oppenheim had made a *Cannibal feast* in which a group of dummies representing men sat at a table on which lay a woman with a golden face, her body covered with food. There were two guest exhibitors, Robert Rauschenberg and Jasper Johns, who showed that pop art had a bond with surrealism. The most interesting newcomer was Friedrich Schröder-Sonnenstern, a self-taught German painter, whom Bellmer had discovered in Berlin. Schröder-Sonnenstern had begun to paint in 1949, when he was fifty-seven. Before this he had been a canteen hand, a stable boy in a circus and a farmworker, and had been both in prison and in mental hospital.

225, 226

He worked exclusively in coloured crayons, and his drawings showed men and women in a music hall which represented the universe.

In Breton's entourage there was no shortage of young painters to replace those who went off on their own as they came to maturity. Breton was always available to consider the claims and demands of the young members of the group. He considered that these new artists on whom he had passed judgment, or who had drawn their inspiration from him, were the hopes of surrealism. Yves Laloy, who was first an architect, used a plastic language inspired by Kandinsky to evoke geometric constructions and celestial buildings whose forms are no more than rhythms. Alberto Gironella, the Mexican painter, based his work on the metamorphoses which he inflicted on works of art of the past; on the basis of Goya's *Queen María Luisa of Bourbon-Parma* and in 1960-1 of Velázquez' *Queen Mariana,* he produced a series of picture objects, all different variations

230

226 Detail of *Cannibal feast* (see Ill. 225)

227
UGO STERPINI
The armed armchair
1965

228
JEAN-CLAUDE SILBERMANN
To the delight of the maidens
1964

229
JEAN-CLAUDE SILBERMANN
*Semiramis. Sign for an
unforgettable night*
1964

on a theme which he dissected as if he were seeking to perform a complete exegesis.

Le Maréchal began by writing poems, and in his paintings showed a visionary universe which seems to be seen through misted binoculars, with buildings vacillating in space at the whim of Le Maréchal's apocalyptic imagination. In 1963 another poet, Jean-Claude Silbermann, made *Sly Signs,* plywood cut-outs, which are signs for imaginary shops.

228, 229

Hervé Télémaque, the Haitian painter, began in 1961 to paint pictures in which his personal mythology integrates surrealism with pop art. Télémaque borrows from comic strips and posters, and enriches them with collages and inscriptions. The Cuban painter Jorge Camacho, who came to surrealism in 1961, paints vehement pictures which show scenes of torture. Another Cuban, the sculptor Agustín Cadenas, made genuine totems in ebony or marble, polished, perforated and embossed, with the aim of making them look like naturally developed products.

221

The 'XIᵉ Exposition Internationale du Surréalisme' held at the Galerie de *L'Œil* in Paris in December 1965, may be regarded as Breton's spiritual testament. The theme which was first chosen was 'the surrealist vision of woman'; it is not without significance that this theme was later replaced by that of *'L'Ecart absolu'* - 'absolute divergence'. Charles Fourier, the nineteenth-century utopian socialist, had used this term in *La Fausse Industrie* to indicate a method based on the principle of 'using the spirit of contradiction in a broad sense, and of applying it not to such and such a philosophical system, but to all systems taken together, and then to civilization which is the warhorse of these systems, and to all humanity's present social mechanism'. *L'Ecart absolu* is thus a determination to say and to do the opposite of everything which has been said and done previously. This is the ultimate lesson that the founder of surrealism intended to bequeath to his age; to swim against the current in every way, not in a spirit of sterile opposition, but with the aim of returning to the source of everything.

This exhibition was presented as 'an exhibition of *battle,* which comes *directly* to grips with the most intolerable aspects of the society in which we live', an exhibition, moreover, which excluded the 'anti-surrealist idea of a detailed *programme* which would imme-

ALBERTO GIRONELLA
Queen Mariana
1961

diately become a source of poetic emptiness and artistic poverty'. Pierre Faucheux's design for the exhibition provided a setting for works which showed this denial symbolically, such as the *Discomputer (le Désordinateur)*, a machine in which a pigeon hole containing an object was lit up when a button on a keyboard was depressed. There were also ten compartments which contained objects made as a protest against various aspects of the servitude of modern life, from technocracy to sport. The public passed under an *Arch of Defeat*, erected as a protest against military victories, to reach the *Consumer,*

a scarecrow made up of two mattresses arranged in the form of a cross, in the middle of which was a tub full of newspapers. A series of paintings by the newcomers; some of the major works of the masters of surrealism'; objects displayed in an open room which it 227 was forbidden to enter; and surprising furniture by Ugo Sterpini and Fabio de Sanctis, all testified to the permanence of surrealist values after more than forty years of spiritual adventure which had been so rich in varied experiences.

The death of André Breton in 1966 marked the end of surrealism as an organized movement. The number of tributes from his oldest companions which appeared in the Parisian daily papers showed the degree to which he had been able to be not so much the leader of a school as a director of conscience, in the best sense of the word. Even those who had been long divided from him by differences of every kind, men like Aragon, Michel Leiris, Max Ernst, and the cinema historian Georges Sadoul, made public statements of the sad nostalgia they felt. Surrealist activity without Breton was unimaginable; now that he was no longer working in association with Duchamp, surrealist exhibitions could only be retrospectives. It is true enough that, over the years which followed the birth of surrealism, some scribblers had delighted in burying Breton. Others had made desperate efforts to assimilate him into intellectual fashions which varied according to the caprice of opinion, and people were shocked to observe that he resisted the twists and turns of time. The word 'surrealist' will continue to be used to denote any bizarre work which uses the power of the dream to pass beyond the confines of reality. But the epithet should not be used without due consideration. André Breton always showed profound scorn for what he described as 'applied phantasmagoria' or 'bazaar surrealism'. He gave no credit to painters who were content merely to imitate the methods of the true surrealists without being driven on by their adventurous and rebellious spirit. Surrealism, as it was practised by the group of artists and poets who began the movement, will remain an honoured and irreplaceable model for all those creators who see art not as the search for an aesthetic, but as the bringing into action of ineffable states of being, mysteries of the universe.

231 ANDRÉ MASSON *Portrait of André Breton* 1941

Biographies

Bibliography

List of illustrations

Index

Biographies

ARP, Jean or Hans (1887-1966). After study-ing at the Ecole des Arts Décoratifs in his native Strasbourg, he was a student from 1905 to 1907 at the Weimar Academy. During a stay in Munich in 1911, he met Kandinsky, and in the following year he took part in the second *Der blaue Reiter* exhibition. In 1915, in Zurich, he met Sophie Taeuber, whom he married in 1921, and with whom he made em-broideries, tapestries and *papiers collés*. Arp took part in the birth of Dada in 1916 at the Cabaret Voltaire, Zurich. In the same year he made his first wood reliefs. In 1920, in Cologne, he and Max Ernst produced a series of collages which they called *Fatagaga* ('*Fabrication de tableaux garantis gazométriques*' — 'manufacture of paintings guaranteed to be gasometric'); and in Hanover he published his first collection of poems, *Die Wolkenpumpe*. He moved to Paris in 1925, and a year later settled in a house at Meudon. In 1930 he made his first *papiers déchirés* and exhibited with the Cercle et Carré group. In the following year he began to produce circular relief sculptures. During the war he took refuge in Switzerland, where Sophie Taeuber died in 1943. Arp came back to Meudon in 1946, and published a collected edition of his poems, *Le Siège de l'air*. He made enormous sculptures for the Harvard University Graduate Center (1950), for the campus of the University of Caracas (1953), for the UNESCO Secre-tariat building in Paris (1957), for the Brunswick Technische Hochschule (1960), for Bonn University Library (1961), and also cement *Steles* and *Walls* for the Kunst-gewerbeschule in Basle. His work was a blend of Dada, abstract art and surrealism.

BELLMER, Hans (1902-75). The son of an engineer who wanted him to follow in his footsteps, Bellmer abandoned his studies at the Berlin Technische Hochschule in 1924

and struck out on his own personal path. He met Otto Dix and George Grosz, who taught him satirical drawing, and began to earn his living as a typographer and illustrator. In 1927, after a short stay in Paris, where he discovered Seurat and Pascin, he married and opened an in-dustrial advertising agency in Berlin. In 1933 he made a *Doll*, which was simul-taneously to be the ideal object of his dreams and a protest in the name of childhood against the stifling adult world. His photographs, drawings, paintings and written work henceforth revolved around this super-toy. He settled per-manently in Paris in 1938, and was always a faithful adherent of surrealism. With drawings like *The Thousand Girls* (*Mille Filles*), 1939-1941, and *Four Persons,* 1941, he began a cycle of quintessential works in which he entirely remade female anatomy and which, together with his portraits and his illustrations, showed him to be the true heir of the great draughtsmen of the German Renaissance.

BRAUNER, Victor (1903-66). During his childhood in Romania he came under the influence of the spiritualist seances of which his father was a devotee. When he left the Bucharest School of Fine Arts in 1924, he founded the review *75 HP* in association with the poet Ilarie Voronca. In this publication he propounded a means of expression which he baptized ' picto-poetry '. He settled in Paris in 1930 and worked for a time with Brancusi, before joining the surrealist group in 1933. After his exhibition at the Galerie Pierre in 1934, for which André Breton wrote a preface, he went back to Romania in 1935 and stayed until 1938. After his return to Paris he lost an eye, an accident of which he had had premonitions. Immediately after this he moved into his 'period of Chimae-ras', which included all kinds of twilight scenes: *Psychological space* (1939) ; *The Inner Life* (1939). Next, living as a refugee in a village in the Hautes-Alpes, he did candle-

smoke drawings (fumages), and encaustic pictures on themes inspired by his studies of magic. He pushed this style further in his Paris studio in 1947, when he embarked on a great variety of experiments. In 1948 he broke with the surrealists and abandoned his ' magic period ' to express an extraordinary mythology, often in complete cycles like *Onomatomania* (1949) and *The Withdrawn Ones* (1951-2). In the last years of his life, he lived mainly in his house at Varengeville, where his meditations on nature filled his painting with a serene philosophy.

CALDER, Alexander (1898-1976). Although his mother was a painter and his father a sculptor, Calder's first enthusiasm was for engineering. Born in Philadelphia, from 1915 to 1919 he studied at the Stevens Institute of Technology at Hoboken, New Jersey, and he worked for some time as an engineer. In 1923 he began to take drawing lessons at the Art Students' League in New York. He went to Paris in 1926, where he made his first animated objects — a miniature circus — and showed in the Salon des Humoristes in 1927. He also made sculptures in steel wire (*Josephine Baker*, 1926), geometric metal sculptures to which Arp later gave the name of stabiles, and animated sculptures which were brought into motion either by hand, as in *Goldfish bowl* (1929), or by a motor, as in *Torpedo shape executing a dance movement* (1932). In 1933, he returned to the United States and moved to a farm at Roxbury in Connecticut, where he developed the constructions which moved at the slightest breath of air, to which Duchamp gave the name of mobiles. He went on alternating stabiles and mobiles and the *Constellations* which were a combination of the two. In 1953 Calder bought a house at Saché in Touraine, and from this time on the bulk of his work was done in his French studio. He made enormous sculptures such as *Hextopus*, 1955, *Teodelapio*, 1962, *Southern Cross*, 1963, and *Caliban*, 1964,

which were erected in various public places. He also painted in gouache and oil, and made jewellery.

CARRINGTON, Leonora (1917-). At the age of nineteen she took painting lessons from Amédée Ozenfant, who was teaching in her native London. Shortly afterwards she met Max Ernst and followed him to France, where she lived with him from 1938 at Saint-Martin-d'Ardèche. She took part in the ' Exposition Internationale du Surréalisme ' in Paris in 1938, and from then on was a regular contributor to all the movement's exhibitions. The atmosphere of the English Gothick novel is reflected in her collection of short stories *La Dame ovale*, Editions G.L.M., Paris 1939, and in her paintings like *At the Inn of the Dawn Horse*, 1942. After she had been treated for nervous depression she made this the subject of a moving autobiographical story, 'En bas', *VVV*, New York 1944. After a stay in New York she settled in Mexico, where her stories and paintings, while remaining fantastic, have been affected by local influences.

CHIRICO, Giorgio de (1888-1978). Born in Greece, he studied in the fine art department of the Athens Polytechnic School from 1903 to 1906 and painted landscapes on the banks of the Phalerian Gulf, and in the countryside near Athens. He left Greece in 1906, and went to Munich where he enrolled at the Royal Academy of Fine Arts. His thought was greatly influenced by the German philosophers, and by Nietzsche in particular. In 1909 he began a tour of Italy where he visited museums and amassed impressions which led him to begin, with *The Enigma of an Autumn Afternoon* (1910), his evocations of 'the melancholy of the afternoons of fine autumn days in Italian towns'. He lived in Paris from 1911 to 1915, and exhibited in the Salons d'Automne and the Salons des Indépendants; his work was appreciated only by Picasso and Apollinaire. He spent the years

1915-18 in Ferrara, where with Carlo Carrà he invented *pittura metafisica*, ' metaphysical painting '. Then he moved to Rome, where he lived from 1918 to 1925, and was a founder member of the *Valori Plastici* group. In Rome he soon changed his style. He abandoned the dreamlike mystery of his arcades, porticos, mannequins (or dummies) and so-called ' evangelical ' still lifes, and turned towards classicism. This change became final in Paris in 1925-30, where he tried to impose this new style in his designs for the ballet *Bal* written by Rieti for Diaghilev in 1929. During this period he had a number of brushes with Breton and his friends, who accused Chirico of betraying his genius. On his return to Rome Chirico proudly enfolded himself in academic-style work, sometimes accompanying his signature with the title ' Pictor optimus '. To understand this second period of Chirico one must read his story, *Une aventure de Monsieur Dudron*, written in 1939, in which he shows himself in the guise of a mad and solitary painter.

DALÍ, Salvador (1904–89). He was born at Figueras, in Catalonia. In 1921 he entered the School of Fine Arts in Madrid; in spite of his eccentricity he was a methodical worker, and visited the Prado every day to copy paintings of every school. He became a friend of Federico García Lorca, who wrote an ode in his honour. In 1925 he exhibited at the Dalmau gallery in Barcelona. His first surrealist work was the scenario for the film *Un Chien andalou* (1928), made by Luis Buñuel. He was introduced into the surrealist group by Miró, and in 1929, at the Galerie Gocmans in Paris, he showed paintings which foreshadowed his ' paranoiac-critical ' activity. He made particularly skilful use of the double image technique in the *Metamorphosis of Narcissus* (1937, London, Tate Gallery), which shows a human figure which is at the same time a hand holding an egg. In 1939 Dalí left for the United States, and lived at Del Monte

near Hollywood; there he painted canvases like *The Family of Marsupial Centaurs* (1941). In 1949-50 he entered his ' mystical ' period but maintained that he was still a surrealist. This period ended with a ' nuclear ' period, at the start of which came *Exploded Raphaelesque Head* (1951), and *Assumpta Corpuscularia Lapislazulina*, 1952. He then withdrew to his house at Cadaqués on the coast of Catalonia, leaving it only to mount clownish displays, in Paris and elsewhere, which tend to mask his true qualities as a painter.

DELVAUX, Paul (1897-). He studied architecture at the Brussels Académie des Beaux-Arts, and from 1924 onwards painted landscapes and portraits under the influence of Permeke; he became known through a major exhibition of his work in 1928 at the Palais des Beaux-Arts in Brussels. He joined the surrealist movement in 1936, encouraged by the examples of Chirico and Magritte. From *Pink knots* (1937, Antwerp, Musée Royal des Beaux-Arts) to *Girls at the water's edge* (1966), his paintings explore the same mysterious and sensual universe. Henri Storck's film *Le Monde de Paul Delvaux* (1947) had a commentary by Paul Eluard. Delvaux painted murals at the Ostend Kursaal in 1952, and also at the Liège Institute of Zoology in 1960.

DOMÍNGUEZ, Oscar (1906-57). Born and bred in the Canary Isles, he had his first exhibition in 1933 at the Círculo de Bellas Artes in Tenerife. He then came to Paris, where he was an active member of the surrealist movement from 1934 to 1940. Paul Eluard, until his death, gave Domínguez friendship and support which helped him greatly. Domínguez made many discoveries which he was not always able to make full use of in his paintings and his objects. He of in his paintings and his objects. He used decalcomania, and even foreshadowed action painting in the way he spread his colours on the canvas with ' an arm movement as random and rapid as that

of a window cleaner ' (Breton). After the war, his painting suffered as a result of his being cast in the role of social entertainer; despite plans for tapestries and ' paintings on felt ', his evolution remained hesitant.

DUCHAMP, Marcel (1887-1968). Duchamp was one of six children, born in Normandy; two of his brothers, the painter Jacques Villon and the sculptor Raymond Duchamp-Villon, were also to become famous. After studying at the Académie Jullian, Marcel Duchamp went through a ' fauve ' period and was present at the birth of cubism. In 1912, when he took part in the foundation of the ' Salon de la section d'Or ', his friend Apollinaire introduced him as ' Marcel Duchamp, who is disturbing '. Duchamp painted very few pictures; one of them, *Nude descending a staircase* (1912, Philadelphia, Museum of Art), was a triumph at the New York ' Armory Show ' in 1913. In New York in 1917, Duchamp published two reviews, *The Blind Man* and *Rongwrong,* invented the ' readymade ' and the ' optical machine ', and made his first glass panel — *To be looked at with one eye from close to for almost an hour* (1918, New York, Museum of Modern Art). His ' large glass ', *The Bride stripped bare by her bachelors, even* (1915-23, Philadelphia, Museum of Art), had been prepared in detailed notes. In 1923 he abandoned painting, and took up a wide range of unrelated activities : he experimented with a martingale on the Monte Carlo roulette tables, exercised himself with the spoonerisms of *Rrose Sélavy* etc. He played chess as a professional in the French championship team, and published a book on endgames, *L'Opposition et les cases conjuguées sont réconciliées* (1932). He had an overwhelming influence on dadaism and on surrealism. He published the documents of *The Bride stripped bare...* in his *Green Box,* 1934, and brought his complete works together in a 'portable museum', *Valise* or *Boîte-en-Valise* (1942), which came out in an edition of three hundred. One room in the Museum of Art in Philadelphia is given over to his work.

ERNST, Max (1891-1976). After studying philosophy at Bonn University, Ernst took up painting, influenced at first by August Macke. He became friendly with Arp in 1914, and in 1919, with Johannes T. Baargeld, founded the Cologne dadaist group. He and Baargeld together published the review *Die Schammade* (only one number was published, in 1920). In the previous year, Ernst had made his first collages; in 1922 he moved to Paris, where he helped in the foundation of surrealism. His invention of ' frottage' in 1925 allowed him to produce some remarkable work, which together with his ' collage-novels ' such as *La Femme 100 Têtes,* are the best of his early output. His great period began with the paintings to which he gave the title *Garden aeroplane trap* (1935-6), and with sequences of paintings produced by means of the technique of decalcomania, *The Nymph Echo* (1936, New York, Museum of Modern Art), and *Joie de vivre* (1936). This period continued in the United States, where he lived from 1941 to 1953, with *Antipope* (1942, Venice, Peggy Guggenheim collection), *Rhenish night* (1944) and *The Eye of Silence* (1945, St Louis, Mo., Washington University). When he returned to France, Ernst remained constant to his surrealist activity, and in 1954 he won the Grand Prix at the Venice Biennale. The paintings in which he used traditional methods, such as *Messalina as a child* and *The Famous Dream-smith* (1959), were far less original than those in which he allowed chance to give rein to his visionary gifts.

FREDDIE, Wilhelm (1909-). Freddie painted the first surrealist picture to be shown in Denmark (1930). He became a disciple of Dalí, and constantly produced a stream of violent images of sexuality and revolt. His most famous picture was *Monument to war* (1936, Silkeborg Museum), which was shown at his exhibition in Copenhagen in 1937. From 1948

onwards he evolved towards a kind of lyrical abstraction. He has made two films, *Final refusal of a request for a kiss* (1949) and *Eaten horizons* (1950).

GIACOMETTI, Alberto (1901-66). Swiss born, he began to paint in 1913, and to make sculptures in 1914. After a short stay at the Ecole des Arts et Métiers in Geneva in 1919, he visited Italy where he copied antiques and did portraits from life. In 1922 he went to Paris where until 1925 he studied under Bourdelle at the Académie de la Grande Chaumière. In 1928 he joined up with André Masson and Michel Leiris, and he was a member of the surrealist group from 1930 to 1935. His sculpture had an influence on the surrealists' conception of the object. His first one-man show was held at the Galerie Pierre Cole in Paris in 1932. After his break with surrealism, his closest relationship was with André Derain, and he did not exhibit from 1935 to 1947. After the war he formed an association with the existentialists and with Jean Genet, who wrote *L'Atelier de Giacometti* in 1954. He painted portraits and sculpted figures which, after 1956, he never finished. In 1962 he won the Grand Prix for sculpture at the Venice Biennale.

GORKY, Arshile, real name Vosdanig Adoian (1904-48). Born in Armenia, Gorky studied at the Polytechnic Institute at Tiflis in Georgia from 1916 to 1918. He went to New York in 1920; after having spent much time in museums and attended evening classes, he became a teacher of drawing at the New York School of Design from 1926 to 1931, and then at the Grand Central School of Art. He came under the influence of cubism and abstractionism, from which he was emancipated by his discovery of Miró and by his meeting with the surrealists in New York in 1942. In 1945 he settled at Sherman in Connecticut, where a series of tragic events led up to his suicide. His last pictures gave a decisive impulse to American abstract expressionism.

KIESLER, Frederick (1896-1966). He studied from 1910 to 1916 in his native Vienna, at the Technische Hochschule and the Akademie der bildenden Künste. He was an architect, a painter, a sculptor and theatrical producer, and was at first a member of the *De Stijl* group. His first plan for the ' continuous house ' was shown in Vienna in 1924. He became a naturalized American subject in 1932, and was theatre director of the Juilliard School of Music in New York from 1933 to 1957. Among buildings constructed from his plans are the Art of This Century Gallery (1942), and the World House Gallery (1956), both in New York, and the Sanctuary of the Book in Jerusalem (1961-5), which was built to house the Dead Sea Scrolls.

LAM, Wifredo (1902-82). Born in Cuba, the son of a Chinese father and a black Cuban mother, Lam studied first at the Havana Escuela de Bellas Artes, and then, from 1924, in Madrid, where he painted in the spirit of Spanish baroque. He arrived in Paris in 1937, and was taken under the wing of Picasso. His first exhibition was held in 1938 at the Galerie Pierre. He returned to Havana at the outbreak of the Second World War, and then, basing himself on jungle shapes, he created a style of prodigious figuration : *Astral Harp* (1944, Brussels, Urvater collection), *Animal Papaya* (1945), *Luguando Yombe* (1950, Paris, private collection). Lam travelled constantly between Paris, New York, Milan and Havana; wherever he went, he carried with him his immutable inner universe.

MAGRITTE, René (1898-1967). After leaving the Brussels Académie des Beaux-Arts in 1918, he tried his hand at several experimental styles, including abstract painting. In 1925 he and E.L.T. Mesens published the

reviews *Œsophage* and *Marie*, which were close in spirit to surrealism. He lived in France from 1927 to 1930, and took part in the activities of the Paris surrealist group. During this stay he developed his pictorial style which brings together figures of the visible world in an unexpected order. After his return to Brussels, he led a peaceful, sedentary life, but one which was extremely adventurous in the sense of the discoveries which he made in the field of the plastic arts. He gave added depth to a poetic idea by often studying it simultaneously in a gouache and in a painting. From 1940 to 1946 he passed through a neo-impressionist period, which he justified by his urge to embellish objects systematically. He then resumed the thread of his initial inspiration with paintings like *The Art of Conversation* (1950, Brussels, private collection), which is a pile of rocks forming the word RÊVE, ' dream '. He did an immense fresco for the Casino at Knokke-le-Zoute, to which he gave the name *The Enchanted Domain* (1951-3). From *The Sensitive Rope* (1955), a giant glass in a landscape, right up to one of his last paintings *The Amiable Truth* (1966), which is a meal shown in a *trompe-l'œil* style on a wall, he maintained an untiring pursuit of the marvellous. Some exponents of pop art have claimed to be influenced by him.

MALKINE, Georges (1898-1970). In 1924, André Breton cited Malkine in the *Manifeste du surréalisme* as one of the guests in the ' Château du Merveilleux '. Malkine showed paintings and collages at the Galerie Surréaliste in his native Paris in 1927, and then left for the South Seas. He returned in 1930, and did another series of paintings, breaking off abruptly in 1933. In 1949 he emigrated to the United States, where he resumed painting, and exhibited at the Weingartner Gallery in New York in 1955 and at the University of Long Island in 1961. He returned to Paris in 1966 and showed at the Galerie Mona Lisa, and was greeted by a tribute from his old friends, from Aragon to Jacques Prévert.

MASSON, André (1896–1987). Soon after his birth at Balagny (Oise, France), his parents moved to Brussels, where he began to draw at a very early age. In 1912 they sent him to Paris, where he studied mural painting at the Ecole Nationale des Beaux-Arts. After having tried various trades, in 1922 he met the dealer D.-H. Kahnweiler, who gave him financial support. He joined the surrealists in 1924, and did automatic drawings, portraits, and sand paintings. He moved away from the movement in 1929 and joined up with Georges Bataille, in 1934 illustrating his review *Acéphale*. In 1937 he designed the sets and costumes for Jean-Louis Barrault's production of *Numance* by Cervantes. Subsequently, reconciled with the surrealists, he produced a number of ' paroxysm paintings '. He lived in the United States during the war, and there published *Anatomie de mon univers* (1943). He returned to France in 1945 and did stage designs for Jean-Paul Sartre's play *Morts sans sépulture*. In 1947, the year he completed his large painting *Niobé* (Paris, Galerie Louise Leiris), he settled near Aix-en-Provence, where he painted strange haunted landscapes. He won the Grand Prix National des Arts in 1954, and became a member of the Council for National Museums in 1962; despite this official recognition, André Masson lost nothing of his violence. His late large paintings *Flayed men, and women in armour* (1963) and *Malevolent wizards threatening the people from the heights* (1964), have all the dash and spirit of the works of his youth.

MATTA, real name Roberto Matta Echaurren (1911-). From 1929 he studied architecture at the Academia de Bellas Artes in his native Santiago. He came to Paris in 1934, and studied under Le Corbusier, who enabled him to take

part in the planning of the 'Radiant City'. He spent the years from 1935 to 1937 in Spain, where he met Federico García Lorca, who gave him a letter of introduction to Dalí. Dalí in turn put Matta in touch with André Breton. In 1939, Matta left for New York, and in 1941 he made a trip to Mexico where he began to paint *The Earth is a Man* (1941, New York, William Rubin collection). In 1944 he met Marcel Duchamp, who described him as 'the most profound painter of his generation'. From 1949 to 1955 Matta lived in Rome, where his painting took on a polemical character. In 1957 his reputation was established by his retrospective at the Museum of Modern Art in New York. In 1958 he painted a mural for the UNESCO Secretariat building in Paris : *Three constellation beings facing the fire.*

MIRÓ, Joan (1893-1983). Born in Barcelona, in 1910 he joined a commercial firm there as a clerk. He began to paint in 1912, attended art schools, and formed a friendship with Artigas, who was later to found the Agrupacio Courbet. In 1918 Miró held his first exhibition at Dalmau's gallery in Barcelona, and on moving to Paris in 1921 he held another, unsuccessful, exhibition at the Galerie La Licorne. In *Ploughed Land* (1924, Philadelphia, N. Clifford collection) and *Head of Catalan peasant* (1924) marked the beginning of a change of style. He had a great success as a promoter of surrealist painting. In 1926 he and Max Ernst collaborated on designs for Diaghilev's Ballets Russes production of *Romeo and Juliet*. This was the subject of a vigorous polemic, and won the disapproval of the surrealist group. Six years later he designed the sets and costumes for *Jeux d'enfants,* Léonide Massine's ballet for the Ballets Russes de Monte Carlo. In 1940, at Varengeville he began to paint *Constellations*, a series of paintings all of the same size, which he finished at Montroig in Catalonia in 1941. From 1954 to 1959 he spent most

of his time on lithographs and ceramics. From 1956 he lived at Palma de Mallorca, in a house built by José Luis Sert.

PAALEN, Wolfgang (1905-59). Born in Vienna, he settled in Paris in 1928; after being a member of the Abstraction-Création group he became a surrealist in 1935. He made a contribution to pictorial automatism by his invention of 'fumage', which he used to make fantastic pictures: *Magnetic storms* (1938), *Sunspots* (1938). He went to Mexico in 1939 and there, in association with Lee Mullican and Gordon Onslow-with Lee Mullican and Gordon Onslow-Ford, founded the Dynaton movement, which published a review called *Dyn* (1942-44). This movement based itself on a new concept of reality, which it called 'dynatic' (from the Greek *dynaton,* 'possible'), and set out to reconcile art and science, thus excluding all mysticism or metaphysics. Its motto was 'no more subject painting, but no more pictures without a theme'. Paalen attributed special values to colours : blue signified the stable and material element, and red and yellow were used to indicate things of the mind. During a stay in Paris in 1951, he renewed his contact with surrealism; but he no longer believed in the virtues of automatism.

PICABIA, Francis (1879-1953). He studied in his native Paris, where his Spanish-born father became an attaché at the Cuban legation. In 1898, after working in Cormon's studio at the Ecole des Beaux-Arts, Picabia met Pissarro, whose influence moved him into his impressionist period. In 1908, Edouard André published the first book about him : *Picabia, le peintre et l'aquafortiste.* He married Gabrielle Buffet in 1909. In 1912 he began his 'orphic' period, supported by Apollinaire. He visited New York in 1913, and had an exhibition at Alfred Stieglitz's gallery, *291.* He took part in the beginnings of Dada in Paris, and this coincided with the full flowering of his 'mechanist' period (1918-21), which is

exemplified by works like *Child carburettor* (1917, New York, Solomon R. Guggenheim Museum) and *The Amorous Parade* (1917, Chicago, Morton G. Neumann collection). He published several collections of poems : *Cinquante-deux miroirs* (1917), *Rateliers platoniques* (1918), *Poésie ron-ron* (1919), etc. From 1925 to 1935 he lived in the Château de Mai near Cannes, and followed his ' monster ' period with his *Transparencies* (1926-35). He passed through a ' narrative ' period, when he painted nudes (1939-43). After the war he held an exhibition, at the Galerie Denise René, of works which he described as ' sur-irrealist '. In 1949 he had a big retrospective show, ' Cinquante ans de plaisir ', at the Galerie René Drouin.

PICASSO, Pablo (1881-1973). The Spanish master, who, from his blue period to his pink period, from cubism to neo-classicism, himself embraced all the various temptations offered by modern painting, gave his support to surrealism to a degree which Breton assessed thus : ' Picasso of his own accord turned towards surrealism, and, as far as he was able, came to meet it. Evidence of this can be found in part of his output from 1923 to 1924, several works from 1928 to 1930, metal constructions of 1930-31, the semi-automatic poems of 1935, right up to the play *Le Désir attrapé par la queue* of 1943. '

RAY, Man (1890-1976). In 1907 he threw up his architectural studies and decided to devote himself to painting. The New York ' Armory Show ' of 1913 pushed him towards abstraction, and he then worked on paintings like *Seguidilla* (1919), and on a collection of colour prints, *Revolving Doors*, which he published later. He was drawn towards Dada by a meeting with Marcel Duchamp, who introduced him to the idea of ' readymades '. He moved to Paris in 1921, and worked on photography, doing portraits, nudes, unexpected images. His album of ' rayograms ', *Champs délicieux*, had a preface by Tzara. He has

made several films : *Emak Bakia* (1927), *Etoile de Mer* (1928), *Le Mystère du Château de Dé* (1929). He lived from 1940 to 1950 in the United States, and when he returned to Paris he continued to practise both painting and photography. In 1954, at the Galerie Furstemberg, he exhibited his *Shakespearian Equations,* which were a series of paintings done between 1948 and 1950 and inspired by mathematical objects. He once made a *Talking Picture*, attached to a gramophone.

SAVINIO, Alberto, real name Andrea de Chirico (1890-1952). Savinio, who was Giorgio de Chirico's brother, studied piano and composition at the Athens conservatoire, and later at Munich under Max Reger. He lived in Paris from 1911 to 1915 and published a sequence of poems, ' Les Chants de la Mi-Mort ', in *Les Soirées de Paris* in 1914. He then moved to Italy, where his first book, *Hermafrodito*, came out in 1918. He composed ballet music; his ballet *Perseus*, with choreography by Fokine, was performed at the Metropolitan Opera in New York in 1924. He began to paint during his second spell in Paris from 1926 to 1934. Keeping music, painting and poetry all going, he took part in several exhibitions in Italy. He did his own designs for his ballet *Vita dell'Uomo* which was staged at La Scala in 1951. One room at the 1954 Venice Biennale was given over to his work.

SVANBERG, Max Walter (1912-). He began painting in Stockholm in 1953, and his first exhibitions after the war provoked lively discussion. In 1948 he founded the Swedish ' imaginist ' group, but he soon left them. He began a correspondence with the Parisian surrealists, and in 1955 exhibited at the Galerie de l'Etoile Scellée under the aegis of Breton. In 1950 he published an album of lithographs with a preface by Steen Colding, and in 1958 he illustrated an edition of Rimbaud's *Les Illuminations.*

TANGUY, Yves (1900-55). His father was a

sea-captain, and Tanguy himself went to sea as an officer cadet in the French merchant navy. His native Brittany is always secretly present in his painting. In 1920 Tanguy became friendly with Jacques Prévert, and they both joined the surrealist group in 1925. His work, which he never explained, and the meaning of which he claimed not to know, falls into three stages. From 1926 to 1930 his paintings show an aerial universe. From 1930 he showed beaches stretching out to infinity, swarming with mineral elements shaped like knuckle bones. In 1939 he emigrated to the United States with his wife Kay Sage, and was naturalized in 1948. His third period is typified by the accumulation and piling up of stones, and by the evocation of a submarine world. After 1950 this period included some very large paintings. One of his last paintings was *Imaginary numbers* (1954). Kay Sage, who was herself a talented painter and poet, committed suicide in 1961.

TANNING, Dorothea (1912-). When she was twenty, she enrolled at the Chicago Academy of Arts, but stayed there only a short time. She left for New York, where the exhibition ' Fantastic Art, Dada, Surrealism ' of 1936 decided her on her vocation. She had already painted some pictures by the time she met Max Ernst in 1942 in New York; her first one-woman show was in 1944 at the Julien Levy gallery. In 1946 she married Max Ernst, and went to live with him at Sedona in Arizona. In 1955 they moved to Huismes in Touraine. Dorothea Tanning's painting, after a period of fantastic figuration, was invaded by iridescent mists, through which can be glimpsed bacchanalian orgies, as in *Eperdument* (1960), one of the best pictures of this later style.

TOYEN, real name Marie Germinova (1902-80). After the First World War she played a part in the avant-garde circle in Prague which included Franz Kafka.

She was a member of the ' Devetsil ' group, which combined researches into all forms of modern art, and which in 1933 engendered Czechoslovak surrealism. Toyen, who was married to the painter Jindrich Styrsky, began by doing abstract paintings, passed through a period of figuration, in which she used a technique ahead of her time (blobs and dribbles), and then settled down into pure imagery. After Styrsky's death she had a show in Prague in 1945. In 1947 she came to Paris for her show at the Galerie Denise René, and she stayed on in France. She produced a cycle of drypoints, *Neither wings nor stones : wings and stones* (1954), and also a series of paintings which recall the shop signs from the Street of the Alchemists in Prague : *At the sign of the Golden Wheel* (1951), and *At the sign of the Blue Face* (1951), etc. Her adherence to surrealism is unshakeable ; her work is one of the surrealist secrets most worthy of being discovered.

TROUILLE, Clovis (1889-1975). In 1905 he began to study at the Ecole des Beaux-Arts in Amiens. After some impressionist paintings and some satirical drawings which were published in local papers, he painted *The Palace of Marvels* (1907), an evocative parade of mountebanks, the first work characteristic of his style. He worked in a Paris factory which made shop window dummies, where his job was making up and restoring their faces, and he stopped painting until 1930. Subsequently the paintings he sent to the Salon des Indépendants and the Salon des Surindépendants aroused enormous curiosity. His anarchistic and erotic imagery was long matured at his home in Buttes-Chaumont, where he lived a quiet and peaceful life. In 1960 he was awarded the Labour Medal and a diploma commemorating thirty-five years work in the same firm. His only one-man show was held at the Raymond Cordier gallery in Paris in 1963, when Trouille was seventy-four.

Bibliography

General works : chronological order

André Breton : *Les Pas perdus*, Gallimard, Paris 1924.

André Breton : *Le Surréalisme et la peinture*, Gallimard, Paris 1928; new edition 1965.

Louis Aragon : *La Peinture au défi*, Galerie Goemans, Paris 1930 (text reproduced in *les Collages*, Hermann, Paris 1965).

Cahiers d'art (special numbers devoted to Surrealism), Paris 1935-6.

David Gascoyne : *A Short Survey of Surrealism*, Cobden Sanderson, London 1935.

Alfred Barr, jr. and Georges Hugnet : *Fantastic Art, Dada, Surrealism*, Museum of Modern Art, New York 1936.

André Breton and Paul Eluard : *Dictionnaire abrégé du surréalisme* (published on the occasion of the 'Exposition Internationale' at the Galerie des Beaux-Arts), Paris 1938.

Maurice Nadeau : *Histoire du Surréalisme*, Editions du Seuil, Paris 1945; *The History of Surrealism*, Collier Books, New York 1967; *Documents Surréalistes*, Paris 1948; new edition 1964.

André Breton and Marcel Duchamp : *Le Surréalisme en 1947* (catalogue of the 'Exposition Internationale du Surréalisme'), Galerie Maeght, Paris 1947.

Almanach surréaliste du demi-siècle (special number of *La Nef*), Paris 1950.

Dieter Wyss : *Der Surrealismus*, L. Schneider, Heidelberg 1950.

René Gaffé : *La Peinture à travers Dada et le surréalisme*, Editions des Artistes, Brussels 1952.

André Breton and Gérard Legrand : *L'Art magique*, Club Français du Livre, Paris 1957.

Marcel Jean and Arpad Mezei : *Histoire de la peinture surréaliste*, Editions du Seuil, Paris 1959; *A History of Surrealist Painting*, Weidenfeld and Nicolson, London 1967.

Eros (catalogue of the 'Exposition Internationale du Surréalisme'), Galerie Daniel Cordier, Paris 1959.

Jean-Louis Bedouin : *Vingt ans de surréalisme, 1939-1959*, Denoël, Paris 1961.

Patrick Waldberg : *Le Surréalisme*, Skira, Geneva 1962.

Victor Crastre : *Le Drame du surréalisme*, Editions du Temps, Paris 1963.

Surrealism, Yale University Press, New Haven 1964.

Alain Jouffroy : *Une Révolution du regard*, Gallimard, Paris 1964.

Robert Benayoun : *Erotique du Surréalisme*, Jean-Jacques Pauvert, Paris 1965.

Patrick Waldberg : *Surrealism* (a documentary anthology), Thames and Hudson, London, and McGraw-Hill, New York, 1966.

L'Ecart absolu (catalogue of the 'Exposition Internationale du Surréalisme'), Galerie de l'Œil, Paris 1965.

Michel Sanouillet : *Dada à Paris*, Jean-Jacques Pauvert, Paris 1965.

José Pierre : *Le Surréalisme*, Editions Rencontre, Lausanne 1966.

Monographs : alphabetical order of artists

Constantin Jelinsky : *Les Dessins de Bellmer*, Denoël, Paris 1966.

Sarane Alexandrian : *Victor Brauner l'illuminateur*, Cahiers d'Art, Paris 1954.

Alain Jouffroy : *Victor Brauner*, Musée de Poche, Paris 1959.

Sarane Alexandrian : *Les Dessins magiques de Victor Brauner*, Denoël, Paris 1965.

James Johnson Sweeney : *Alexander Calder*, Museum of Modern Art, New York 1951.

James Thrall Soby : *Giorgio de Chirico*, Museum of Modern Art, New York 1955.

René Crevel : *Dali ou l'antiobscurantisme*, Editions Surréalistes, Paris 1935.

James Thrall Soby : *Salvador Dali*, Museum of Modern Art, New York 1946.

Robert Descharnes : *Dali de Gala*, Bibliothèque des Arts, Paris 1963.

Max Girard and Salvador Dalí : *Dali de Draeger*, Paris 1968.

Paul-Aloïse de Bock : *Paul Delvaux*, Jean-Jacques Pauvert, Paris 1967.

Maurice Nadeau : *Les Dessins de Paul Delvaux*, Denoël, Paris 1967.

Robert Lebel : *Sur Marcel Duchamp*, Trianon Press, Paris 1959.

Max Ernst : Œuvres de 1919-1936, Cahiers d'Art, Paris 1937.

Patrick Waldberg : *Max Ernst*, Jean-Jacques Pauvert, Paris 1958.

John Russell : *Max Ernst, his life and work*, Thames and Hudson, London, and Abrams, New York 1967.

Marcel Brion : *Léonor Fini*, Jean-Jacques Pauvert, Paris 1955.

Constantin Jelinsky : *Léonor Fini*, Editions Clairefontaine, Lausanne 1968.

Jacques Dupin : *Alberto Giacometti*, Maeght, Paris 1962.

William Seitz and Julien Levy : *Arshile Gorky*, Museum of Modern Art, New York 1962.

Michel Butor : *Jacques Hérold*, Musée de Poche, Paris 1964.

Jacques Charpier : *Wifredo Lam*, Musée de Poche, Paris 1961.

Louis Scutenaire : *René Magritte*, Librairie Sélection, Brussels 1947.

Patrick Waldberg : *René Magritte*, De Rache, Brussels 1965.

Michel Leiris and Georges Limbourg : *André Masson et son univers,* Editions des Trois Collines, Geneva 1947.

Hubert Juin : *André Masson,* Musée de Poche, Paris 1963.

Alain Jouffroy : *Le Réalisme ouvert de Matta,* Cahiers d'Art, Paris 1953.

Patrick Waldberg : *Matta, l'aube, le vertige,* Quadrum, Brussels 1958.

Jacques Dupin : *Miró,* Flammarion, Paris 1961; *Joan Miró, life and work,* Thames and Hudson, London, and Abrams, New York 1962.

Michel Sanouillet : *Francis Picabia*, Editions du Temps, Paris 1964.

James Thrall Soby : *Yves Tanguy*, Museum of Modern Art, New York 1965.

Alain Bosquet : *Dorothea Tanning,* Jean-Jacques Pauvert, Paris 1966.

Jean-Marc Campagne : *Clovis Trouille,* Jean-Jacques Pauvert, Paris 1965.

Writings by artists

Jean Arp : *Jours effeuillés,* Gallimard, Paris 1966.

Hans Bellmer : *La Poupée,* G.L.M., Paris 1936. *Les Jeux de la Poupée,* Paris 1946. *L'Anatomie de l'Image,* Le Terrain Vague, Paris 1957.

Giorgio de Chirico : *Hebdoméros,* Editions du Carrefour, Paris 1929; new edition Flammarion, Paris 1964. *Memorie della mia vita,* Rome 1945.

Salvador Dalí : *La Femme Visible,* Editions Surréalistes, Paris 1930. *La Conquête de l'Irrationel,* Editions Surréalistes, Paris 1935. *The Secret Life of Salvador Dali,* Vision, London 1948. *Les Cocus du vieil art moderne,* Fasquelle, Paris 1954. *Journal d'un génie,* La Table Ronde, Paris 1964. *Le Mythe tragique de l'Angélus de Millet,* Jean-Jacques Pauvert, Paris 1964. *Lettres à Dali,* Albin Michel, Paris 1966.

Marcel Duchamp : *Marchand du Sel,* Le Terrain Vague, Paris 1958. *Entretiens* (conversations with Pierre Cabanne), Pierre Belfond, Paris 1966.

Max Ernst : *Au-delà de la peinture* (special number of *Cahiers d'Art*), Paris 1937.

Jacques Hérold : *Maltraité de peinture,* Editions Falaize, Paris 1957.

André Masson : *Anatomie de mon univers,* Kurt Valentin, New York 1943. *Le Plaisir de peindre,* La Diane Française, Nice 1950. *Métamorphose de l'artiste,* Editions Pierre Cailler, Geneva 1956.

Man Ray : *Self-portrait,* Hamish Hamilton, London 1965.

List of illustrations

27 MARCEL DUCHAMP *Apolinère enameled*
1916-17
Readymade
Philadelphia, Museum of Art, Louise
and Walter Arensberg collection

28 MARCEL DUCHAMP *Chocolate Grinder
No. 1* 1913
Philadelphia, Museum of Art, Louise
and Walter Arensberg collection

29 FRANCIS PICABIA *A little solitude
amidst the suns (A picture painted to
tell and not to prove)* 1919
Paris, private collection

30 MARCEL DUCHAMP *Valise* 1942
Montage of photographs, facsimiles
and reduced scale copies of the artist's
works
Philadelphia, Museum of Art, Louise
and Walter Arensberg Collection

31 FRANCIS PICABIA *Optophone* 1918 (?)
Paris, Mme Henry collection

32 MAX ERNST *The hat makes the man* 1920
Collage
New York, Museum of Modern Art

33 MAN RAY *The rope dancer accompanies
herself with her shadows* 1916
New York, Museum of Modern Art

34 FRANCIS PICABIA *Novia* 1917
Paris, former Tristan Tzara collection

35 FRANCIS PICABIA *Amorous Procession*
1917
Chicago, Mr and Mrs Morton G.
Neumann collection

36 MAN RAY *Legend* 1916
Brussels, Urvater collection

37 MAX ERNST and JEAN ARP *Fatagaga* 1920
Collage
Berne, private collection

38 FRANCIS PICABIA Cover for *Littérature*
1922
New series No. 7, December 1922

39 Cover for *Le Cœur à barbe* 1922
Le Cœur à barbe was a 'transparent jour-
nal' published by Tzara, Eluard and
Ribemont-Dessaignes in April 1922

40 ANDRÉ BRETON, TRISTAN TZARA,
VALENTINE HUGO and GRETA KNUTSON
*Exquisite Corpse c.*1933
New York, Museum of Modern Art

41 JACQUES HÉROLD, ANDRÉ BRETON,
YVES TANGUY and VICTOR BRAUNER
Exquisite Corpse 1934
Paris, Jacques Hérold collection

42 JACQUES HÉROLD, ANDRÉ BRETON,
YVES TANGUY and VICTOR BRAUNER
Exquisite Corpse 1934
Paris, Jacques Hérold collection

43 PABLO PICASSO *Portrait of André Breton*

44 PIERRE ROY *Danger on the stairs* 1927-8
New York, Museum of Modern Art

45 GIORGIO DE CHIRICO *The Brain of the
Child* 1914
Stockholm, Nationalmuseum

46 GIORGIO DE CHIRICO *Melancholy* 1912
London, private collection

47 GIORGIO DE CHIRICO *The Philosopher's
Walk* 1914
Paris, Marie-Laure de Noailles col-
lection

48 GIORGIO DE CHIRICO *The Disquieting
Muses* 1917
Milan, Fondazione Gianni Mattioli

49 GIORGIO DE CHIRICO *Premonitory por-
trait of Apollinaire* 1914
Wood engraving by Pierre Roy

50 MAX ERNST *At the Rendez-vous of
Friends* 1922
Hamburg, Dr Lydia Bau collection

51 MAX ERNST *Self-portrait* 1922 (detail
of *pl. 50*)

52 MAX ERNST *Two children are threatened
by a nightingale* 1924
Painting with wooden construction
New York, Museum of Modern Art

53 MAX ERNST *Le start du châtaigner* 1925
Frottage on paper, reproduced in
Histoire Naturelle
London, Roland Penrose collection

54 MAX ERNST *Conjugal diamonds* 1926
Frottage on paper, reproduced in
Histoire Naturelle

55 MAX ERNST *The Virgin spanking the Infant Jesus before three witnesses: André Breton, Paul Eluard and the artist* 1928
Brussels, Mme Jean Krebs collection

56 MAX ERNST *Pietà, or the Revolution by night* 1923
London, Roland Penrose collection

57 GIORGIO DE CHIRICO *Hector and Andromache* 1917
Milan, Fondazione Gianni Mattioli

58 ANDRÉ MASSON *Battle of Fishes* 1927
Paint, sand and pencil
New York, Museum of Modern Art

59 ANDRÉ MASSON *The Great Lady* 1937
Paint, sand, shells and feathers
Paris, Galerie Louise Leiris

60 MAX ERNST *Men will know nothing of it* 1923
London, Tate Gallery

61 MAX ERNST *Natural history* 1923
Decoration for Paul Eluard's house at Eaubonne
Paris, Galerie François Petit

62 ANDRÉ MASSON *Furious suns* 1925
Automatic drawing, ink
Paris, Galerie Louise Leiris

63 ANDRÉ MASSON *Automatic drawing, ink* 1925
Paris, Galerie Louise Leiris

64 JEAN ARP *Automatic drawing, ink* 1916
New York, Museum of Modern Art

65 MAX ERNST *Napoleon in the wilderness* 1941
New York, Museum of Modern Art

66 ANDRÉ MASSON *Gradiva* 1939
Knokke-le-Zoute, G. J. Nellens collection

67 JOAN MIRÓ *Dutch interior* 1928
New York, Museum of Modern Art

68 JOAN MIRÓ *Person throwing a stone at a bird* 1926
New York, Museum of Modern Art

69 ANDRÉ MASSON *Fish drawn in the sand* 1927

Berne, Kunstmuseum, Stiftung Hermann u. Margrit Rupf

70 JOAN MIRÓ *Olée* 1924
Brussels, B. Goldschmidt collection

71 JOAN MIRÓ *Man and woman* 1931
Object-painting
Private collection

72 JOAN MIRÓ *Drawing* 1924

73 JOAN MIRÓ *Portrait of a Lady in 1820* 1929
New York, Museum of Modern Art

74 JOAN MIRÓ *Head of Woman* 1938
Los Angeles, Mr and Mrs Donald Winston collection

75 YVES TANGUY *Four hours of summer, hope* 1929
Paris, private collection

76 PABLO PICASSO *Woman bather, seated* 1930
New York, Museum of Modern Art

77 PABLO PICASSO *Woman bather playing with a ball* 1932
New York, Mr and Mrs Victor W. Ganz collection

78 YVES TANGUY *The Rapidity of Sleep* 1945
Chicago, Art Institute

79 JOAN MIRÓ *Portrait* 1950
New York, Mr and Mrs Pierre Matisse collection

80 YVES TANGUY *Infinite divisibility* 1942
Buffalo, Albright-Knox Art Gallery

81 YVES TANGUY *The Storm* 1926
Philadelphia, Museum of Art, Louise and Walter Arensberg Collection

82 JEAN ARP *Chinese Shadow* 1947
Stone
Paris, Michel Seuphor collection

83 JEAN ARP *Configuration* 1930
Philadelphia, Museum of Art, A. E. Gallatin Collection

84 JEAN ARP *Painted wood* 1917
Collection of the artist

85 GEORGES MALKINE *The Home of Erik Satie* 1966
Paris, private collection

86 MAN RAY *Promenade* 1941
New Haven, Yale University Art
Gallery, Société Anonyme Collection

87 MAN RAY *Rayogram* 1927
New York, Museum of Modern Art

88 MAN RAY *Drawing* 1938
London, Roland Penrose collection

89 MAX ERNST *The sap rises* 1929
From *La femme 100 têtes*, published
by Editions du Carrefour, 1929

90 MAX ERNST *Loplop et la Belle Jardinière*
1929
From *La Femme 100 têtes*, published
by Editions du Carrefour, 1929

91 MAX ERNST *Loplop and the mouse's
horoscope* 1929
From *La Femme 100 têtes*, published
by Editions du Carrefour, 1929

92 SALVADOR DALÍ *The Great Masturbator*
1929
Paris, private collection

93 SALVADOR DALÍ *The Persistence of
Memory* 1931
New York, Museum of Modern Art

94 SALVADOR DALÍ *Dancers, lion, horse . . .
invisible* 1930
Paris, Vicomtesse de Noailles col-
lection

95 SALVADOR DALÍ *Hysterical and aerody-
namic female nude* 1934
Sculpture
(Reproduced from *Erotique du Surré-
alisme* by R. Benayoun, J.-J. Pauvert,
Paris 1965)

96 SALVADOR DALÍ *The Ghost of Vermeer
van Delft, which can be used as a table*
1934
Cleveland, A. Reynolds Morse collec-
tion

97 SALVADOR DALÍ *Birth of liquid desires*
1932
Venice, Peggy Guggenheim Foun-
dation

98 SALVADOR DALÍ *Mae West* c.1934-6
Gouache

Chicago, Art Institute, gift of Mrs
Gilbert W. Chapman

99 SALVADOR DALÍ *The City of Drawers*
1936
Indian ink drawing
Edward James collection

100 SALVADOR DALÍ *Gradiva* 1932
Indian ink drawing
Private collection

101 SALVADOR DALÍ *Sleep* 1937
Edward James collection

102 SALVADOR DALÍ *Soft construction with
boiled beans : Premonition of civil war*
1936
Philadelphia, Museum of Art

103 LUIS BUÑUEL and SALVADOR DALÍ
Skeletons of bishops 1930
Shot from the film *L'âge d'or*, 1930

104 ALBERTO GIACOMETTI *The Couple* 1926
Plaster

105 ALBERTO GIACOMETTI *Suspended Ball or
the Hour of Traces* 1930
Plaster

106 ALBERTO GIACOMETTI *The Invisible
Object* 1934-5
Bronze

107 ALBERTO GIACOMETTI *The Palace at
4 a.m.* 1932
Wood, glass, metal and string
New York, Museum of Modern Art

108 OSCAR DOMÍNGUEZ *Decalcomania* 1937
New York, Museum of Modern Art

109 OSCAR DOMÍNGUEZ *Nostalgia for Space*
1939
New York, Museum of Modern Art,
gift of Peggy Guggenheim

110 VICTOR BRAUNER *Self-portrait* 1931
Paris, private collection

111 VICTOR BRAUNER *Mediterranean land-
scape* 1932
Paris, private collection

112 VICTOR BRAUNER *The Last Journey* 1937
Paris, private collection

113 VICTOR BRAUNER *The Triumph of Doubt* 1946
Paris, Alexandre Iolas collection

114 VICTOR BRAUNER *Totem of wounded subjectivity* 1948
Paris, private collection

115 VICTOR BRAUNER *Victor Victorios crushing the casters of spells* 1949
Paris, private collection

116 VICTOR BRAUNER *The Strange Case of Monsieur K* 1934
New York, Alexandre Iolas collection

117 HANS BELLMER *Landscape 1800* 1942
Drawing
Paris, Georges Hugnet collection

118 HANS BELLMER *Vanity* 1963
Drawing with gouache
Paris, Line and Patrick Waldberg collection

119 OSCAR DOMÍNGUEZ *Los Porrones* 1935
Knokke-le-Zoute, G. J. Nellens collection

120 HANS BELLMER *Doll* 1936
(Cast in aluminium, 1965)
Paris, Galerie François Petit

121 RENÉ MAGRITTE *Annunciation* 1929-30
Brussels, E.L.T. Mesens collection

122 RENÉ MAGRITTE *The Companions of Fear* 1942
Brussels, Mme Jean Krebs collection

123 RENÉ MAGRITTE *Threatening Weather* 1928
London, Roland Penrose collection

124 RENÉ MAGRITTE *Perpetual motion* 1934
London, Grosvenor Gallery, Eric Estorick collection

125 RENÉ MAGRITTE *La folie des grandeurs* 1961
Paris, Galerie Alexandre Iolas

126 RENÉ MAGRITTE *La folie des grandeurs* 1967
Bronze
Paris, Galerie Alexandre Iolas

127 PAUL DELVAUX *The Sabbath* 1962
Private collection

128 RENÉ MAGRITTE *Philosophy in the boudoir* 1947
New York, Thomas Claburn Jones collection

129 RENÉ MAGRITTE *The Man in the Bowler Hat* 1964
New York, Simone Withers Swan collection

130 PAUL DELVAUX *The Echo* 1943
Paris, Claude Spaak collection

131 RAOUL UBAC *Brûlage* 1939-40
Collection of the artist

132 RAOUL UBAC *Fossil* 1938
Photo-relief
Collection of the artist

133 PAUL DELVAUX *The Iron Age* 1951
Ostend, Museum voor Schoone Kunsten

134 PAUL DELVAUX *The Hands (The Dream)* 1941
Paris, Claude Spaak collection

135 WILHELM FREDDIE *Monument to war* 1936
Denmark, Silkeborg Museum

136 JINDRICH STYRSKY *Little Jesus* 1949
Collage
Private collection

137 TOYEN *Silken feasts* 1962
Paris, Line and Patrick Waldberg collection

138 TOYEN *In the warmth of the night* 1968
Collage
Private collection

139 ROLAND PENROSE *Portrait of Valentine* 1937
London, collection of the artist

140 TOYEN *The Mirage* 1967
Paris, Galerie François Petit

141 ALBERTO SAVINIO *The departure of Ulysses* 1930
Private collection

142 MARCEL DUCHAMP *Why not sneeze Rrose Sélavy?* 1921
Readymade
Philadelphia, Museum of Art, Louise and Walter Arensberg Collection

143 MERET OPPENHEIM *Cup, saucer and spoon in fur* 1936
New York, Museum of Modern Art

144 JOSEPH CORNELL *Taglioni's jewel casket* 1940
New York, Museum of Modern Art

145 MAN RAY *Destroyed object* 1932
A drawing showing what the object was like before destruction

146 JOSEPH CORNELL *Set for making soap bubbles* 1948
USA, William N. Copley collection

147 MAN RAY *Gift* 1921
Readymade (replica of the object of 1921)
Milan, Galleria Schwarz

148 WOLFGANG PAALEN *Leafy furniture cover* 1936

149 ANDRÉ BRETON *Poem-object* 1935
London, Roland Penrose collection

150 ANDRÉ BRETON *Symbolically functioning object* 1931
Private collection

151 JEAN BENOÎT *Costume for the Execution of the Will of the Marquis de Sade* 1950
Being-object

152 JEAN BENOÎT *The Necrophile (dedicated to Sergeant Bertrand)* 1964-5
Being-object

153 'Exposition Internationale du Surréalisme', Galerie des Beaux-Arts, Paris 1938 : the pool; one of the four beds; *The Horoscope*, an object by Marcel Jean; paintings by Paalen, Penrose and Masson

154 'Exposition Internationale du Surréalisme', Galerie des Beaux-Arts, Paris 1938 : *Never*, an object by Domínguez; the brazier; the sacks of coal

155 SALVADOR DALÍ *Rainy Taxi* 1938
At the 'Exposition Internationale du Surréalisme', Galerie des Beaux-Arts, Paris 1938

156 ANDRÉ MASSON *Girl in a black gag with a pansy mouth* 1938

At the 'Exposition Internationale du Surréalisme', Galerie des Beaux-Arts, Paris 1938

157 KURT SELIGMANN *Ultra-furniture* 1938
At the 'Exposition Internationale du Surréalisme', Galerie des Beaux-Arts, Paris 1938

158 RICHARD OELZE *Expectation* 1936
New York, Museum of Modern Art

159 KAY SAGE *Tomorrow is never* 1955
New York, Metropolitan Museum of Art

160 KURT SELIGMANN *Souvenir of America* 1943
Buffalo, Albright-Knox Art Gallery

161 PABLO PICASSO Composition for the cover of *Minotaure* 1933
Papier collé, cardboard, drawing pins and pencil
Minotaure, No. 1, 1933

162 BRASSAÏ *Photograph of graffiti* 1933
Illustration to his article 'Du mur des cavernes au mur d'usine', which appeared in Nos. 3 and 4 of *Minotaure*, December 1933

163 OSCAR DOMÍNGUEZ *Freud, Magus of Dream (knave of spades)* 1940
A card in the surrealist pack designed in Marseilles. Domínguez' design was traced by Delanglade
(Reproduced from *Erotique du Surréalisme* by R. Benayoun, J.-J. Pauvert, Paris 1965)

164 MORRIS HIRSHFIELD *Nude with cupids* 1944
New York, Sidney Janis Gallery

165 DOROTHEA TANNING *Les Petites Annonces faites à Marie* 1951
Houston, Texas, Mr and Mrs Jean de Menil collection

166 WIFREDO LAM *The Jungle* 1943
Gouache
New York, Museum of Modern Art

167 ROBERTO MATTA *Venus' walk* 1966
Central panel of a polyptych
Private collection

227 UGO STERPINI *The armed armchair* 1965
Bronze

228 JEAN-CLAUDE SILBERMANN *To the delight of the maidens* 1964
Sly Sign

229 JEAN-CLAUDE SILBERMANN *Semiramis. Sign for an unforgettable night* 1964
Sly Sign
(Reproduced from *Erotique du Surréalisme* by R. Benayoun, J.-J. Pauvert, Paris 1965)

230 ALBERTO GIRONELLA *Queen Mariana* 1961
Painting-object
Paris, Joyce Mansour collection

231 ANDRÉ MASSON *Portrait of André Breton* 1941
Ink drawing
Paris, Galerie Louise Leiris

Index